The Norton Simon, Inc.
Museum of Art

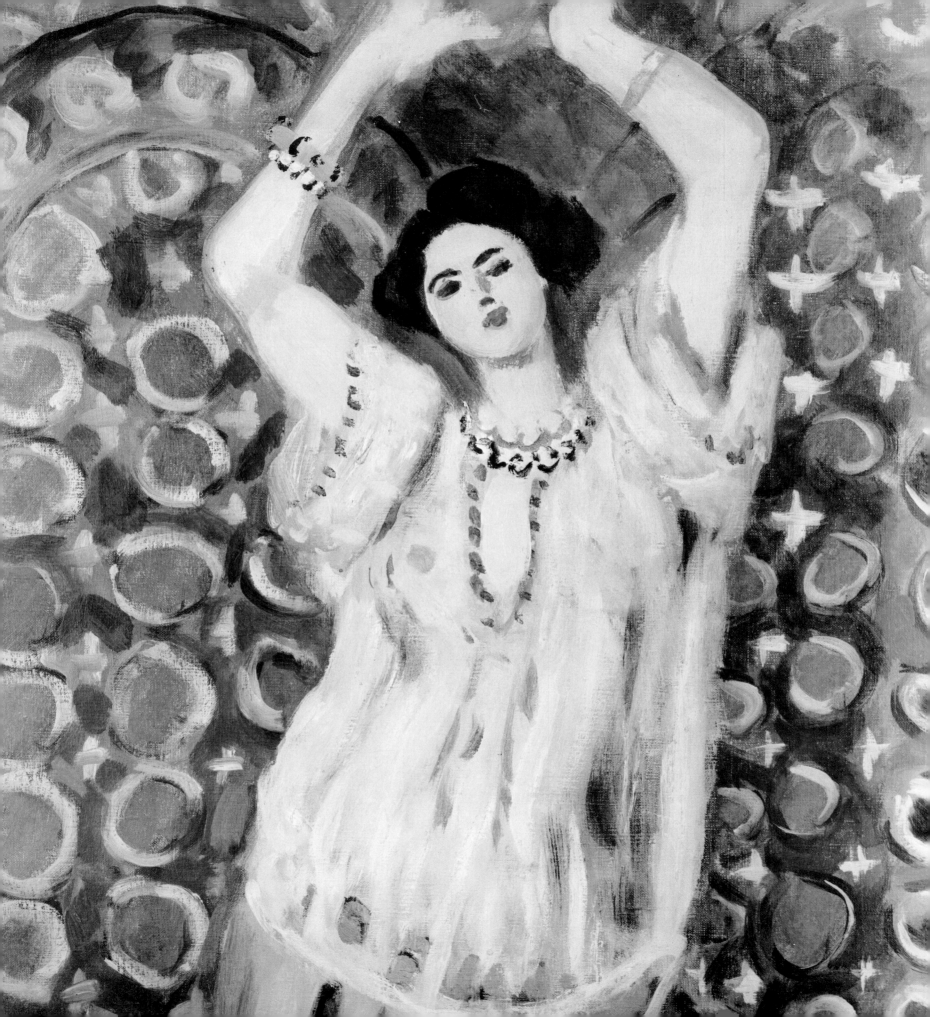

Selections from the Norton Simon, Inc. Museum of Art

Edited by David W. Steadman

The Art Museum

Princeton University

Distributed by Princeton University Press

Library of Congress Catalogue Card
Number 72-77426
ISBN cloth: 0-691-03887-2
ISBN paper: 0-691-03886-4

Designed by James Wageman
Type set by Typoservice Corporation
Printed by The Meriden Gravure Company
Photographs supplied by
the Norton Simon, Inc. Museum of Art

The College Art Association of America,
through a grant from the Ford Foundation,
has made sets of slides of the objects in
this exhibition available for distribution
for educational purposes.

Distributed by Princeton University Press,
Princeton, New Jersey 08540

Contents

List of Illustrations

Acknowledgments

EVERY great project has an inspiring force behind it. Without the understanding and support of the Norton Simon, Inc. Board of Directors and its chief executive, David J. Mahoney, this exhibition would not have been possible. Not only has the Board of this company created the Norton Simon, Inc. Museum of Art but it also has constantly striven to kindle in others an enduring interest in art similar to its own. Norton Simon, the President of the Norton Simon, Inc. Museum of Art, has encouraged the exhibition from its inception and has kindly written the introduction to this catalogue. Robert S. Macfarlane, Jr., President of Foundation Funds of Norton Simon, Inc., has been most generous of his time and wise advice. Darryl Isley, Vice-President and Curator, Norton Simon, Inc. Museum of Art, has overseen the creative and burdensome task of securing good photographs and providing material for the catalogue entries.

The constant support of Princeton University's Department of Art and Archaeology has enabled The Art Museum to produce this catalogue. Faculty members Felton L. Gibbons, Robert A. Koch, John Rupert Martin, Sam Hunter, Thomas L. B. Sloan, Marian Burleigh-Motley, and Robert Judson Clark, and three distinguished graduates of the Department of Art and Archaeology, Joseph C. Sloane, John David Farmer, and H. H. Arnason, have generously written introductory essays that will, we hope, help the visitor to more fully appreciate the exhibition. Wen C. Fong, Chairman of the Department, has stimulated, inspired, and guided all of us. His leadership at every stage has made this exhibition possible.

Virginia Wageman, Editor and Administrative Associate at The Art Museum, has been unstinting in her work in copy-editing and supervising the details of the catalogue's production. Peter Morrin and Mary Laura Gibbs helped to verify the accuracy of the catalogue entries.

DAVID W. STEADMAN
Acting Director
The Art Museum

WHILE the East coast exhibition of over one hundred masterpieces from the famous Norton Simon, Inc. Museum of Art is in itself a major event in the art world, the fact that it is being done in conjunction with the teaching programs of The Art Museum, Princeton University, has a profound significance not only for Princeton but also for the nation as a whole.

Though well known for its excellent library and research facilities in the teaching and study of the history of art, Princeton has been slow in developing an important university art museum. Through administrative initiative and alumni support, a new museum building was dedicated in 1966. Since then, attendance at The Art Museum has increased dramatically; in the last two years alone the attendance figure has nearly doubled.

The exhibition of major works from the Norton Simon, Inc. Museum of Art, which is to last one full calendar year, now presents the Department with the unprecedented opportunity to study and teach directly from these great works of art. The faculty of the Department of Art and Archaeology, as well as three distinguished alumni of the Department, have worked together to produce an exhibition catalogue that surveys European art from the fifteenth to the twentieth centuries. Many members of the Department have remodeled parts of their courses around the exhibition. For students and faculty alike, the impact of this experience will be felt, we trust, for a long time to come.

As a nation, we have had an erratic record in government support of the arts. The collecting of works of art in this country has depended largely on the initiative and enterprise of private individuals. Blessed with a sense of psychological distance, the collectors of the New Continent are catholic in taste, historical and encyclopedic in their approach to collecting. Great tycoon collectors—Morgan, Freer, Kress, Mellon, to mention only a few—were able to acquire for America an entire background in art, almost overnight. In time, these privately owned collections became accessible to the public at large. Modern American art museums are both encyclopedic repositories of the world's great art and active educational institutions.

It is said that in a democracy, education is the most direct route to social and cultural betterment. Through museums, great art becomes democratized, so to speak, reaching out to the millions rather than to a privileged few. The remarkable growth in awareness of the fine arts in post World War II America is reflected in the number of completely new, as well as greatly expanded, art museum buildings across the country. Since society's need for art will continue to grow, while the supply of great art is limited, there are only two ways—other than the increasingly difficult task of acquiring one's own permanent collections—to fill the future needy museums: One way is the use of constantly improving reproductions and replicas to teach outstanding works of art at second hand. The other is to have more traveling exhibitions on both long- and short-term bases.

The Norton Simon art treasures are the greatest single-group of works of European art still without a permanent home today. Instead of building his own museum, Mr. Simon has, with the brilliant aid of Robert S. Macfarlane,

Jr. (who happens to be Princeton '54), worked out a program of rotating year-long loan exhibitions from holdings of the Norton Simon, Inc. Museum of Art as well as The Norton Simon Foundation and Mr. Simon's personal collection, beginning with an exhibition at the Los Angeles County Museum of Art, which opened in June of this year, and this one at Princeton and one at San Francisco in the spring of 1973. An important element in this imaginative, and educationally beneficial, new program is the fact that this Princeton exhibition is encouraged and fully endorsed by Norton Simon, Inc., one of the largest consumer-product corporations in America. If Mr. Simon is properly admired for his enterprising genius in forming one of the world's great art collections at a relatively late point in time, he should now be further congratulated for his social insights and for furthering the future aesthetic education and cultural development of this country.

Needless to say, we at Princeton are proud to be part of Norton Simon, Inc.'s innovative project. On our part, this exhibition coincides with our need to develop The Art Museum, Princeton University, and to teach and train future scholars directly from outstanding works of art. For the Simon treasures, on the other hand, to begin their tour at Princeton is to start from one of the fountainheads of art scholarship and education in America. It is hoped that the exhibition of the Norton Simon, Inc. Museum of Art treasures at Princeton, where they will form part of the teaching program, will point to a new direction for future corporate and foundation support for visual arts and art education in this country.

WEN C. FONG
Edwards S. Sanford Professor of Art and Archaeology
Chairman, Department of Art and Archaeology

ONE of the most profound means of human communication is the visual arts. By establishing a meaningful dialogue between an artist's vision of the world and our own perceptions, art can help us to understand ourselves more fully. Moreover, art at its finest gives us a deep sense of history, tradition, and the true potentialities of man's creativity. In today's world where oftentimes scientific development is regarded as the highest goal and where the individual frequently feels alienated from himself and those around him, the role of art becomes increasingly important in keeping open the lines of communication.

We can learn to see nature through the eyes of the artist not only on a conscious level but subconsciously or intuitively as well. Our visual impressions of cities such as Venice and Paris, for instance, have been colored by the cityscapes of Guardi and Pissarro. We may observe a vase of "Redon flowers" or walk beneath a "Ruisdael sky." In each case, the artist has given us an added dimension in our perception of the world around us.

The artist helps us to better understand human nature through portraiture. By participating in his insights, we learn not only about the particular sitter, but how to observe and probe into the personalities in our own lives. We, like the artist, become psychologically acute. In van Gogh's *Portrait of the Artist's Mother* (cat. 33), painted after a photograph of her, we can see how the painter transcends the mere recording of physical data through his own inner perception of the woman's spirit. In the less personal and more formal portrait van Dyck painted of the *Marchesa Lomellini-Durazzo* (cat. 7), the artist still manages to convey the smoldering arrogance behind the brooding face.

The move away from representational art can be seen dramatically in Degas's pastel *Woman Drying Her Hair* (cat. 41), executed shortly before his death. It is remarkable that this artist, who began his career in the formal tradition of Ingres, should have come at the end of his life to the brink of abstract art. We might look at ourselves and ask, have we equally changed in our ability to alter and enlarge our perceptions of man and the world?

Judging from the enormous rise in museum attendance throughout the country, it seems obvious that people are actively searching for something. Perhaps it is for a sense of history or the self-awareness that art can provide. Norton Simon, Inc.'s support of the Norton Simon, Inc. Museum of Art is a unique and meaningful way for a company to fulfill this growing need and to exercise corporate citizenship.

There are several corporations in America that have extensive collections of contemporary art. However, Norton Simon, Inc. has taken a different approach. It is unique because the focus of its collection has been old master, Impressionist, and modern paintings, and nineteenth- and twentieth-century sculpture. Further, the collection is not corporately owned and therefore is not an asset of the corporation. Rather the collection is owned by a foundation that receives its principal support from Norton Simon, Inc. It must be made clear that much of this would not be possible without the understanding and commitment to corporate citizenship on the part of David J.

Mahoney, chief executive of Norton Simon, Inc., and the company's progressive Board of Directors. Continued corporate support insures that the collection will expand and serve an even larger public.

The concept of the Norton Simon, Inc. Museum of Art (formerly the Hunt Foods and Industries Foundation) has emerged slowly in the past two decades. It was engaged originally in general charitable activities, which were later shifted to other corporate foundations. The program of the Norton Simon, Inc. Museum of Art thus became one of acquiring works of art and making them available to the public. In 1962 the Foundation completed the construction and donation of a branch public library to the city of Fullerton, together with a fine collection of books on art. In the mid-1960s the Foundation seriously considered the possibility of constructing a museum to house its growing collection. Abandonment of this project in the late sixties was due to a more profound interest in and a realization of the greater national need for the collecting of art. The decision was made to emphasize collecting European works of art from the Renaissance to the twentieth century, and the collection now comprises over three hundred paintings, watercolors, drawings, and sculptures from those periods. The present exhibition of over one hundred works is the first to bring together so large a number of paintings, watercolors, and sculptures from the collection.

It is a privilege to have this exhibition at Princeton University, where one out of four undergraduates attends at least one course in the Department of Art and Archaeology during his college years, and where, on the graduate level, future generations of art scholars and museum curators will be trained. We hope that the exhibition will help to continue the growing interest in art among the students and the general public.

NORTON SIMON

**The Norton Simon, Inc.
Museum of Art**

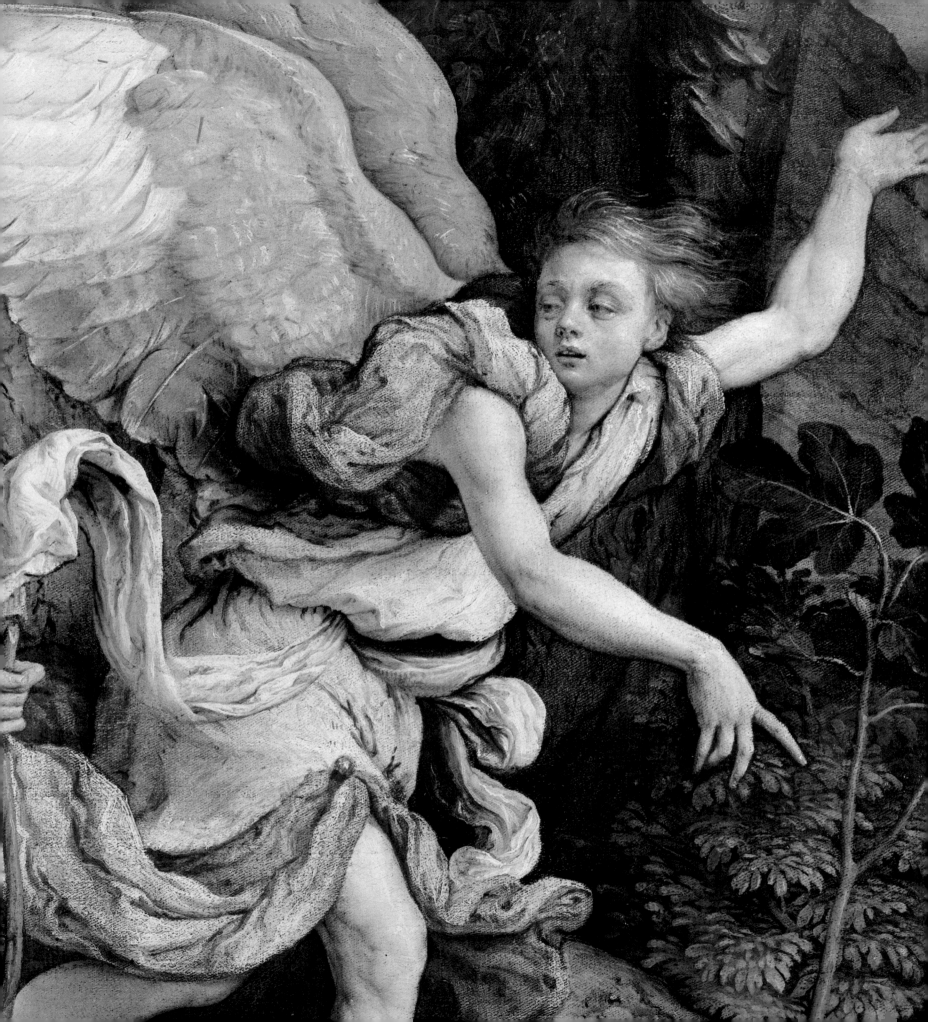

FEW would contest that Giovanni Bellini was the greatest Venetian painter of the fifteenth century. In his long career stretching from the middle 1450s to his death in 1516, his genius dominated religious and history painting in Venice, his few late efforts in mythology proved seminal, and he made key contributions to the art of portraiture. The *Portrait of Joerg Fugger* (cat. 1) in the Norton Simon, Inc. Museum of Art Collection is a miniature and, it would seem, a minor example of Bellini's art in this field. But for several reasons the Fugger portrait has historical importance beyond its modest appearance: it is among the first—perhaps in fact the earliest—of Bellini's portraits; inscribed with the date 1474, it is his first firmly dated work; it documents his contact with the German colony in Venice by portraying one of this group's leading members; and it raises questions concerning Bellini's contact with an influential visitor to Venice in these years, the itinerant Sicilian painter Antonello da Messina.

Bellini's Fugger portrait was not discovered until the mid-1920s by a German art historian, enviably serendipitous, in the attic of the Castle Ober-kirchberg near Ulm, still owned by a recent Count Fugger. It is thus possible to assume that the portrait remained in the hands of the Fugger family until less than fifty years ago, when it commenced peregrinations through the art market that ended in the great Contini-Bonacossi Collection of Florence. After this was recently dispersed, the painting came directly to the Norton Simon, Inc. Museum collection. When first published by its discoverer in 1926, the small portrait was recorded to have a crucial inscription on its back reading: *Joerg Fugger a di XX Zugno MCCCCLXXIIII* (Joerg Fugger on the 20th of June 1474). The young heir of a great German mercantile family, whose seat was in the south German town of Augsburg, is shown in three-quarter view, his hazel eyes looking intently out of the picture to the left. The crown of his medium brown hair is contained by a garland, an attribute that occurs in other Bellini portraits and designates the young man as a recent student of ancient learning. If there should be doubt about the portrait's inscribed identification, other facts support it as a record of the youngest Fugger son: Joerg was born in 1453, about when Bellini began to paint, and was thus about twenty-one—a likely age for the sitter—at the time of the portrait, when, in addition, young Fugger was known to have been in Venice.

Giovanni Bellini's *Joerg Fugger* is not only an early portrait important for his own art; it also exemplifies Venetian artistic contacts with Germany well back in the fifteenth century. It is always important to realize how richly Venetian and transalpine art cross-fertilized each other. To mention but two examples, Albrecht Dürer's two trips to Venice twenty and thirty years after the Fugger portrait were essential for his development (he was warm in praise of Giovanni Bellini after the second), and Bellini's two most significant followers, Giorgione and Titian, decorated the huge new German trading center in Venice in 1508.

Giovanni's Fugger portrait, in which the sitter is placed in a three-quarter pose that suggests real space around him, leads the way forward from stiffer early Renaissance models. But, more than that, by showing the artist in

contact with a leading German trading family, the painting helps locate pathways over the Alps down which varied ideas could flow.

Most art scholars who have written on the Fugger portrait have concerned themselves with another sector of its sphere of influence, a possible relation with the North transmitted through an Italian means, the traveling Sicilian painter Antonello da Messina. Since the first historians of Italian art, Antonello has been considered crucial in the development of portraiture and of technique not only for his own brilliant inventions but because it is believed that during his wanderings he came in contact with Flemish oil paintings and disseminated this new technique when he returned to Sicily. It is known that he visited Venice in 1475 and 1476; the major altarpiece he did there is simultaneous with a similar one by Bellini, and the precedence of the one over the other has been a matter of indecisive discussion for decades. In view of this contest of influences between two greats, the appearance of the Fugger portrait, bust-length and three-quarter view like most of Antonello's, causes automatic invocation of the Sicilian's name. The 1474 date on the portrait is of course awkward in view of Antonello's 1475 arrival in Venice, but ready hypotheses leap forward to fill the gap: that the Messinese made earlier unrecorded visits to Venice or that his paintings were there before him. However, these speculations seem to me gratuitous. Antonello's influence on Bellini and the development of the oil technique in Venice were, as nature and history required, gradual organic processes, and the Fugger portrait is an early, native, and still somewhat conservative product of Bellini's Venetian imagination, touched by northern experiences that may have come through his patrons as well as from myriad sources. These need not have included Antonello, whose travels had early brought greater sophistication to his portraits. A historical document of importance and a miniature link between two cultures, Bellini's Fugger portrait marks the charming beginning he made in this field and points to the remarkable distance he traveled from this point to his late portraits like the *Doge Loredano* in the London National Gallery, a work of full High Renaissance ideality.

Giovanni Bellini was one of several masters who established Venetian painting on its aspiring High Renaissance path. His great successor, who followed this path to its end, was of course Titian, and his greatest followers in turn, who with him dominated Venetian art in the sixteenth century, were Tintoretto and Veronese. A fourth name is sometimes added to this triumvirate, that of Jacopo da Ponte from Bassano in the foothills of the Venetian Alps north and west of the city. Bellini and Tintoretto, the city's two greatest religious painters, were native Venetians; Titian, also from the mountains, and Veronese, from Verona, settled in the lagoon city for their entire long careers. Jacopo Bassano, as he is called after his native town, pursued a different path more loyal to his origins, dividing his time between Venice and his home on the Brenta with its spectacular views of the mountains behind.

Bassano's brilliant painting of the *Flight into Egypt* (cat. 2) records his double loyalty and what may be called the creative advantages of provinciality. As he does often in his paintings, Jacopo enriches this one with

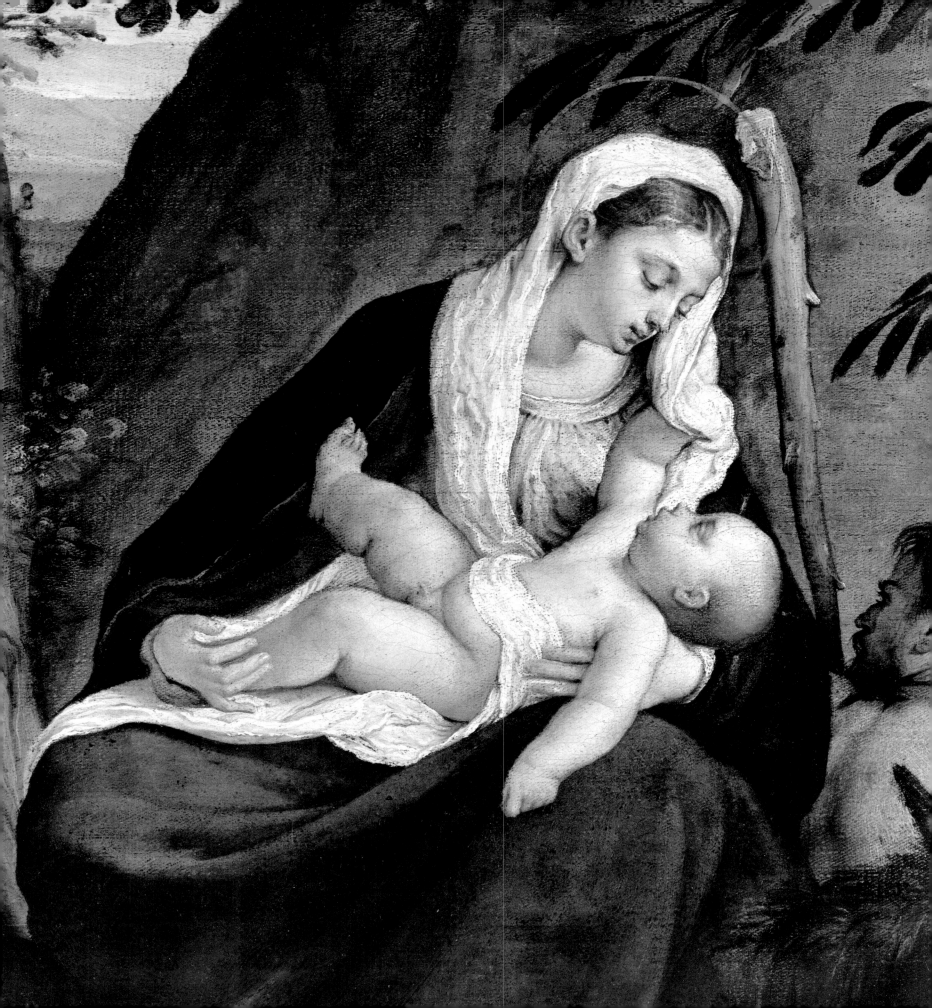

Figure 1. Titian, *Madonna and Child and Two Angels*, fresco (Ducal Palace, Venice)

authentic notes of country life: on the left there is a peasant loosing some chickens from a basket so that, after the Italian custom, they can feed off nature; there is an itinerant soldier accompanying the Holy Family pausing in the road, his head tipped back to drink from his cask; in the middle ground are rough thatched huts and an eye-catching and eye-resting view of blue mountains beyond. Such elements of landscape and everyday life later came to dominate Bassano's paintings more than those of most sixteenth-century masters; and when Baroque artists sought new categories in independent landscape and genre painting, they were happy to turn to Jacopo for instruction.

But the *Flight into Egypt* is not without its more metropolitan sophistications. The pose of the Madonna with the wriggling Child is directly based on a well-known (though now deteriorated) Titian fresco in the Ducal Palace of Venice (fig. 1). Jacopo had already adapted it to a very early work of his own in the middle 1530s, also a *Flight into Egypt,* now in the Bassano Museum (fig. 2); both borrowings of a stable motif by the older master for the mounted and moving Mother and Child are so ingenious and bold that any criticism of the derivation fades. Some of the buildings in the *Flight,* especially the ramshackle huts, reappear in another work by Jacopo that is about simultaneous, his *Trinity* at Angarano near Bassano. Like other artists of his time, when originality had quite a different meaning from today, Jacopo Bassano had no qualms in reusing motifs that he probably had recorded in drawings. Despite his well-meaning and typical eclecticism, his design for the *Flight into Egypt* is as a whole striking in its brilliant originality. In the Venetian tradition, the colors are vibrant and shot with light, helping to define the forward-driving energies of the journey. The varied animation of the figures is also captured by the general forward motion, yet each retains an individual character on which the eye can dwell at rest: the aged, red-faced, but determined Joseph, the muscular shepherd behind the donkey's neck who poignantly provides a foil to the group of Virgin and Child, and above all the lead-off angel almost frenetically urging the party on amidst the rustle of its swirling light-colored draperies. This vivid painting, with its

18

Figure 2. Jacopo da Ponte,
Flight into Egypt (Bassano Museum)

facile energetic technique, has been most reliably dated to the early 1540s when Jacopo was in his early thirties. Such a placement in his career is convincing, for this was Bassano's best moment when his highly personal style had matured but was not yet absorbed, as later happened, in the formalities of his sons' weaker art.

Mannerism, the dominant style of sixteenth-century Italy, did not thrive in conservative Venice, dedicated to Titian's persistent classic ideals. However, Jacopo Bassano, to some degree always a mainland and a provincial artist, was freer from the conservative strictures of Venice itself and developed his own personal quasi-Mannerist style well exemplified here. The broken and varied rhythms introduced by the angel and the complex movement within a tight plane are modified Mannerist traits in Jacopo's painting; on the other hand the ample background space and the vivid naturalism of individual motifs owe nothing to the forced artifices of sixteenth-century style. This idiosyncratic mixture of realism and Mannerism in Jacopo, so brilliantly illustrated by the *Flight into Egypt*, was in the future variously fruitful. It spoke strongly to the emerging Baroque, to artists like the Carracci in Bologna, and to such northern visitors seeking coloristic enrichment of their styles as Rubens and van Dyck, who are also represented in the present exhibition (cat. 6, 7).

1

Giovanni Bellini
Italian, ca. 1430–1516

Portrait of Joerg Fugger, 1474

Oil on panel
26 x 20 cm (10¼ x 7⅞ in)
Inscribed on back (covered over): *Joerg Fugger a di XX Zugno MCCCCLXXIIII*

COLLECTIONS: Johannes, Count of Fugger-Oberkirchberg; Walter Schnackenberg; F. Kleinberger and Co.; Contini-Bonacossi Collection.

EXHIBITIONS: Royal Academy of Art, London, 1930, *Exhibition of Italian Art, 1200–1900,* no. 270; Palazzo Ducale, Venice, 1949, *Mostra di Giovanni Bellini,* no. 74.

LITERATURE: August L. Mayer, "A Portrait of Joerg Fugger Ascribed to Giovanni Bellini," *Burlington Magazine,* 48 (1926): 219; Detlev von Hadeln, "Two Portraits by Giovanni Bellini," *Burlington Magazine,* 51 (1927): 4; Georg Gronau, *Giovanni Bellini: Des Meisters Gemälde* (Stuttgart, 1930), p. 205, pl. 69; Raimond van Marle, *The Development of the Italian Schools of Painting,* 19 vols. (The Hague, 1935), 17: 254; Carlo Gamba, *Giovanni Bellini* (Milan, 1937), p. 72; Vittorio Moschini, *Giambellino* (Bergamo, 1943), p. 23, pl. 82; Philip Hendy and Ludwig Goldscheider, *Giovanni Bellini* (Oxford, 1945), p. 27, pl. 40; Luitpold Dussler, *Giovanni Bellini* (Vienna, 1949), pp. 44, 92, pl. 75; Bernard Berenson, *Italian Pictures of the Renaissance,* 2 vols. (London, 1957), 1: 31; Fritz Heinemann, *Giovanni Bellini e i Belliniani,* 2 vols. (Venice, 1959), 1: 75, no. 269; Rodolfo Pallucchini, *Giovanni Bellini* (Milan, 1959), p. 138, fig. 93; Giuseppe Fiocco, *Giovanni Bellini* (London, 1960), p. 14, pl. 19; John Pope-Hennessy, *The Portrait in the Renaissance* (N.Y., 1966), pp. 63, 311.

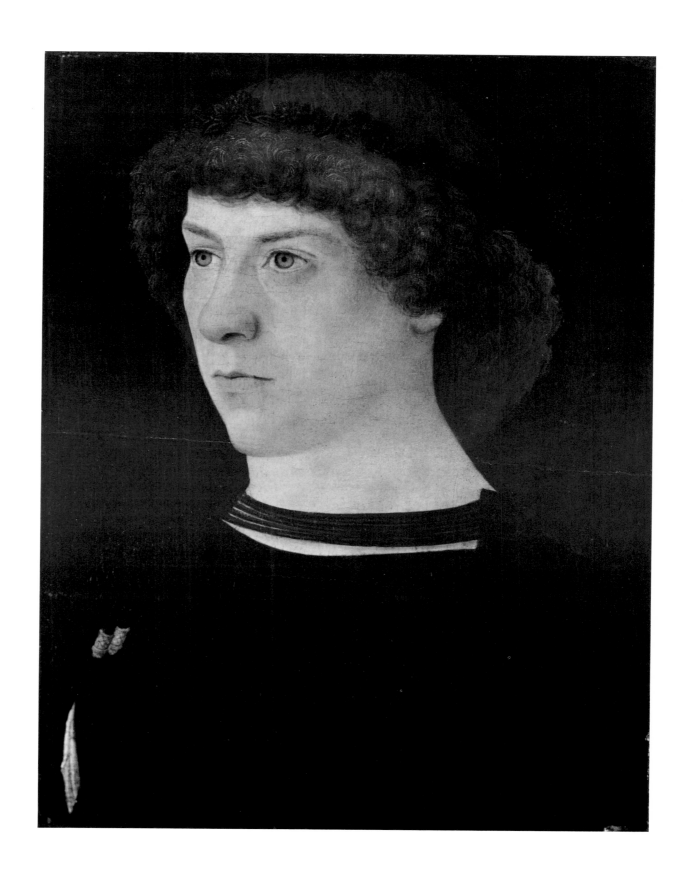

2

Jacopo da Ponte, called Il Bassano
Italian, 1510–92

Flight into Egypt, ca. 1540

Oil on canvas
119 x 198 cm (47 x 78 in)

COLLECTIONS: General Craig (sale,
Christie's, London, Apr. 18, 1812, no.
11); Sir Joseph Hawley; Sir Henry Haw-
ley; Annie Massey; Lord Rendel of
Hatchlands; H. S. Goodhart-Rendel;
Prinknash Abbey (sale, Christie's, Lon-
don, Dec. 5, 1969, no. 112).

EXHIBITIONS: Royal Academy of Art,
London, 1879, "Winter Exhibition," no.
206 (as Venetian school); Royal Acad-
emy of Art, London, 1960, *Italian Art
and Britain*, no. 86.

LITERATURE: Benedict Nicolson, "Some
Little Known Pictures at the Royal Acad-
emy," *Burlington Magazine*, 102 (1960):
76, fig. 39; Luke Herrmann, "A New
Bassano 'Flight into Egypt,'" *Burlington
Magazine*, 103 (1961): 465; Christie,
Manson and Woods, *Highly Important
Pictures by Old Masters* (London, Dec. 5,
1969), no. 112.

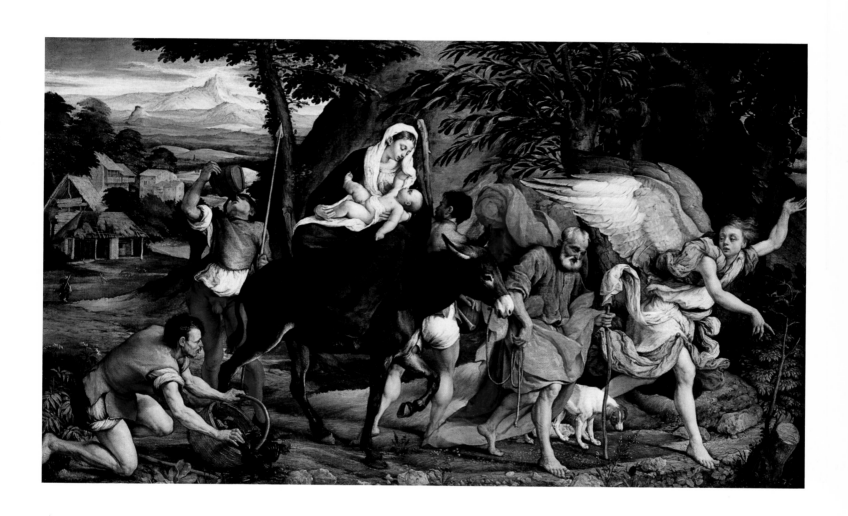

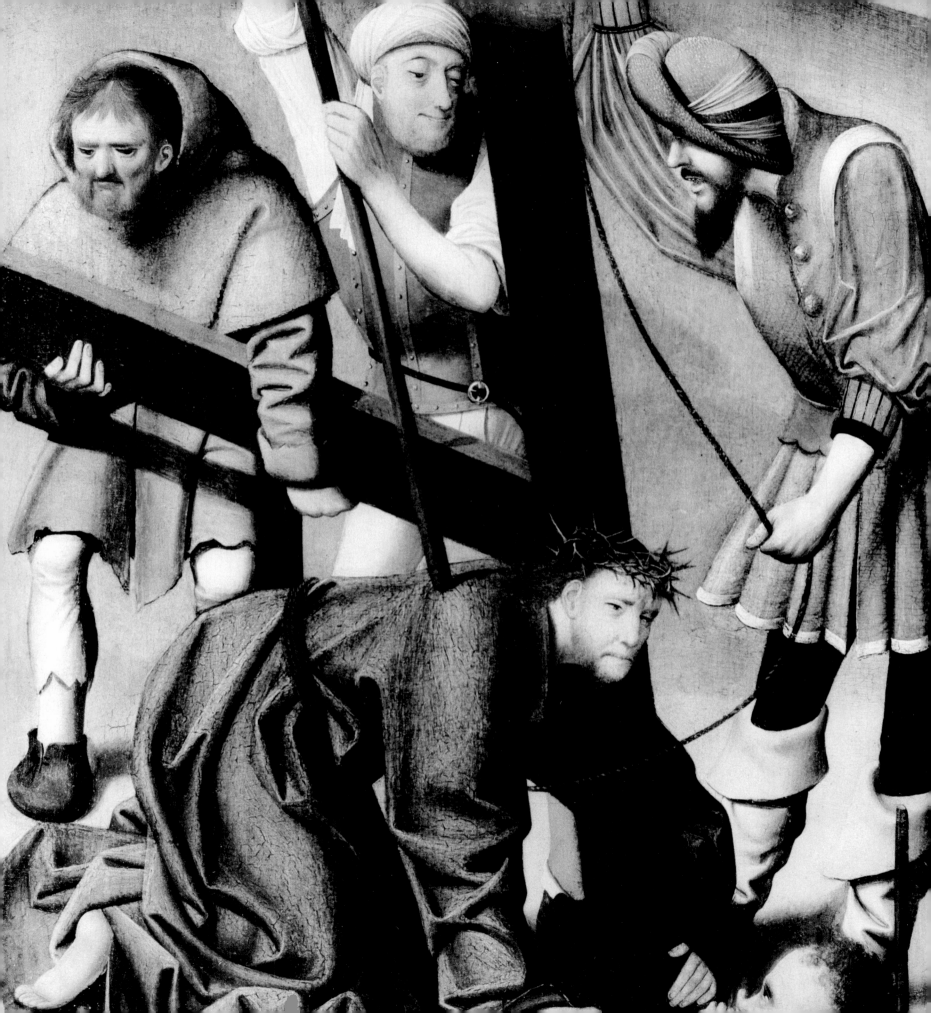

THE ART of the northern Renaissance is sparsely but nicely represented in this exhibition. There are two pairs of panel paintings that define widely different aspects of a waning interest in religious subject matter at the time of the Reformation in the early sixteenth century in Holland and Germany. Gospel stories become essentially vehicles for genre and caricature, while the Adam and Eve of Genesis become sensuous nudes.

Northern
16th-Century Painting

Robert A. Koch

The small pair by an unidentified Dutch painter known as the Master of Alkmaar, after the town in which his major painting *The Seven Works of Mercy* once existed as a church commission (now in the Rijksmuseum, Amsterdam), is the only known remnant of another altarpiece that depicted episodes from the Passion of Christ, here the *Scourging of Christ* (cat. 3) and the *Road to Calvary* (cat. 4). Both compositions were trimmed somewhat at top and bottom, probably when the painting was dismembered for easier disposition, and possibly as early as the middle of the sixteenth century when Protestant iconoclasm with its hatred of religious art was rampant in Holland.

Each composition has a Dutch sense of neatly ordered space. Details are minimal, and the colors, while often bright, are not joyous ones. Almost all figures are caricatured, Christ's tormentors as well as the group of witnesses to the flagellation. Like a group portrait, the unusual, genre-like addition to this theme reveals the Dutchman's democratic preference for nameless numbers—though the figure in black at the extreme left has the air of a self-portrait. The image of Christ is pallid, pathetic, unfelt. Folksy and puritanical, the Master of Alkmaar has been liberated from the conventional Catholic devotional picture, and thus he is in tune with a notable contemporary, that even more unorthodox Netherlander Hieronymus Bosch.

Without the achievement of Albrecht Dürer one would be sorely pressed to justify the use of the word "renaissance" in speaking of northern European art of this period, the early sixteenth century; for it was he alone who first effectively absorbed, in two visits to Italy, one of the basic components of the classical ideal, the male and female nude as objects of aesthetic beauty. Dürer transplanted the flame to Nuremberg and thence to all of Europe via his engraving of *Adam and Eve* of 1504, and he monumentalized our "first parents" in a pair of life-sized paintings in 1507 (now in the Prado, Madrid). Dürer's print is the direct ancestor of the impressive, life-sized panels of *Adam* and *Eve* by Lucas Cranach the Elder, which are in this exhibition (cat. 5).

Cranach fanned Dürer's flame into a roaring bonfire, abandoning with insouciance Dürer's scientific interest in the human body. With his flourishing workshop, Cranach created many dozen alluring naked female beauties for his patrons in the Wittenberg circle around the provincial court of the Saxon Elector Frederick the Wise. Whether the figure was Venus, Eve, Diana, or Judith, mythological or biblical, all were subjected to the same formulae and all served the interest of erotic provocation.

Perhaps because it was a compromising portrayal of the nude, and one that included both male and female figures, the Fall of Man (or Adam and

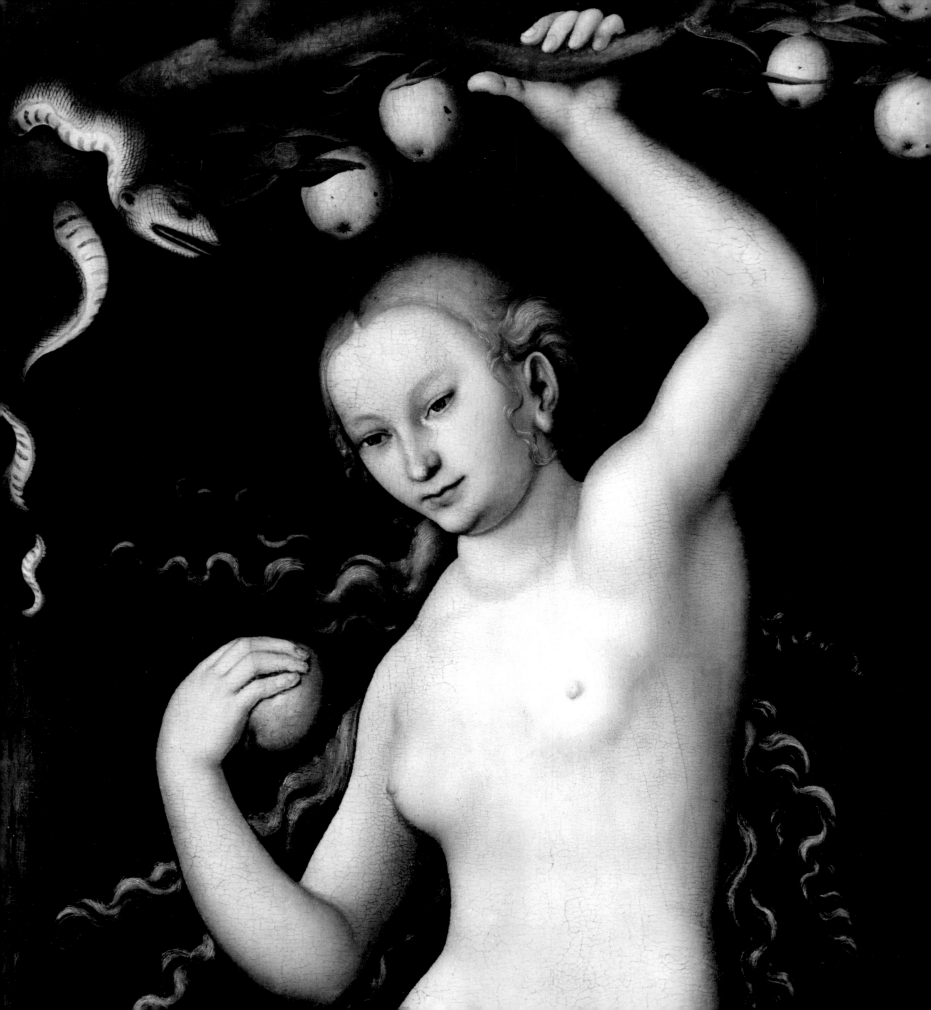

Eve) proved to be the most popular theme in the Cranach repertory, with Venus and Cupid the runner-up. Twenty or so paintings of the Fall of Man have been catalogued. These are mostly on two separate panels, and they follow the precept of Dürer's paintings in the Prado in being more or less life-sized, with a dark, nearly neutral background that serves as a foil for the unclothed bodies. The pair in this exhibition, surely by Cranach's own hand, is signed with the personal device of Cranach the Elder, a winged serpent. It is closest in style and composition to a pair in the Uffizi, which bear the date 1528. Most of Cranach's nudes date from this time on, when the artist was approaching a by no means senile sixty years of age. The Princeton Art Museum's fine *Venus and Cupid* dates from an earlier, more salubrious and rather less mannered period in Cranach's stylistic development.

"In spite of their sidelong glances, Cranach's sirens never cease to be objets d'art, to be enjoyed as dispassionately as crystals or enamels," notes Sir Kenneth Clark. Whatever the present-day spectator brings to a Cranach nude, and especially to those wearing nothing but plumed hats and jewelry, it can hardly be disputed that they serve collectively as examples of the pleasurable side of the classical heritage.

3

Master of Alkmaar
Flemish, active 1490–1520

Scourging of Christ, ca. 1500–10

Oil on panel
47.2 x 25 cm (18⅝ x 9¾ in)

COLLECTIONS: Lord Bagot; M. Knoedler
and Co.

EXHIBITIONS: Thomas Agnew and Sons,
London, 1946, *Thirty-five Masterpieces
of European Painting*, no. 27; M. Knoed-
ler et Cie., Paris, 1969, *Maîtres Anciens*,
no. 13.

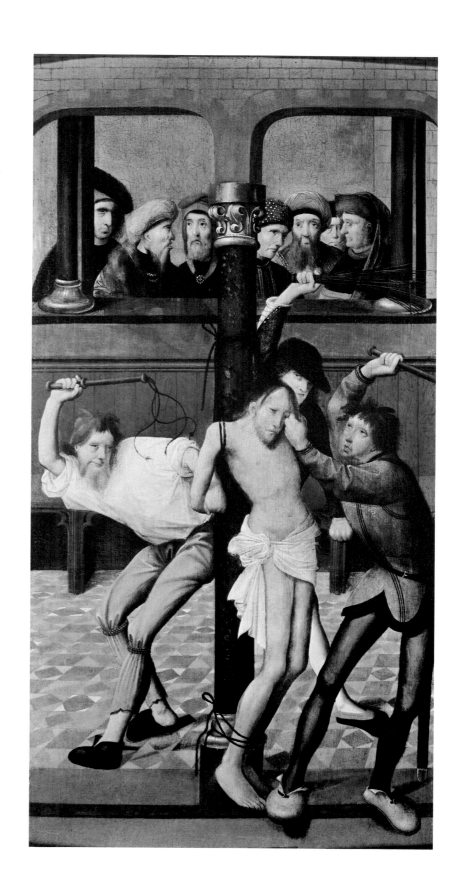

4

Master of Alkmaar
Flemish, active 1490–1520

Road to Calvary, ca. 1500–10

Oil on panel
47.2 x 23.7 cm (18⅝ x 9⅜ in)

COLLECTIONS: Lord Bagot; M. Knoedler
and Co.

EXHIBITIONS: Thomas Agnew and Sons,
London, 1946, *Thirty-five Masterpieces
of European Painting*, no. 26; M. Knoed-
ler et Cie., Paris, 1969, *Maîtres Anciens*,
no. 13.

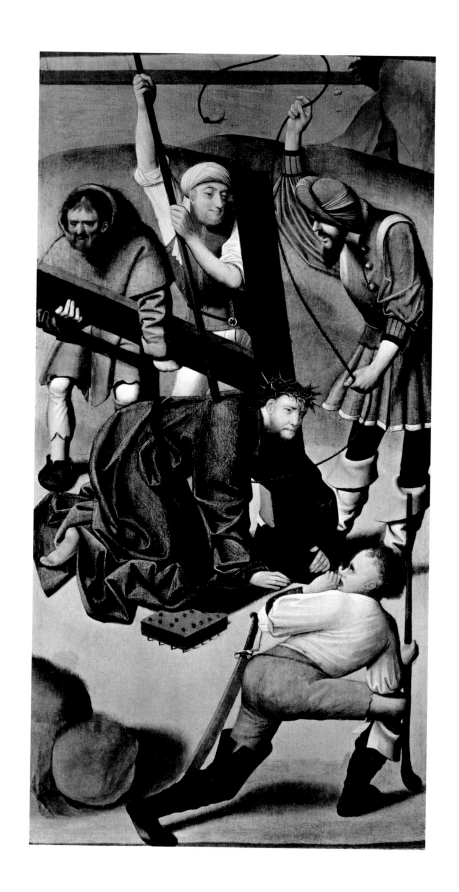

5

Lucas Cranach the Elder
German, 1472–1553

Adam and *Eve,* ca. 1530 (a pair)

Oil on panels
190 x 70 cm (75 x 27½ in)
The *Adam* is signed with the artist's
serpent device, lower right

COLLECTIONS: Count Paul Stroganoff;
Hermitage, Leningrad (sale, Lepke, Ber-
lin, May 12, 1931, nos. 44, 45); J. Goud-
stikker; Marshall Hermann Goering;
Government of the Netherlands; Comdr.
George Stroganoff Scherbatoff.

LITERATURE: James A. Schmidt, "Adam
und Eve von Cranach," *Pantheon,* 7
(1931): 194–95; Max J. Friedländer and
Jakob Rosenberg, *Die Gemälde von
Lucas Cranach* (Berlin, 1932), no. 164.

NOTE: The *Adam* and *Eve* are owned
jointly by the Norton Simon, Inc. Mu-
seum of Art and The Norton Simon
Foundation.

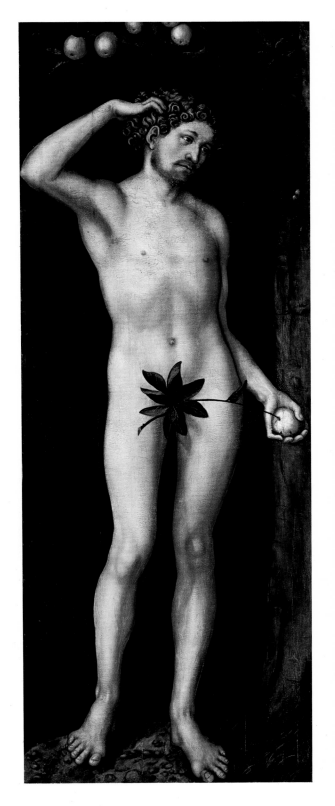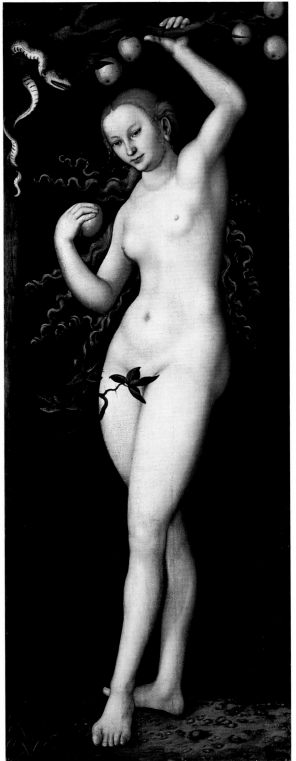

John Rupert Martin

IN THE FIRST decades of the seventeenth century Italy was still the unchallenged leader of European painting. Artists from all over Europe flocked to Rome, where their imaginations were fired by the brilliant achievements of Caravaggio and Annibale Carracci. Yet some of the most significant developments in Baroque painting were destined to take place north of the Alps. Within a few years, the rise of flourishing national schools in Flanders and Holland effectively brought an end to the Italian hegemony. The change in attitude is plainly reflected in the careers of the two greatest artists in the Netherlands. Rubens, born in 1577, considered a lengthy sojourn in Italy to be essential to the formation of his art, whereas Rembrandt, born a generation later, in 1606, saw no necessity to leave his native Holland.

Rubens, who returned from Italy to Antwerp in 1608, was appointed court painter to the Archdukes Albert and Isabella, the sovereigns of the Spanish Netherlands, whose portraits he was to paint from time to time. In Antwerp, Rubens quickly outshone all his fellow artists and as early as 1611 was described by an admirer as "the god of painters." One result of his phenomenal success was the establishment of a large and efficient workshop where, with the aid of pupils and assistants, he could carry out the numerous commissions for altarpieces, mythologies, and other large paintings that came to him from everywhere in Europe. The ablest of his assistants was Anthony van Dyck, who worked in Rubens's studio as pupil and collaborator from about 1618 until late in 1620.

When Archduke Albert died in 1621, his widow, the Infanta Isabella Clara Eugenia, became governor of the southern Netherlands. It was not an easy task, for the country was still entangled in the interminable war between Spain and the Dutch republic. Rubens continued to serve as Isabella's court painter and on several occasions acted as her trusted diplomatic agent. His painting of the Infanta (cat. 6) shows her in the gray habit of the Poor Clares that she wore after the death of Albert; she holds in her hands one end of the black veil that covers her head, and the cord tied round her waist has three knots, symbolizing the three vows of the Order of Saint Clare. The portrait was painted in Antwerp, when the Infanta stopped there for a few days in July 1625, following a visit to the Dutch city of Breda, which had recently been captured by Spanish forces under the Marquis of Spinola.

Despite the subdued coloring, the portrait of the Infanta gives an impression of intense warmth and vitality, which results both from the glowing light that surrounds the head and from the partly unfinished background against which the figure is placed. In the sensitive rendering of the face, Rubens succeeds in conveying the forceful yet sympathetic character of the Spanish princess whose government of the southern Netherlands, during an especially difficult and trying period, won her the love and respect of the people. The portrait-type seen in this work became the official likeness of the Infanta Isabella, and as such was frequently copied. Within a year or two it was engraved in reverse by Paulus Pontius, with an allegorical frame and Latin verses alluding to the capture of Breda (fig. 3). It was also used as a model by van Dyck for his full-length portrait of the Infanta now in the

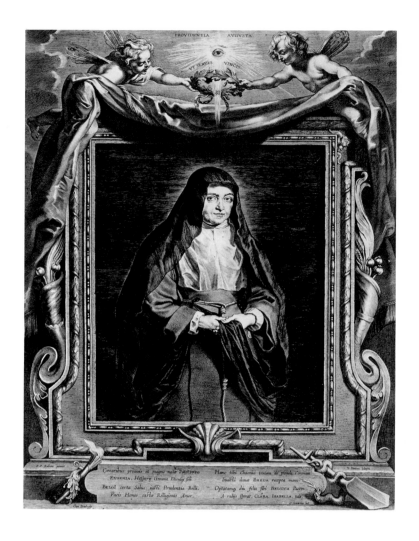

Figure 3. Paulus Pontius
after Rubens,
The Infanta Isabella Clara Eugenia,
engraving

Pinacoteca at Turin. Many years later the same type reappears, this time in half-length, in the engraving by Lucas Vorsterman after van Dyck's design for the great series of portraits known as the *Iconography* (fig. 4).

Unlike Rubens, van Dyck was to make portraiture the central activity of his artistic career. The younger master, eager to assert his independence, left Rubens's studio in 1620 and a year later made his way to Italy. His reputation as a portraitist of genius was established in Genoa, where he worked for such aristocratic patrons as the Doria, Cattaneo, and Spinola families. Van Dyck's portrait of a Genoese noblewoman, the Marchesa Lomellini-Durazzo (cat. 7), belongs to this period of the early 1620s and is one of the most perfectly preserved paintings by van Dyck. In it he leaves no doubt of his indebtedness to Rubens, although the influence of Titian may also be discovered in such passages as the highlights on the sleeves and skirt. But in this relatively early work van Dyck has already achieved the subtle balance of courtly distinction and unaffected naturalness that was to bring him international success as the portraitist of the aristocracy.

Whereas Rubens and van Dyck were sustained by the dual patronage of church and aristocracy, Dutch painting of the seventeenth century is almost wholly secular and bourgeois. In the portraits of Hals and Rembrandt it is not princes that we see represented, but merchants and professional men. Some of the most gifted masters are specialists, not in religious and mythological subjects, but in landscape and genre.

Jan van Goyen is the leading master of the early or tonal phase of Dutch landscape, the most distinctive feature of which is the prominence given to the sky. In his *Winter Scene with Skaters* (cat. 8), van Goyen takes up one of the most popular themes of the seventeenth century in Holland. With its low horizon and its open expanse of frozen river beneath windswept clouds, this little sketch-like panel admirably suggests the damp, cold atmosphere of a winter's day. The dominant gray-brown tonality is relieved by patches of bright color in the nearer figures enjoying themselves on the ice.

If van Goyen is the painter of sky and atmosphere, Jacob van Ruisdael is "the painter of the forest." This great artist, who represents the classical phase of the middle years of the century, introduces a note of grandeur into his vision of nature. In his *Woody Landscape with a Pool and Figures* (cat. 9) the space is filled by monumental trees and heavy masses of foliage which envelop the scene in shadow, except for a brightly lit patch where the sun breaks through in the middle ground. Great clouds move in majestic order across the sky, as if echoing and magnifying the features of the landscape below. The figures, as is often true of Ruisdael's earlier works, were painted by another hand.

The importance of the sea to the young Dutch republic is reflected in the extraordinary growth of marine painting in the seventeenth century. In his accuracy of technical detail, Abraham Storck is typical of the masters who devoted themselves to painting "portraits of ships." In his *Vessels Offshore in a Calm* (cat. 10), the lofty sky filled with powerful cloud masses, the quality of light as it is seen over the water, and even such motifs as the cluster of three sailing vessels at the right and the frigate firing its cannon in the middle distance are all reminiscent of the work of Willem van de Velde the Younger, one of the most influential of the Dutch sea-painters.

The art of Jan Steen, the greatest painter of popular life in seventeenth-century Holland, reminds us how tenuous is the borderline between genre and allegory at this period. His painting of a drunken woman (cat. 11), who has collapsed in utter helplessness and who, to the great amusement of the bystanders, has to be ignominiously carted home on a wheelbarrow, might appear at first glance to record an actual happening witnessed by the artist. In reality this is a moralizing picture, a warning against the evils of strong drink, as is made clear by the biblical text inscribed on the canopy over the door of the house: *Wine is a mocker* (Proverbs 20:1). Steen's keen observation and lively sense of human foibles enable him to turn the subject into a genuinely comic incident. The young woman's plight is made all the more incongruous by her fine clothes—fur-trimmed jacket, shot-silk dress, and red stockings—all, alas!, in sorry disarray.

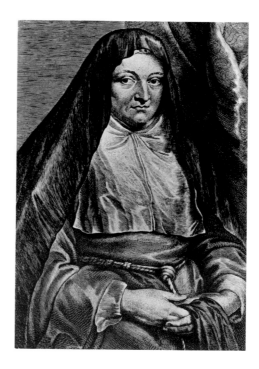

Figure 4. Lucas Vorsterman after van Dyck, *The Infanta Isabella Clara Eugenia,* engraving

6

Peter Paul Rubens
Flemish, 1577–1640

The Infanta Isabella Clara Eugenia,
1625

Oil on canvas
115 x 88 cm (45 x 34½ in)

COLLECTIONS: Archduke Leopold Wilhelm; Duke of Devonshire; Baron Thyssen; Rosenberg and Stiebel; Norton Simon.

LITERATURE: Max Rooses, *L'Oeuvre de P. P. Rubens,* 5 vols. (Antwerp, 1886–92), 4: 196–97, no. 970; Edward Dillon, *Rubens* (London, 1909), pp. 150, 223; Rudolf Heinemann, *Stiftung Sammlung Schloss Rohoncz, Lugano* (Lugano, 1937), 1, no. 360; Gustav Glück, "Rubens as Portrait Painter," *Burlington Magazine,* 76 (1940): 178, fig. 11 B; Wildenstein and Co., London, 1950, *Peter Paul Rubens,* p. 40; Château Rubens, Elewijt, 1962, *Rubens Diplomate,* p. 107.

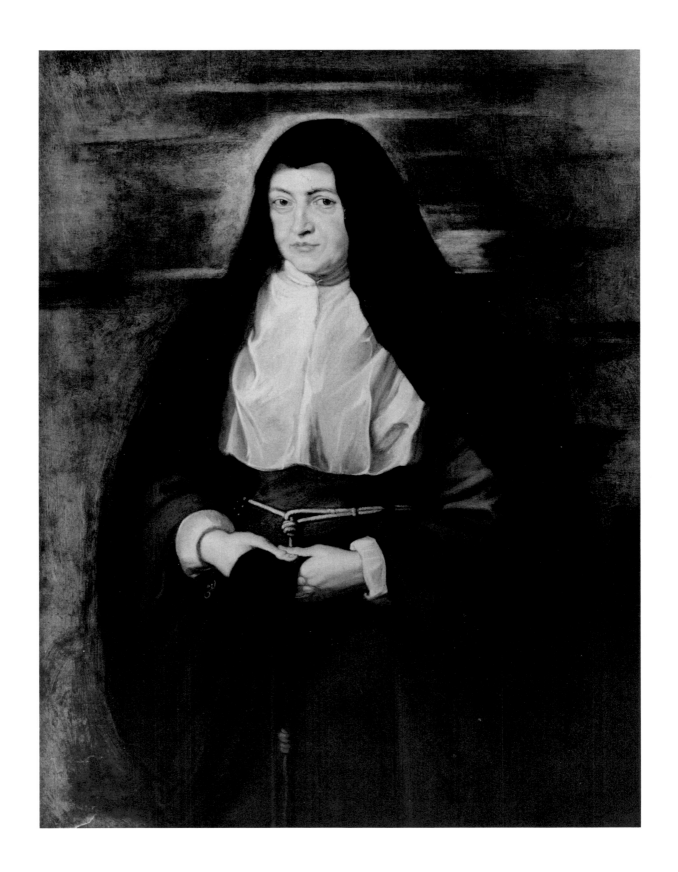

Anthony van Dyck
Flemish, 1599–1641

Portrait of the Marchesa Lomellini-Durazzo, ca. 1622–27

Oil on canvas
100 x 75 cm (39½ x 29½ in)

COLLECTIONS: Palazzo Lomellini-Durazzo; Luigi Grassi; Marcus Kappel; Ernest G. Rathenau and Ellen Ettinger; M. Knoedler and Co.; Norton Simon.

EXHIBITIONS: Palazzo dell'Accademia, Genoa, 1955, *100 Opere di Van Dyck*, no. 18.

LITERATURE: M. G. Smallwood, *Van Dyck* (London, 1904), p. 23; Emil Schaeffer, *Van Dyck: Des Meisters Gemälde* (Stuttgart, 1909), p. 183; Wilhelm von Bode, *Die Gemäldesammlung Marcus Kappel* (Berlin, 1914), no. 38; Gustav Gluck, *Van Dyck: Des Meisters Gemälde* (N.Y., 1931), p. 165.

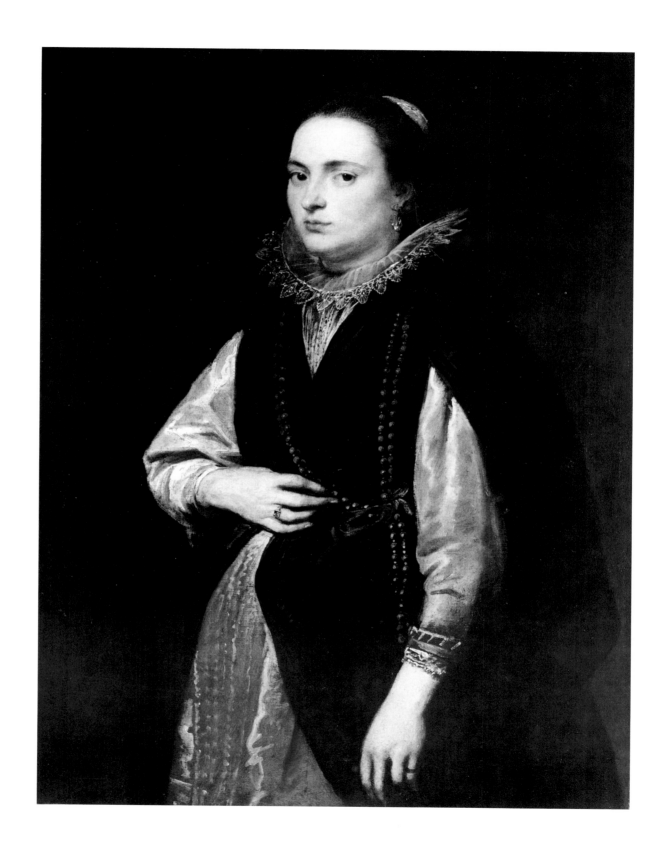

8

Jan van Goyen
Dutch, 1596–1656

Winter Scene with Skaters, 1640

Oil on panel
38.9 x 55.1 cm (15¼ x 21¾ in)
Signed with the artist's monogram and
dated, lower right: *VG 1640*

COLLECTIONS: P. Lyonet (sale, Amster-
dam, Apr. 11, 1791, no. 110); Comte L.
Mniszech (sale, Paris, Apr. 9, 1902, no.
117); Charles Sedelmeyer; Henri Heugel;
Heugel heirs; Galerie Heim.

EXHIBITIONS: Musée Carnavalet, Paris,
1950, *Chefs-d'œuvre des collections
Parisiennes*, no. 23, pl. IV.

LITERATURE: Sedelmeyer Gallery, *Cata-
logue of the Eighth One Hundred Paint-
ings Belonging to the Sedelmeyer Gal-
lery* (Paris, 1902), no. 17; Cornelis Hof-
stede de Groot, *A Catalogue Raisonné
of the Works of the Most Eminent
Dutch Painters of the Seventeenth Cen-
tury*, 8 vols. (London, 1927), 8, no. 1169;
Hans-Urlich Beck, *Jan van Goyen: Cata-
logue Raisonné* (Amsterdam, 1972), no.
G 54.

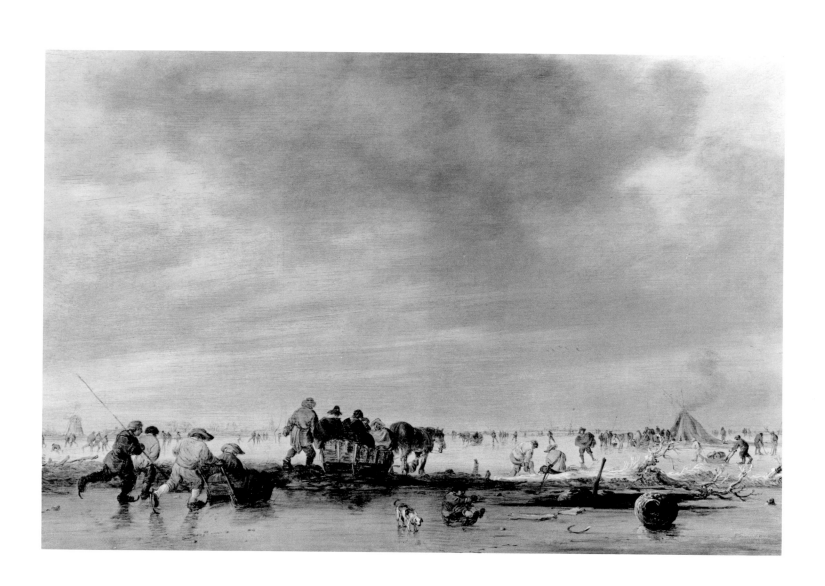

9

Jacob van Ruisdael
Dutch, 1628/29–82

Woody Landscape with a Pool and Figures, n.d.

Oil on panel
70.3 x 92.5 cm (27½ x 36¼ in)
Signed, lower right: *J V Ruisdael*

COLLECTIONS: M. Perrin (sale, Paris, Mar. 4, 1816, no. 38); David McIntoch (sale, Christie's, London, May 16, 1857, no. 47); Lord Fitzwilliam; R. Hooper (sale, Christie's, London, July 22, 1893, no. 71); Martin Colnaghi; Sir Joseph B. Robinson; Princess Labia; P. and D. Colnaghi and Co.

EXHIBITIONS: Royal Academy of Art, London, 1894, *Winter Exhibition*, no. 71; Royal Academy of Art (Diploma Gallery), London, 1958, *The Robinson Collection*, no. 12.

LITERATURE: Cornelis Hofstede de Groot, *A Catalogue Raisonné of the Most Eminent Dutch Painters of the Seventeenth Century*, 8 vols. (London, 1927), 4, no. 586; Jacob Rosenberg, *Jacob Ruisdael* (Berlin, 1928), no. 335.

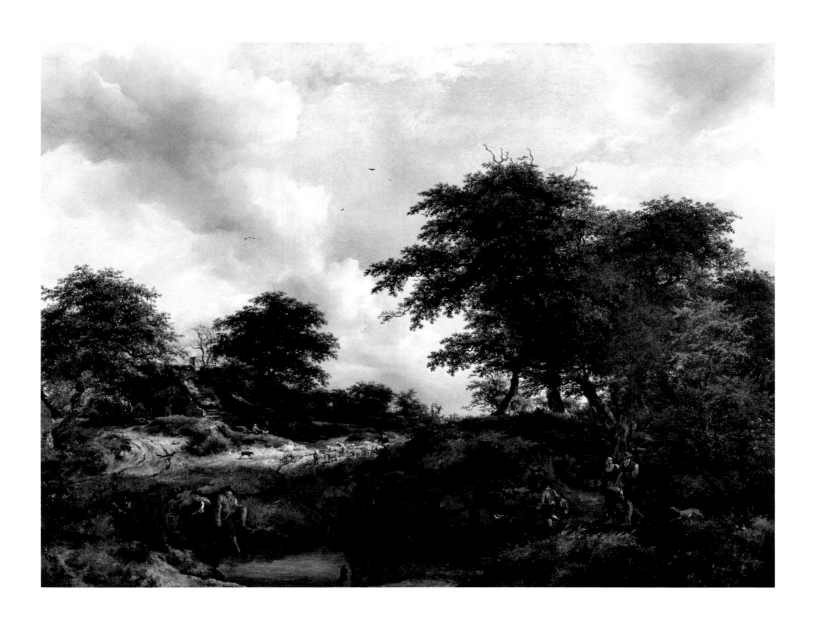

10

Abraham Storck
Dutch, 1630–1710

Vessels Offshore in a Calm, n.d.

Oil on canvas
39.8 x 51 cm (15½ x 20 in)

COLLECTIONS: Private collection (sale,
Sotheby's, London, Mar. 26, 1969, no.
98); R. M. Light and Co.

LITERATURE: Sotheby and Co., *Important
Old Master Paintings* (London, Mar. 26,
1969), no. 98.

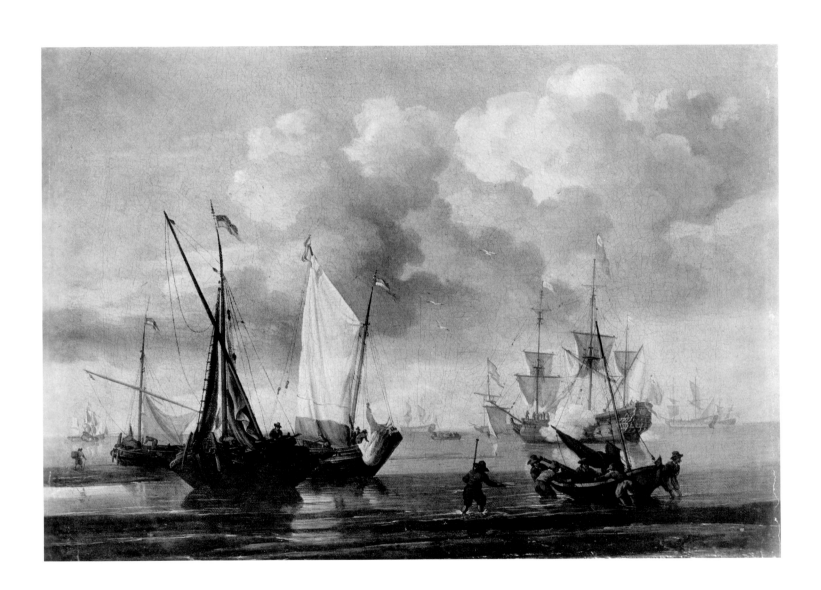

11

Jan Steen
Dutch, 1626–79

Wine is a Mocker, n.d.

Oil on canvas
87.5 x 104.5 cm (34½ x 41 in)
Signed on the well, left: *J. Steen*; in-
scribed over the door: *De Wyn is Een
Spoter, Proverbye 20:1*

COLLECTIONS: Fehl (sale, Amsterdam,
Sept. 17, 1727, no. 12); H. Ketelaar (sale,
Amsterdam, June 19, 1776, no. 223);
Edward Solly (sale, London, 1837); pri-
vate collection, Twenthe (sale, Sotheby's,
London, June 30, 1965, no. 100); Galerie
Cramer.

EXHIBITIONS: Museum Boymans, Rotter-
dam, 1938, *Masterpieces from Four Cen-
turies*, no. 147; Frans Hals Museum,
Haarlem, 1946, *Haarlemsche meesters
uit de eeuw van Frans Hals*, no. 125.

LITERATURE: Cornelis Hofstede de Groot,
*A Catalogue Raisonné of the Works of
the Most Eminent Dutch Painters of the
Seventeenth Century*, 8 vols. (London,
1927), 1, no. 103; Jan Bredius, *Jan Steen*,
2 vols. (Amsterdam, 1927), 2: 63, pl. 67;
Sotheby and Co., *Important Old Master
Paintings* (London, June 30, 1965), no.
100; Cramer Oude Kunst, *Catalogue
No. XV* (The Hague, 1968), no. 59.

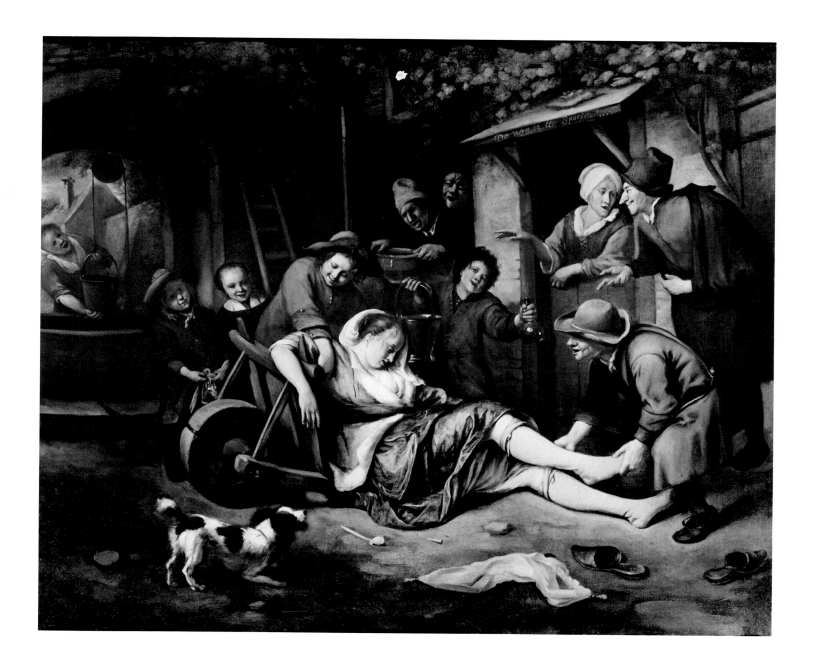

THE SIX eighteenth-century paintings in the exhibition are a very disparate group of one still life, two genre scenes, two portraits, and one cityscape. They all were painted, however, by artists working in the two most important cities for art in the century, and they all share in the elegance, refinement, and sophistication of eighteenth-century art at its finest.

Venice was the home of the three greatest Italian painters of the century: Tiepolo, Canaletto, and Francesco Guardi. Tiepolo maintained the tradition of historical, religious, and allegorical painting established by Bellini, Titian, and Veronese. Canaletto transformed, by the poetry of his colors and the finesse of his touch, the often mundane subject of the cityscape—or, in the case of Venice, "canalscape"—into breathtaking views. Francesco Guardi, the brother-in-law of Tiepolo, was indebted to Canaletto for his subject matter but his style was very personal. His *View of the Rialto from the Grand Canal* (cat. 12) shows his fascination with the flickering quality of light on water and buildings. He uses white highlights that dance across the canvas, imparting a wonderfully agitated rhythm to the scene. Delicate, pen-like strokes portray details such as shutters and railings. The walls of the buildings are not areas of flat color but almost abstract patterns of browns, grays, and pinks. The painting of an actual view hence becomes a vision of glimmering, ever-changing life.

In the eighteenth century France was the dominant political power in Europe, and its capital, Paris, became the art center of the continent. François Boucher, painter to the king, was the leading French painter until the 1760s. His mythologies, allegories, and portraits celebrate a luxurious, pleasurable world of rosy nymphs and gallant lovers. In contrast to the idealized, perfumed universe of Boucher, the world of still-life painters like Chardin and Roland de la Porte at first appears prosaic. Both artists, however, infuse their paintings with poetry—lyric rather than epic poetry. The seemingly casual arrangement in Roland de la Porte's *Still Life* (cat. 13) of grapes, peaches in a porcelain bowl, flowers, a coffee cup, carafe, and coffee tin is actually very tightly organized. The artist has used a pyramidal, triangular composition, which helps to create the feeling of balance and harmony in the painting.

Antoine Vestier is one of many artists who specialized in painting portraits of the rising middle class. He began his career as a miniaturist, painting enamel plaques used in decorating furniture. This talent is obvious in the detailed rendering of the blue taffeta dress embroidered with white and red flowers in his *Portrait of a Lady* (cat. 14). Beautiful as are her clothes, the lady projects through her eyes a deep sadness that even the wistful smile cannot conceal. Compared with another pensive lady in the exhibition, Picasso's *Bust of a Woman* (cat. 48), the restraint and subtlety of Vestier's psychological insight become even clearer.

Marie Louise Elizabeth Vigée-Lebrun's dashing portrait, *Theresa, Countess Kinsky* (cat. 15), is completely different in spirit. The beautiful young woman strides across a landscape, the wind blowing her hair and veil. The coloring is calculated to bring out her best features: the dark blue dress and amber beads emphasize the whiteness of her skin, and the yellow veil her lustrous

David W. Steadman

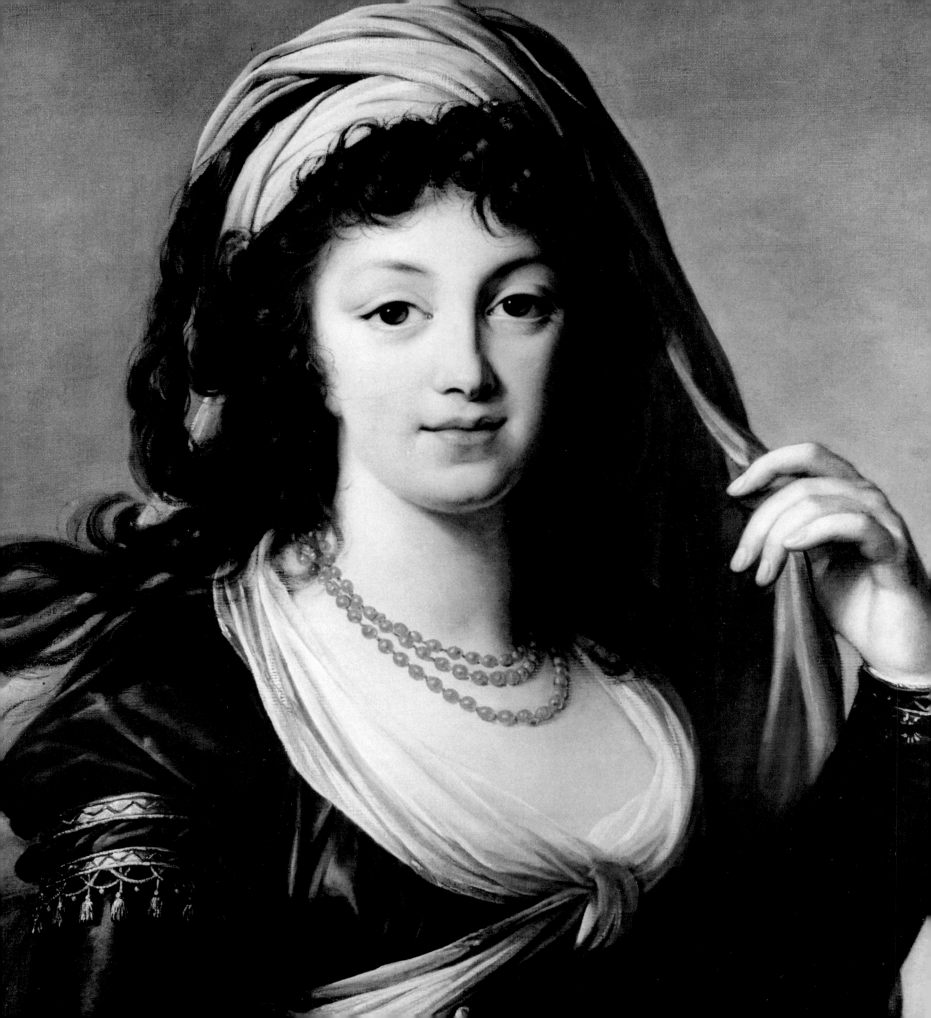

auburn hair. Vigée-Lebrun knew how to flatter her female sitters. Her rise to fame was accomplished by a glowing portrait of Queen Marie Antoinette, who was born in the same year as the artist. Although her election to the Royal Academy was bitterly opposed by many male painters, she was admitted through the intercession of her royal patron.

Because Vigée-Lebrun was so closely linked to the ancien régime, she felt it wise to flee from France at the time of the Revolution in 1779. During the wanderings of her later years she visited Vienna for two years, during which time she painted her portrait of the Polish countess. The beauty of the young woman and the sad, romantic tale of the countess's life inspired Vigée-Lebrun. In her memoires the artist recounts the story of the countess, who was "neither spinster, nor wife, nor widow." Her marriage to Count Kinsky had been arranged by their families: "As soon as the marriage service was over the count said to his wife, 'Madame, we have obliged our parents: I regret to have to leave you, but I cannot hide from you the fact that I am already attached to a woman without whom I cannot live, and I go to rejoin her.' He stepped into his coach and departed."

Louis Leopold Boilly's small, slightly risqué paintings of amorous adventures were popular during the last years of the reign of Louis XVI. During the Revolution he remained in Paris and exhibited his paintings at the art gallery run by Vigée-Lebrun's scoundrel husband, who had not accompanied his wife into exile. His paintings are in the tradition of seventeenth-century genre paintings, but the subjects, the love of narrative and the refinement of gestures and paint handling, are typical of the eighteenth century. In the first scene of the pair, *The Interrupted Supper* (cat. 16), the young woman and her paramour are startled by the approach of the elderly protector. The pendant painting is really a sequel in which the ugly old gentleman storms into the room and berates the girl for her unfaithfulness. The popularity of this latter amusing scene is attested to by the three versions Boilly painted of it and the success of the engraving made after it. It was through the sale of engravings that the artist managed to survive during the years of the Revolution and the Terror, when he was even openly accused of making "immoral" paintings. The demand for small, narrative paintings of contemporary life remained strong in the early nineteenth century, when Boilly became extremely popular, and was to flourish later in the century in the pseudo-historical narrative paintings by many academic artists.

12

Francesco Guardi
Italian, 1712–93

View of the Rialto from the Grand Canal, n.d.

Oil on canvas
42.3 x 61.3 cm (16½ x 24 in)

COLLECTIONS: J. T. Payne (sale, Christie's, London, 1879); Martin Colnaghi; Arthur Pemberton Heywood-Lonsdale; Timothy Heywood-Lonsdale (sale, Christie's, London, Dec. 4, 1964, no. 71); Thomas Agnew and Sons; Norton Simon.

EXHIBITIONS: Royal Academy of Art, London, 1910, *Winter Exhibition,* no. 34; Walker Art Gallery, Liverpool, on loan 1959–64.

LITERATURE: Christie, Manson and Woods, *Important Pictures and Drawings by Old Masters* (London, Dec. 4, 1964), no. 71.

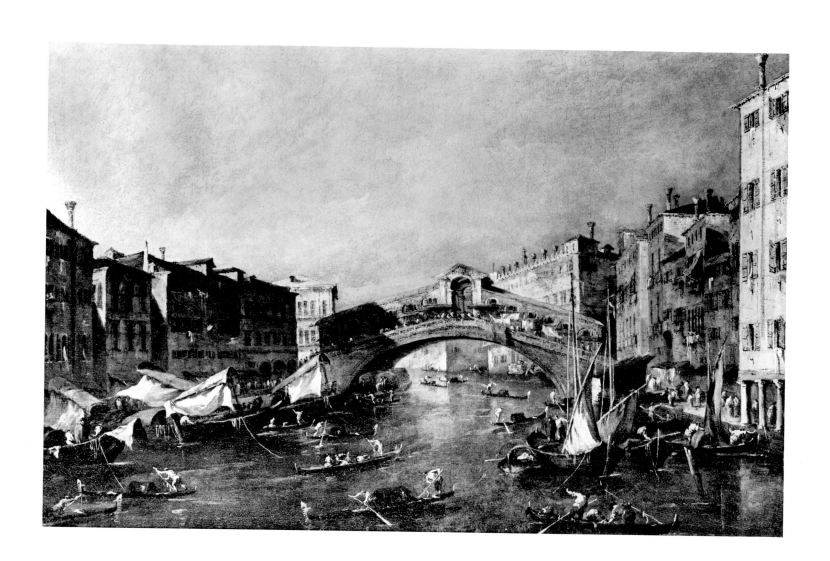

13

Henri-Horace Roland de la Porte
French, 1725–93

Still Life, ca. 1765

Oil on canvas
53 x 65 cm (20⅞ x 25½ in)

COLLECTIONS: Henri Leroux (sale, Palais
Galliera, Paris, Mar. 23, 1968, no. 86);
Old Masters Galleries.

EXHIBITIONS: Salon, Paris, 1765, no. 104;
Galerie Charpentier, Paris, 1952, "Na-
ture Mortes Françaises," no. 200 (attrib-
uted to Vallayer-Coster); Galerie Heim,
Paris, 1959, *Homage à Chardin*, no. 67.

LITERATURE: Denis Diderot, *Salons*,
4 vols. (Oxford, 1957–67), 2 (1960):
142–43, no. 104; Michel Faré, *La Na-
ture Morte en France*, 2 vols. (Geneva,
1962), 1: 167; 2, no. 375; Palais Gal-
liera, *Collection Henri Leroux* (Paris,
Mar. 23, 1968), no. 86.

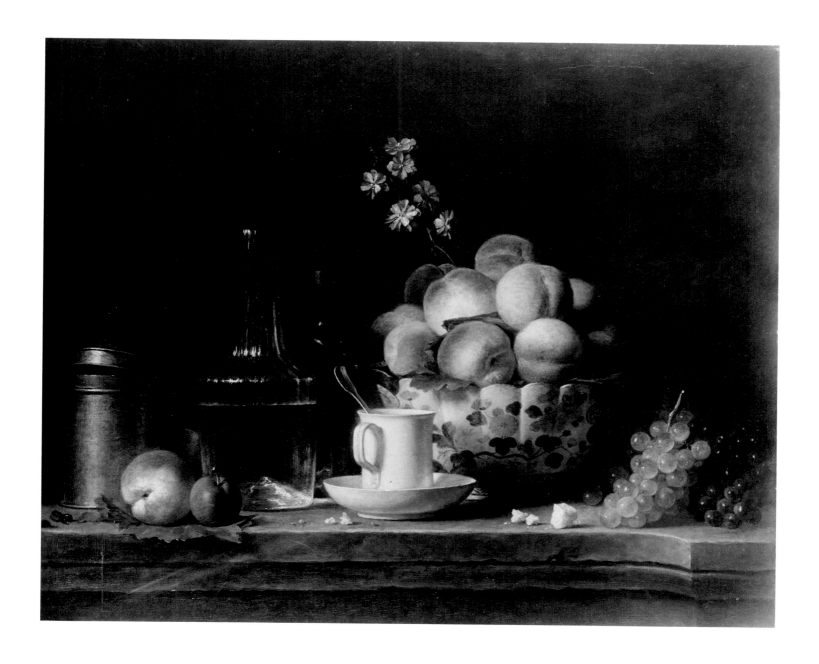

14

Antoine Vestier
French, 1740–1824

Portrait of a Lady, 1783

Oil on canvas
77 x 66.4 cm (30⅛ x 26 in)
Signed and dated, lower left: (V)*estier.*
fecit 1783

COLLECTIONS: Mrs. Borthwick Norton;
Olaf Kier; Arthur Tooth and Sons.

EXHIBITIONS: Portland Art Museum,
Portland, Nov. 1968–Mar. 1969, "Re-
cent Acquisitions by the Norton Simon,
Inc. Museum of Art."

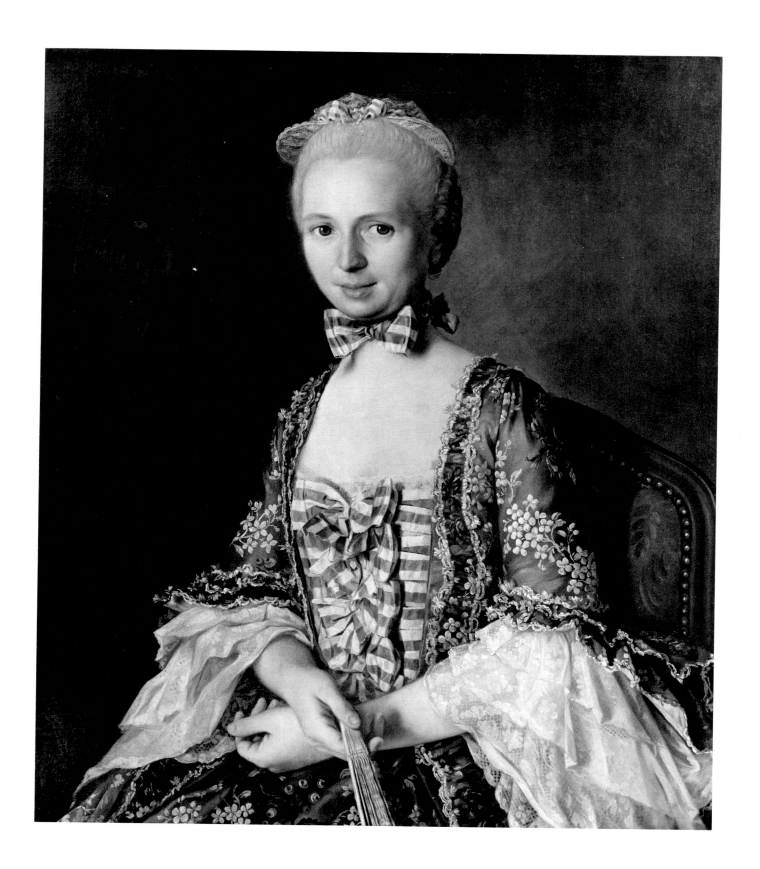

15

**Marie Louise Elizabeth
Vigée-Lebrun**
French, 1755–1842

Theresa, Countess Kinsky, 1793

Oil on canvas
135 x 100 cm (53 x 39 in)
Signed, inscribed, and dated, on tree
trunk: *E. L. Vigée Lebrun, à Vienne,*
1793

COLLECTIONS: Theresa, Countess Kinsky;
Counts Clam-Gallas; Count Franz
Clam-Gallas; Countess Radslav Kinsky;
Dr. A. de Celerin; Schaeffer Galleries.

LITERATURE: Elizabeth Vigée-Lebrun,
Souvenirs de Madame Vigée-Lebrun,
2 vols. (Paris, 1869), 1: 269–71; 2: 368;
Pierre de Nolhac, *Madame Vigée-
Lebrun: Peintre de la Reine Marie An-
toinette* (Paris, 1908), p. 107; André
Blum, *Madame Vigée-Lebrun: Peintre
des Grandes Dames du XVIIIᵉ Siècle*
(Paris, 1914), pp. 63, 101; William Henry
Helm, *Vigée-Lebrun* (London, 1915), pp.
118, 120, 202.

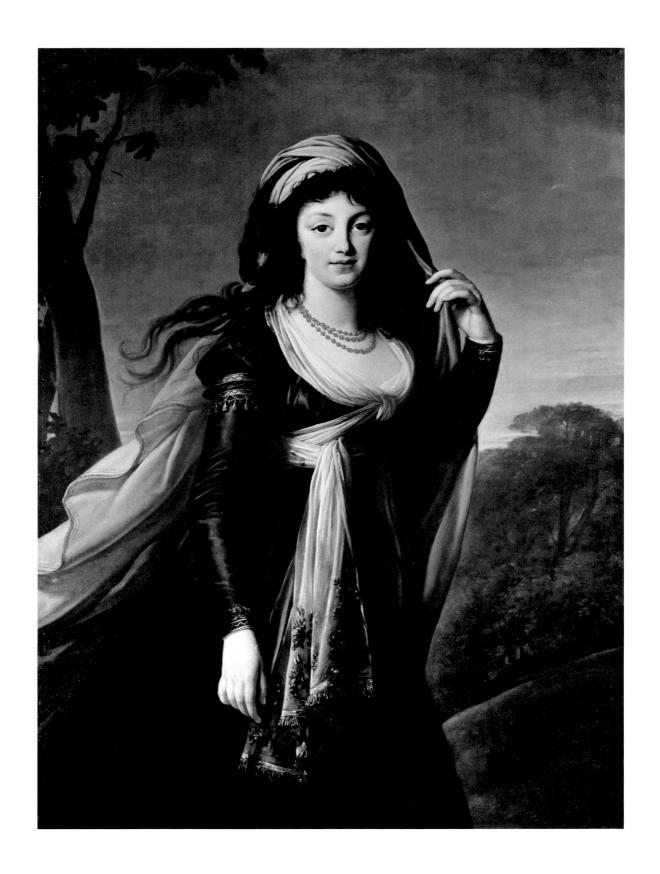

16

Louis Leopold Boilly
French, 1761–1845

The Interrupted Supper, n.d. (a pair)

Oil on canvas
38.2 x 45.3 cm (15 x 18 in)

COLLECTIONS: Sir Richard Wallace; Mme
Lowenstein; Mrs. M. T. Warde (sale,
Christie's, London, Mar. 19, 1965, no.
70); Arthur Tooth and Sons; Norton
Simon.

EXHIBITIONS: Musée Carnavalet, Paris,
1930, *Exposition L. L. Boilly*, nos. 38, 39.

LITERATURE: Henry Harrisse, *Louis Leo-
pold Boilly: peintre, dessinateur et
lithographe* (Paris, 1898), no. 448 (titled
Poussez Ferme), no. 554 (titled *Le
Viellard Jalous*); Christie, Manson and
Woods, *Important Pictures by Old Mas-
ters* (London, Mar. 19, 1965), no. 70.

NOTE: Engravings were made by Petit
after the two paintings under the titles
Poussez Ferme and *Ah! ah! qu'il est sort.*

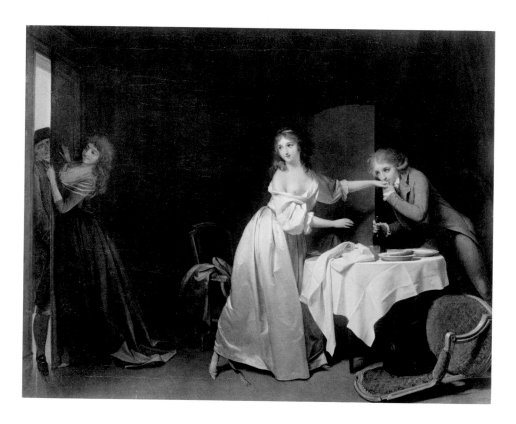

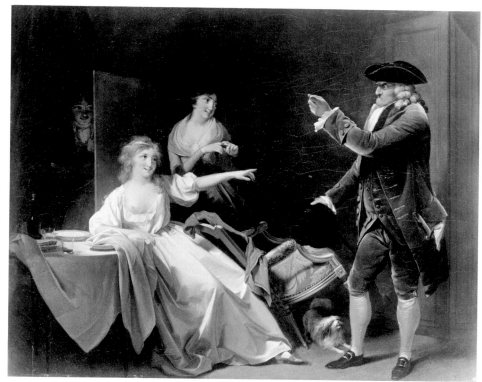

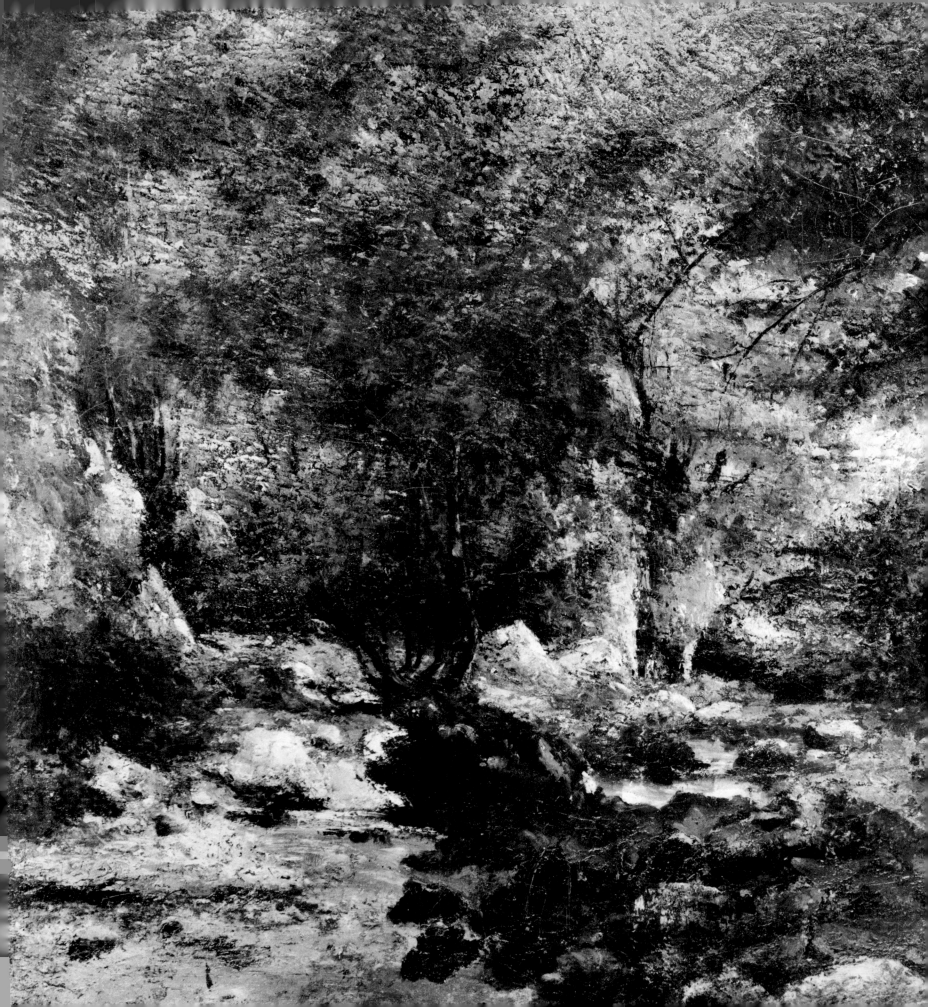

ARTISTIC production in the nineteenth century was almost unbelievably complex. Only in recent years have we begun to appreciate the nature of this complexity and to avoid certain clichés that for many years have hindered a just appraisal. The paintings in this section do not so much offer a unified sequence as they do a series of illustrations of interesting facets of this period.

Three very different products of the romantic movement are shown here, each of which illustrates a certain aspect of the reaction against the classic establishment of J. L. David. Bonington's charming watercolor (cat. 17) could best be described as romantic genre. It is possibly of a contemporary scene, or perhaps from a much earlier day. The subject, which appears as well in a small oil painting by the artist now in Boston (fig. 5), is not very clear, but there are suggestions of illness, a contrast of youth and age, a woman's world almost enclosed by the draperies around the bed. The whole is in a minor key; although Bonington and Delacroix knew each other well, the former lacked the power of imagination so characteristic of his French friend. Watercolor was an English specialty, of course, and we see here a fine example.

Delacroix's *Wounded Arab at the Foot of His Horse* (cat. 18) is also in watercolor, but the theme is quite different from that of the Bonington. After his trip to Morocco in 1831, Delacroix dealt often with variations on the sights that had so filled his eye in the very exotic land across the Mediterranean. But whereas Bonington was always a painter of rather small effects, the little Delacroix watercolor hints at the great surging canvases that made him the undisputed leader of French romanticism—so undisputed, in fact, that it is hard to name other romantic contemporaries to set beside him. One such name is that of Achille Devéria, represented here by the graceful figure of an odalisque (cat. 19). But no one would ever confuse the two masters, for the handling of the paint in this langorous scene is far smoother and quieter than it would be in a Delacroix. Oriental subjects were great favorites because of the extensive concerns of the French with the people of North Africa, though one suspects that the young woman in the Devéria painting is possibly more Parisienne than Moroccaine. The fountain, coffee pot, cigarette, and open blouse seem to suggest that the artist may have thought of the scene as a sort of allegory of the five senses. Works by this painter are rare in America, and this one can serve to remind us how good lesser masters can be.

The mid-century witnessed the triumph of French landscape and a revolutionary shift in thinking about subject matter that was to elevate landscape to the very summit of importance, whereas earlier it had been held to be inferior, if only because it diminished the importance of man, who was dwarfed by the immensity of nature. The leaders of the new landscape group formed the so-called Barbizon school, which took its name from a village on the edge of the forest of Fontainebleau where many of them worked. The Daubigny shown here (cat. 20) is a particularly fine example of the new breadth and freedom of style that marked the best work of these men. The brushwork is bold and deft, the space is broad and the sky lofty and clean. Lingering

Currents in 19th-Century Painting

Joseph C. Sloane

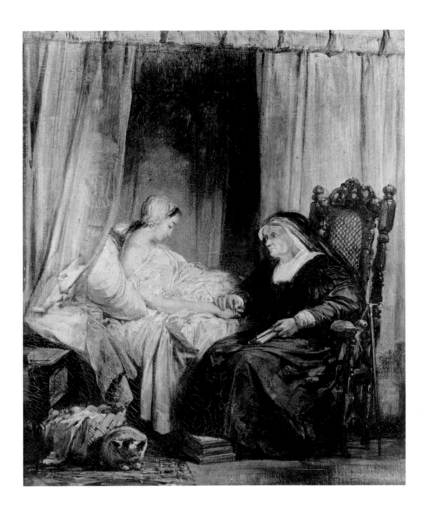

Figure 5. Richard Parkes Bonington,
The Visit, oil on canvas
(Museum of Fine Arts, Boston,
bequest of Josiah Bradlee)

signs of a derivation from the Dutch only heighten the charm of a new conception. The picture is contemporary with the beginning of Impressionism, but shows little or none of its influence, exhibiting a more solid interpretation of hill, trees, and village.

The real hinge on which French art of the fifties and sixties was turning was the work of the robust master from Ornans, Gustave Courbet. Many think of him chiefly as the creator of the *Burial at Ornans*, the *Stonebreakers*, and the huge *Studio* of 1854, but he was, of course, the strongest landscapist of his time, achieving effects with heavy impasto and the palette knife that almost defy analysis. The woodland scene (cat. 21) and the cliffs in winter (cat. 22) both illustrate Courbet's power wonderfully well. Close examination of the painted surface shows how colorful it is, enlivened with surprising dabs of pure color that, at a little distance, blend miraculously into the tone. It is very possible that his use of pure color touches may owe something to Delacroix, just as they may have been noted by the young group around Manet soon to become the Impressionists.

Courbet's strong preoccupation with thick paint was shared by Adolphe Monticelli, whose fine flower piece shows off his technique handsomely (cat. 23). Monticelli, though a distinguished painter, is not well known to the general public because he was never a part of the mainstream of the French art of his time. His interests lay in gleaming effects of color half buried in the matter of the paint itself. The final effect is rough and glowing—entirely pictorial and anticipating the later sacrifice of surface textures of objects so characteristic of the work of the post-Impressionists, such as van Gogh, Gauguin, Seurat, and Cézanne.

But the developments that lead from Barbizon and Courbet through Impressionism to the reaction against it in the last decades of the century do not include all the interesting events of the period. Another sort of painting, rather less easily characterized, shows that the French mind was not as wholly open and dedicated to naturalism as it has generally been thought to have been. This art is subjective, dreamlike, and laced occasionally with more than a suspicion of sex and evil. It is quiet, inward, imaginative, and derives in some way from the subconscious rather than the conscious mind. Gustave Moreau's *Poet and Saint* (cat. 24) is a very fair example. In this painting there is no hint of evil, but everything is enigmatic and suggestive of inner meanings. Is not the saint really the Virgin as the lilies and the closed garden would suggest? Is the poet then the angel of the Annunciation? Such ambiguity was characteristic of Moreau and a large group of European artists who have until recently been largely ignored.

The precise nature of this new symbolism is not easily grasped since it appears in a variety of forms. The connection between the art of Moreau and that of Puvis de Chavannes, for example, is possibly not too obvious, but it is there, nor was it any accident that Puvis, who seemed at first to be the new hope for a revived classicism, later became one of the idols of the whole Symbolist movement. Gauguin was very pleased to learn from Puvis as were all the painters of the Nabis group.

Puvis's *Meeting of Saint Genevieve and Saint Germain* (cat. 25) is a reduced version of a part of the famous murals done for the Panthéon in Paris, a building that was really the Church of Saint Genevieve, the patron saint of the city. This triptych tells the story of her childhood, but more significantly it shows the pale, flat, sure style that made Puvis the greatest mural painter of his day. It was the decorative handling of the mural surface coupled with a sort of dreamlike stillness that endeared him to a whole group of quite radical painters who were looking for a new symbolic meaning to replace the outworn significance of medieval and Renaissance iconography.

No clear pattern emerges from the paintings in this section, but at least a sense of variety, a searching for forms to fit a new world is quite evident. A detailed study of the age that followed would show that almost none of the ideas involved in the work of these painters was ever quite lost. When properly understood, the paintings form an instructive selection from a most varied company.

17

Richard Parkes Bonington
English, 1801–28

The Visit or *The Use of Tears*, 1827

Watercolor on white paper
24.8 x 17.2 cm (9¾ x 6¾ in)
Signed and dated on the footstool:
R. P. Bonington 1827

COLLECTIONS: Private collection, Paris;
Arthur Tooth and Sons.

LITERATURE: A. Dubisson, *Richard
Parkes Bonington: His Life and Work*
(London, 1924), p. 165; Andrew Shirley,
Bonington (London, 1940), pp. 70, 113.

NOTE: This watercolor has also been en-
titled *The Sick Daughter* and *Le Billet-
Doux*. A watercolor and gouache version
of the subject (13.8 x 9.8 cm, mono-
grammed and dated 1826) exists in the
Louvre. An oil painting of the same sub-
ject, titled *The Visit* (fig. 5), is in the
Museum of Fine Arts, Boston. A mezzo-
tint by S. W. Reynolds (London, June 1,
1829) was made after the Norton Simon,
Inc. Museum of Art version and was
called *The Use of Tears*.

18

Ferdinand Victor Eugène Delacroix
French, 1798–1863

*Wounded Arab at the Foot of
His Horse,* n.d.

Watercolor on paper
25.7 x 34.7 cm (10⅛ x 13½ in)
Stamp of the Atelier Delacroix *vente,*
lower right: *E.D.*

COLLECTIONS: Permalo-Gelder; André
Lorenceau.

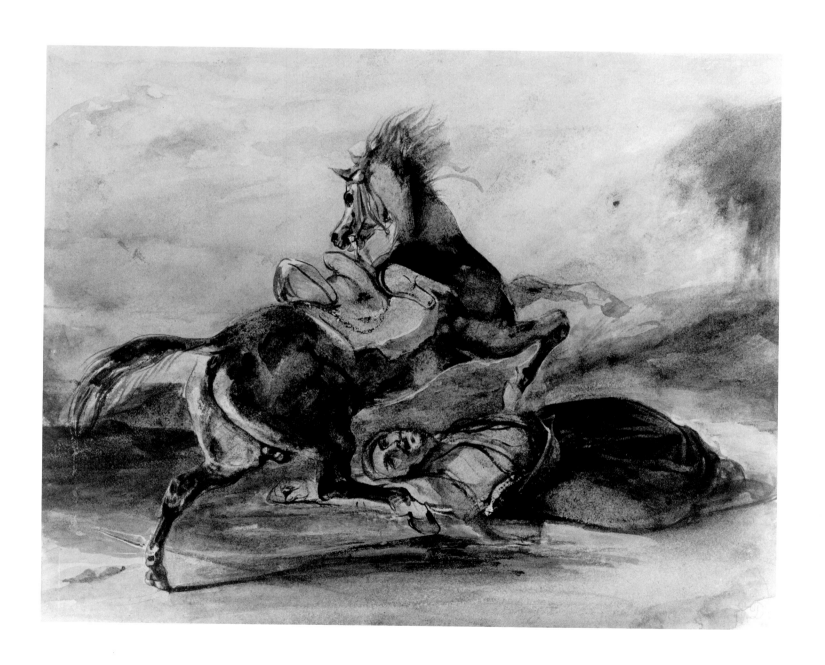

19

Jacques Jean Marie Achille Devéria
French, 1800–57

Odalisque, n.d.

Oil on panel
22.9 x 32 cm (9 x 12½ in)
Signed beneath the coffee pot, lower
left: *A. Deveria*

LITERATURE: Parke-Bernet Galleries, *Old Masters and XVIII and XIX Century Painting* (N.Y., Mar. 2, 1967), no. 95.

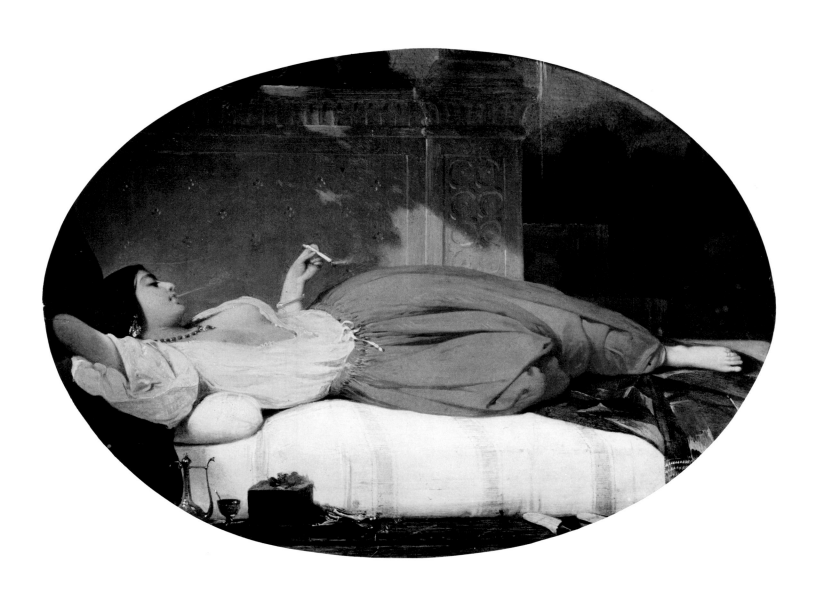

20

Charles François Daubigny
French, 1817–78

*Hamlet on the Seine near
Vernon,* 1872

Oil on canvas
85 x 146 cm (33½ x 57½ in)
Signed and dated, lower left corner:
Daubigny 1872

COLLECTIONS: M. Knoedler and Co.; Cor-
coran Gallery of Art; E. V. Thaw and Co.

EXHIBITIONS: Museum of New Mexico,
Santa Fe, on loan 1959; Los Angeles
County Museum of Art, Los Angeles, on
loan 1966; University of California at
Irvine, Irvine, 1967, *A Selection of
Nineteenth and Twentieth Century
Works from the Hunt Foods and Indus-
tries Museum of Art Collection,* p. 8.

LITERATURE: L. M. Bryant, *What Pic-
tures to See in America* (N.Y., 1915), pp.
188–89, fig. 112.

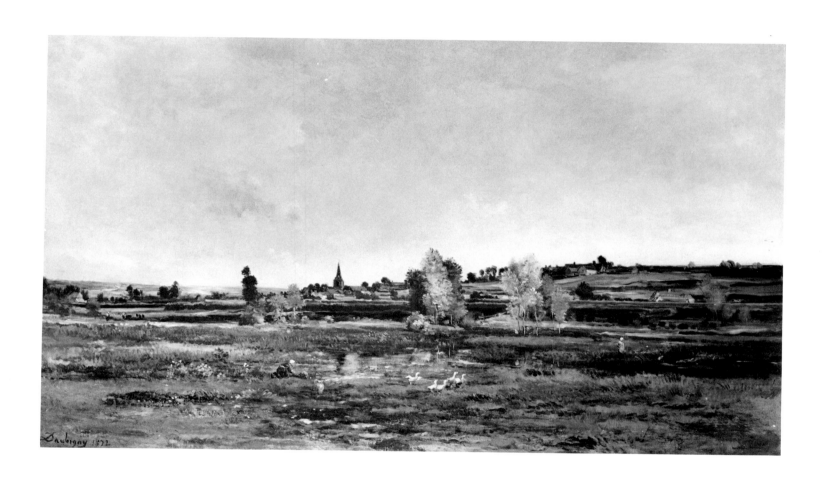

21

Gustave Courbet
French, 1819–77

Forest Pool, 1865

Oil on canvas
76.5 x 92 cm (30 x 36 in)
Signed and dated, lower right:
G. Courbet 65

COLLECTIONS: K. E. Maison; Lefevre
Gallery; Paul Kantor Gallery; Norton
Simon.

EXHIBITIONS: Lefevre Gallery, London,
1950, *XIX Century French Masters*, no.
4; Los Angeles County Museum of Art,
Los Angeles, on loan May 1966; Univer-
sity of California at Irvine, Irvine, 1967,
*A Selection of Nineteenth and Twen-
tieth Century Works from the Hunt
Foods and Industries Museum of Art
Collection*, p. 7.

LITERATURE: Eric Newton, "French
Painters—Courbet," *Apollo*, 56 (1952):
140, 142.

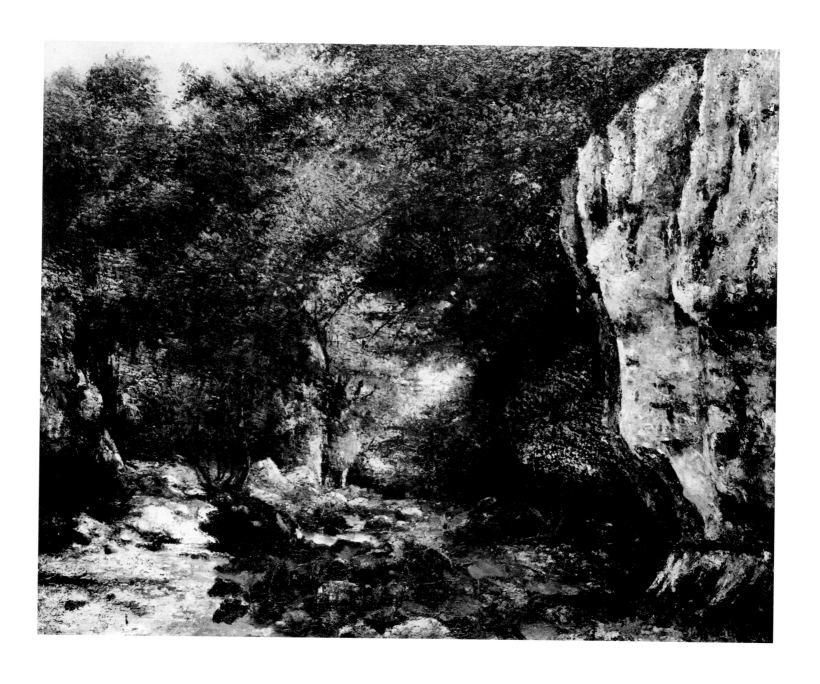

22

Gustave Courbet
French, 1819–77

Cliffs by the Sea in the Snow, 1870

Oil on canvas
55 x 65.7 cm (21½ x 25¾ in)
Signed, lower left: *G. Courbet*

COLLECTIONS: Private collection, Paris;
Drs. Fritz and Peter Nathan.

EXHIBITIONS: Galerie Claude Aubry,
Paris, 1966, *Courbet dans les collections
privées françaises*, no. 25; Portland Art
Museum, Portland, Nov. 1968–Mar.
1969, "Recent Acquisitions by the Nor-
ton Simon, Inc. Museum of Art," no. 3.

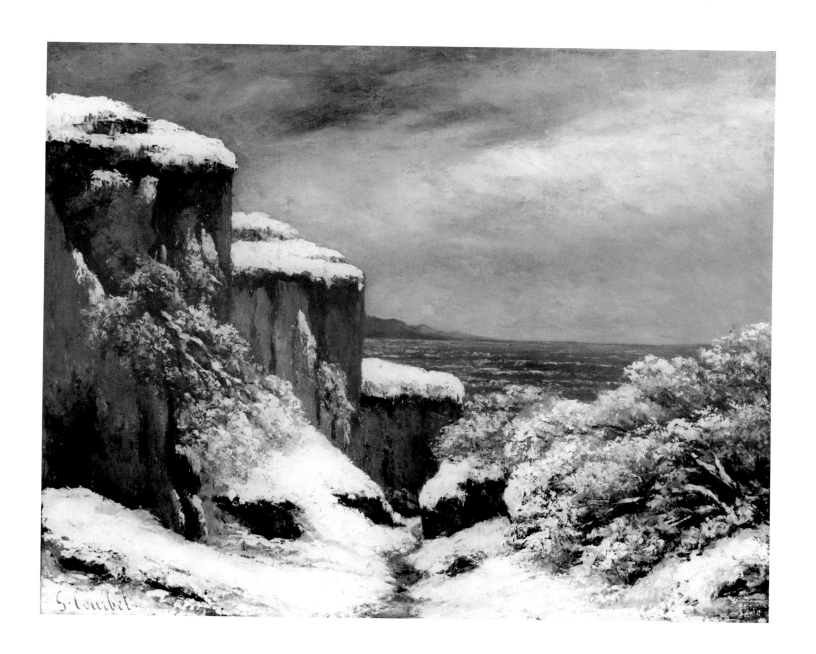

23

Adolphe Joseph Thomas Monticelli
French, 1824–86

Flowers, ca. 1879

Oil on panel
61.6 x 48.5 cm (24½ x 19 in)
Signed, lower right: *Monticelli*

COLLECTIONS: D. Morley; Lefevre
Gallery.

EXHIBITIONS: Lefevre Gallery, London,
1967, *XIX and XX Century French
Paintings,* no. 14; Philadelphia Museum
of Art, Philadelphia, 1969, *Recent Ac-
quisitions by the Norton Simon, Inc.
Museum of Art,* no. 5.

LITERATURE: Aaron Sheer, "Monticelli
and van Gogh," *Apollo,* 85 (1967): 445.

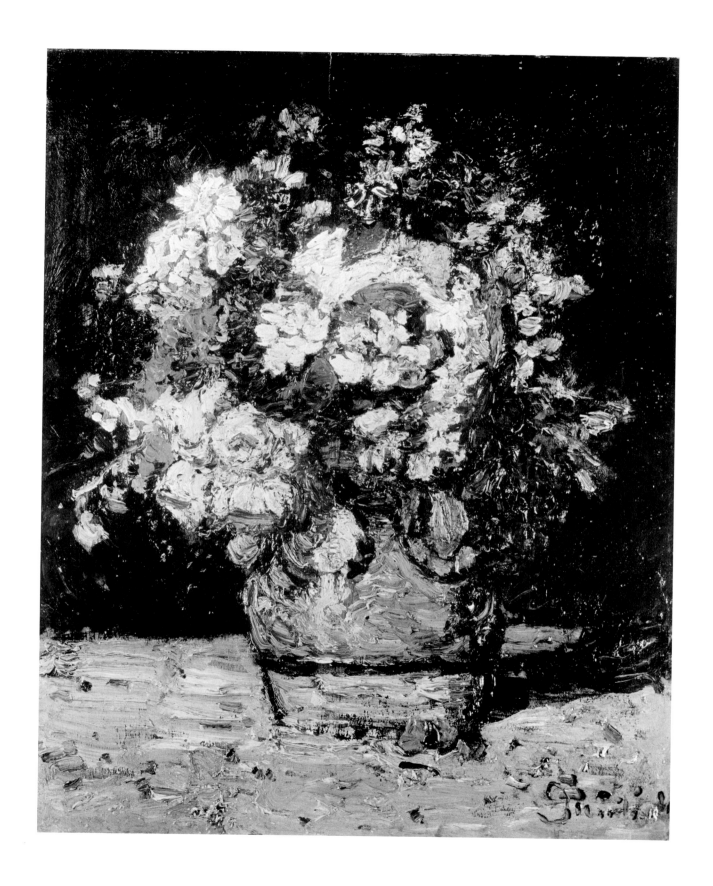

24

Gustave Moreau
French, 1826–98

Poet and Saint, ca. 1869

Watercolor on paper
29 x 16.5 cm (11⅜ x 6½ in)
Signed, lower left corner, with artist's
monogram, then signed: *Gustave
Moreau,* followed by title *Le Poéte et
la Sainte*

COLLECTIONS: Alexandre Dumas Fils
(sale, Hôtel Drouot, Paris, Mar. 2–3,
1896, no. 107); Leopold Goldschmidt;
Drs. Fritz and Peter Nathan.

LITERATURE: Paul Flat, "Gustave
Moreau," *Revue de l'Art ancien et
moderne,* 3 (1898): 232; Léon Deshairs,
Gustave Moreau (Paris, n.d.), pp. 41–42,
pl. XIII.

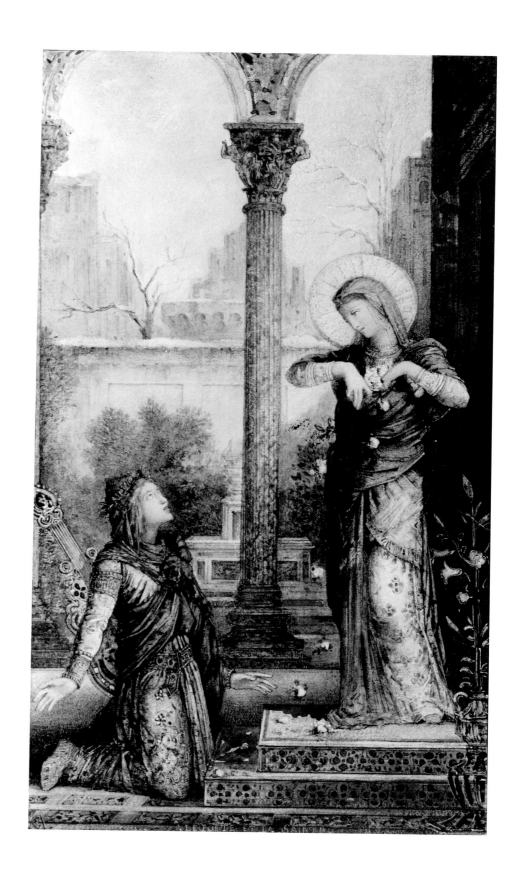

25

Pierre Cecile Puvis de Chavannes
French, 1824–98

*Meeting of Saint Genevieve and
Saint Germain,* 1876–79

Oil on canvas (triptych)
Left wing: 134.2 x 81.8 cm (53 x 32¼ in);
center: 134.2 x 89.4 cm (53 x 35¼ in);
right wing: 131.7 x 81.2 cm (52¾ x 32 in)
Signed and dated, lower right: *P. Puvis
de Chavannes '79*

COLLECTIONS: Mr. and Mrs. James Byron;
Durand-Ruel; The Art Institute of
Chicago; E. and A. Silberman Galleries;
Huntington Hartford Collection, Gal-
lery of Modern Art; Hirschl and Adler
Galleries.

EXHIBITIONS: Salon, Paris, 1876; The Art
Institute of Chicago, on exhibition 1924–
55; Brooklyn Museum, N.Y., 1956, *Re-
ligious Painting: 15th–19th Centuries,*
no. 26; Gallery of Modern Art, N.Y., on
exhibition 1963–67.

LITERATURE: Charles Yriarte, "Le Salon
de 1876," *Gazette des Beaux-Arts,* 13
(1876): 692–95; "Studies for the Child-
hood of St. Genevieve, Puvis de Chavan-
nes," *Bulletin of the Art Institute of
Chicago,* 18 (1924): 117–20; "Chicago
Art Institute Gets Mural Studies by
Puvis de Chavannes," *Art News,* 23
(1924): 1; The Art Institute of Chicago,
*A Guide to the Paintings in the Per-
manent Collection* (Chicago, 1925), pp.
55–57; "A Sketch by Puvis de Chavan-
nes," *Bulletin of the Minneapolis Insti-
tute of Arts,* 19 (1930): 45; The Art In-
stitute of Chicago, *A Guide to the Paint-
ings in the Permanent Collection*
(Chicago, 1932), pp. 51–53.

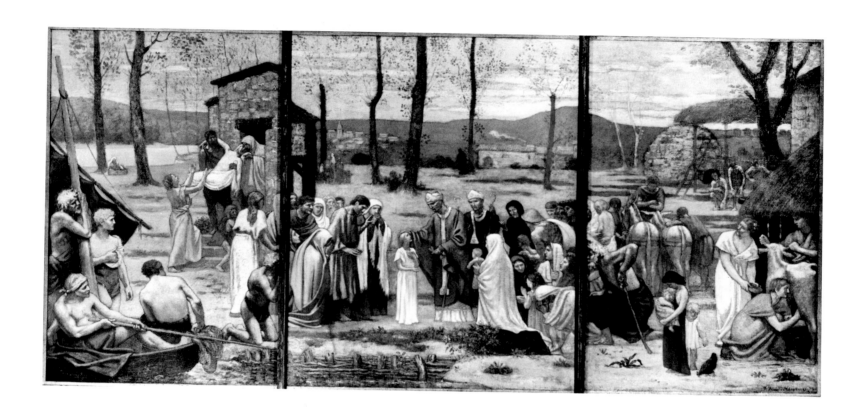

THE FINE, small group of Impressionist paintings in the exhibition provides an effective illustration of just how seductive and distracting this most popular episode in modern painting can be. Who can resist the painterly opulence of Pissarro's floral bouquet (cat. 26), the energy of Boudin's marketplace scene (cat. 27), or the appeal of familiar Parisian architectural vistas and riverside activities in the works by Guillaumin (cat. 28) and Lépine (cat. 29).

The breadth of vision that minor art by definition rarely yields is present in Monet's deceptively unassuming little seascape (cat. 30). He painted it on the Normandy or Brittany coast, near his favored locales of the rock formations of Belle-Isle and the cliffs of Etretat, motifs he depicted repeatedly a few years later. The intimations of grandeur that Monet could extract from a panoramic vista are here a matter of reductive design and a simplified tripartite division of the composition into flattened, variegated color masses of land, sea, and sky. He shared with Cézanne his Goethean reverence for the sublime sweep and immensity that nature revealed to perception, although the increasingly rigorous geometry of the Aix master was at odds with Monet's amorphous color forms and loose brushing.

Despite Monet's broadly massed, elementary shapes, we still have good reason to marvel at the exactness of his vision—the shimmer of the sea discloses in its changing light subtle variations in water depth; the huddled violet shadows of the irregular, rocky coastline shine with reflected orange light, and the tumbled profusion of vegetation on the cliff face has the chaotic truthfulness of nature as much as the disciplined control of art. The cliff's vehement brushstroke and florid color also anticipate the fluent surfaces and mobility of Monet's later Giverny water landscapes. A matter of interest is the concern with an inverted world of reflections, the interplay of shadow and substance, light and dark masses—a visual dialectic whose attention to flux philosophically challenged current ideas of stable material reality. Monet's fascination with water reflections and visual inversions set the stage for the cyclical ideal of the series paintings of the next decade in his isolated motifs of repeated haystacks, poplars, and cathedral facades. It is curious, then, that even as this early, prophetic seascape celebrates the nuanced detail of phenomenal nature, Monet is already moving along the path to a radical optical abstraction that he later described so eloquently in his remarks on his Orangerie mural decorations as an "illusion of an endless whole, of water without horizon or bank." It was this effect that he hoped would provide his audience with a meditative icon and expand the limits of conscious perception through a new kind of color-field painting. That genre of painting was reborn some fifty years later in the heroic-scale Abstract Expressionist painting of postwar American art.

Another fascinating example of a critical transitional painting remarkable both in its own right and as a prophecy of an important new line of artistic development is Seurat's exquisite, small oil sketch *The Stonebreakers, Le Raincy* (cat. 31). Courbet's peasants are the source of this composition, and so are Millet's sentimental and moralizing outdoor scenes of toiling workers in the field. Seurat has already begun to force our attention upon a geometri-

cized pictorial order as much as a human subject matter whose implications appealed to his socialist sympathies for the exploited common laborer. The "broomswept" brush strokes, in Seurat's words, transcend conventional Impressionist hatching and divisionism. They foreshadow the denser web of color and textured pigment evident in the innumerable studies, or "croquetons," that preceded *La Grande Jatte* the following year. Even more surprising are certain compositional strategies that reached their first significant culmination in his large figure composition *Bathing at Asnieres.*

The Stonebreakers is in fact perhaps the first small oil sketch to crystallize the figural phrasing and equilibrium of ordered contrasts of pose dominating the great and complex compositions of Seurat's maturity. The woman in profile at the right, bending forward, and the man at the left in the background who exposes the flat plane of his back both clearly anticipate the attitudes of figures we find at the center of *La Grande Jatte.* There, too, a wittily stylized and mannekin-like female figure (in this case a bourgeois lady of fashion bearing a parasol rather than a member of the proletariat wielding a hoe) becomes the fulcrum for a tense seesaw of profiled silhouettes on either side. Seurat's singularly Renaissance taste for triangular composition and ensembles of three figures in juxtaposed attitudes—fullface, profile, and reversed—have their primitive beginnings in *The Stonebreakers.* The device is more fully explored in the various versions of *The Models* some time later. By juggling poses first of different figures, and then of the identical human form, Seurat may have anticipated a revolution in narrative pictorial style, synthesizing multiple viewpoints, which finally became the keystone of the Cubist aesthetic. While this may seem a quantum leap forward in time and mood from the rustic oil sketch under consideration, surely there is a demonstrable connection between the psychology of representation of the Cubists and not only Seurat but more obviously Cézanne. And there is other and bountiful supporting evidence of an emerging, new vision in the art of the nineties, during a period when Post-Impressionist innovators reacted in their distinct although related ways to Impressionist verism.

Before we conclude that modern art history is a study conveniently based on hindsight of a series of predictable events marching to a foregone conclusion, we must consider Cézanne's inexplicable early portrait *Uncle Dominique* (cat. 32), for which nothing in its own time or pictorial ambience can adequately prepare us. Few twentieth-century paintings can match its simplicity and power of elementary contrasts or its fresh paint quality. Courbet's loaded impasto and Manet's pictorial taste—both obvious influences—do not explain the vitality of this image or its vivid execution. *Uncle Dominique* is rivaled in this exhibition for expressive power only by Rouault's more sinister and crepuscular nudes executed nearly half a century later (cat. 58). It was the public derision stimulated by pictorial extravagances of this kind that particularly tormented Cézanne and helped drive him into the protective seclusion of Aix. In one of the more remarkable acts of expiation within the modern movement, Cézanne did penance for his abortive, youthful

romanticism by transforming his art into a form of classicism of an intellectual rigor unknown in French painting since Poussin.

The other very great portrait in the late-nineteenth-century section of the exhibition comes from the hand of van Gogh. It is a painting of his mother made from a photograph (fig. 6) and carried out in Arles in 1888 (cat. 33). That proved to be a year of particularly bitter disillusionment and anguish for van Gogh, who was haunted by his inability to establish a fraternal, utopian artistic community with Gauguin and by other imagined failures that led to the ghastly act of mutilating his own ear. The frustration of his reforming Christian impulses and his irrational episode are nowhere evident in the paintings of that year, however, even though his letters do seek to characterize his work in larger moral or passional terms. Like some of his more tender portraits of the local characters of Arles, his mother's portrait impresses by the humanity and individuality it reveals of the model. Nonetheless, there are other undercurrents in the strained fixity of her gaze and the angularity of her facial silhouette that parallel the intensity of mood in the great Wertheim self-portrait in the Fogg Art Museum. Today it is the almost Byzantine abstractness and iconic power of van Gogh's imagery that move us rather than his realism or even his personal torment.

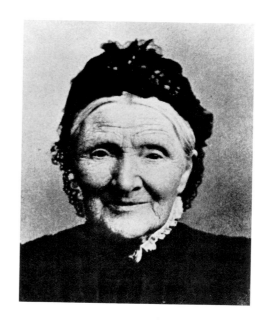

Figure 6. Photograph of van Gogh's mother, from which he painted his *Portrait of the Artist's Mother*

The uniform color backgrounds of his portraits, green in this instance but more often blue or yellow, were mentioned in his letters as symbolic colors, and here, too, it effectively functions to that end, flattening and heightening its image—much as the saints in early Christian and Byzantine mosaics were immobilized on their blue or gold fields and thereby removed from association with the everyday, phenomenal world. In the artist's perhaps most famous statement, he wrote: "I want to paint men and women with that something of the eternal which the halo used to symbolize, and which we now seek to give by the actual radiance and vibrancy of our colorings." Van Gogh's portrait of his mother is as fine an example as one could wish to find of the modern "spiritual" portrait, and it already more than hints at the anguished inwardness of Expressionist portraiture, from Munch through Rouault, Kokoschka, and Schiele.

It is ironic to reflect that Impressionist discoveries in spectral color and fugitive sensation, which had been used to discredit the sterile idealism of the Academy, were within a brief decade supplanted by a renewed emphasis on pictorial structure, or intellectual and emotional content. That fascinating visual metamorphosis, with all its implications for twentieth-century abstract and Expressionist art, can be clearly traced by the curious student through the many revealing examples of late nineteenth-century art in this inexhaustible and rewarding exhibition.

Camille Jacob Pissarro
French, 1830–1903

Bouquet of Flowers, 1876

Oil on canvas
71 x 58.5 cm (28 x 23 in)
Signed and dated, lower right: *C. Pissarro
1876;* inscribed on the back of the canvas: *je certifie que ce tableau/"Bouquet
de fleurs" est/bien de mon pere C. Pissarro/Paulemile Pissarro,/le 18 Mars
1927*

COLLECTIONS: Paulemile Pissarro; Richard Semmel (sale, Galerie Mensing, Amsterdam, June 13, 1933, no. 25); Max Moos; M. Knoedler and Co.; Mrs. Richard Ryan; Mr. and Mrs. Clifford Klenk (sale, Parke-Bernet, N.Y., Oct. 9, 1968, no. 3).

EXHIBITIONS: Musée de l'Orangerie, Paris, 1930, *Centenaire de la naissance de Camille Pissarro,* no. 138; Wildenstein and Co., N.Y., 1945, *Camille Pissarro: His Place in Art,* no. 14; M. Knoedler and Co., N.Y., 1966, *Impressionist Treasures,* no. 23; Philadelphia Museum of Art, Philadelphia, 1969, *Recent Acquisitions by the Norton Simon, Inc. Museum of Art,* no. 9.

LITERATURE: Galerie Mensing, *Richard Semmel Sale* (Amsterdam, June 13, 1933), no. 25; Ludovic-Rodo Pissarro and Lionello Venturi, *Camille Pissarro—son art, son œuvre,* 2 vols. (Paris, 1939), 1, no. 377; Parke-Bernet Galleries, *Ten Highly Important Paintings* (N.Y., Oct. 9, 1968), no. 3.

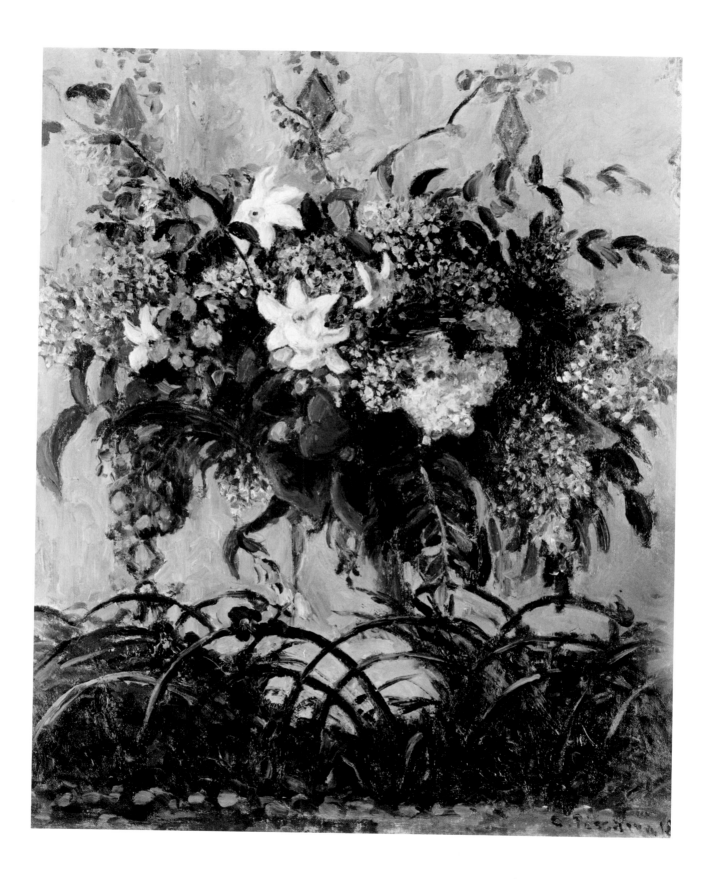

27

Louis Eugène Boudin
French, 1824–98

Old Fish Market in Brussels, 1871

Oil on panel
24 x 33.5 cm (9½ x 13¼ in)
Inscribed and dated, lower left: *Bruxelles 1871*; signed, lower right: *E. Boudin*

COLLECTIONS: Roland Leten; Marl-
borough Alte und Moderne Kunst.

EXHIBITIONS: Palais des Beaux-Arts,
Brussels, 1952, *Les Peintres de la Mer*;
Musée des Beaux-Arts, Ghent, 1953, *La
Peinture dans les Collections Gantoises*,
no. 28; Marlborough Fine Arts, London,
1967, *A Tribute to Paul Maze: The
Painter and His Time*, no. 42; Portland
Art Museum, Portland, Nov. 1968–Mar.
1969, "Recent Acquisitions by the Nor-
ton Simon, Inc. Museum of Art," no. 1.

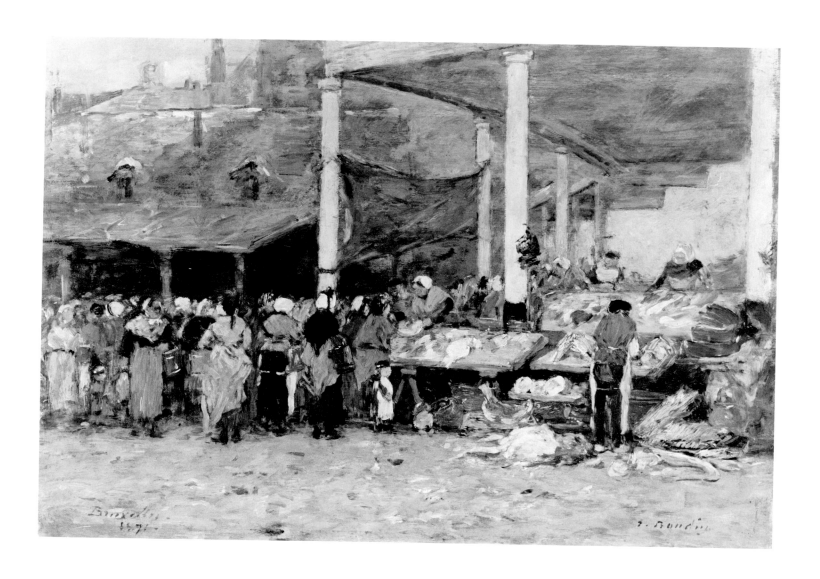

Jean-Baptiste Armand Guillaumin
French, 1841–1927

Break of Day, 1874

Oil on canvas
53 x 63.5 cm (21 x 25 in)
Signed and dated, lower left: *A. Guil-
laumin 5.74*

COLLECTIONS: Bernheim-Jeune; Georges
Hoentschel; Mme Hoentschel de
Malherbe (sale, Sotheby's, London,
Apr. 24, 1968, no. 94).

LITERATURE: Sotheby and Co., *Impres-
sionist and Modern Paintings, Drawings
and Sculpture* (London, Apr. 24, 1968),
no. 94; G. Serret and D. Fabian, *Armand
Guillaumin: Catalogue Raisonné de
l'œuvre Peint* (Paris, 1971), no. 33.

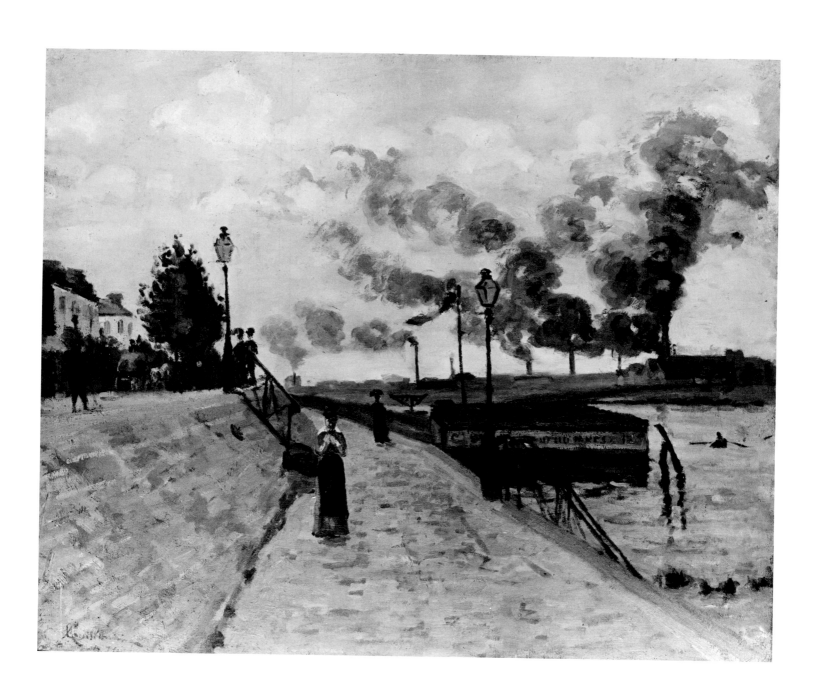

29

Stanislaus Victor Edouard Lépine
French, 1836–92

Pont de l'Estacade, Paris, ca. 1885

Oil on canvas
27 x 41 cm (10¼ x 15¾ in)
Dedicated and signed, lower left: *à M. de
Fourcaud, S. Lépine*

COLLECTIONS: M. de Fourcaud; Fourcaud
heirs; Galerie Schmit.

NOTE: This painting is a sketch for a
larger composition, measuring 125 x 170
cm, which was exhibited at the Salon of
1885 (no. 1561).

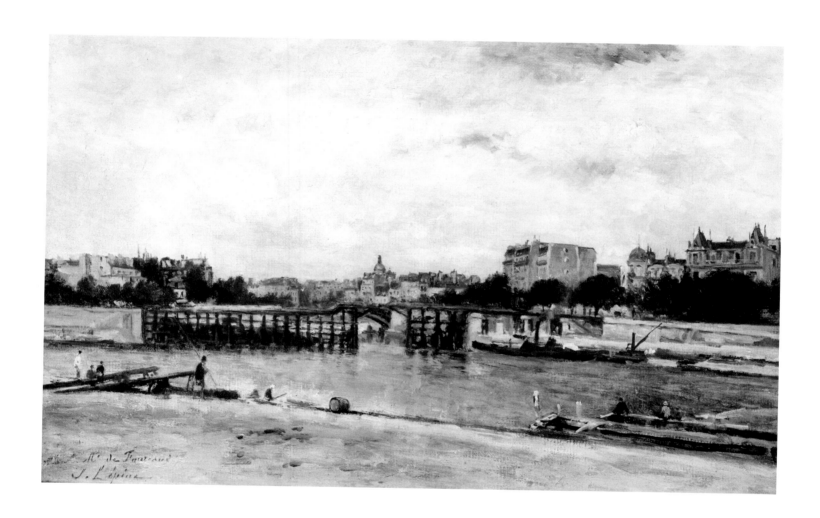

30

Claude Monet
French, 1840–1926

Coast of Normandy, 1882

Oil on canvas
58.5 x 79 cm (23 x 31 in)
Signed and dated, lower right: *Claude Monet '82*

COLLECTIONS: M. Knoedler and Co.; private collection, United States (sale, Christie's, London, June 28, 1968, no. 70); Stephen Hahn Gallery.

EXHIBITIONS: Stephen Hahn Gallery, N.Y., 1968, "Cliffs and the Sea"; Philadelphia Museum of Art, Philadelphia, *Recent Acquisitions by the Norton Simon, Inc. Museum of Art*, no. 4.

LITERATURE: Christie, Manson and Woods, *Important Impressionist and Modern Drawings, Paintings and Sculpture* (London, June 28, 1968), no. 70.

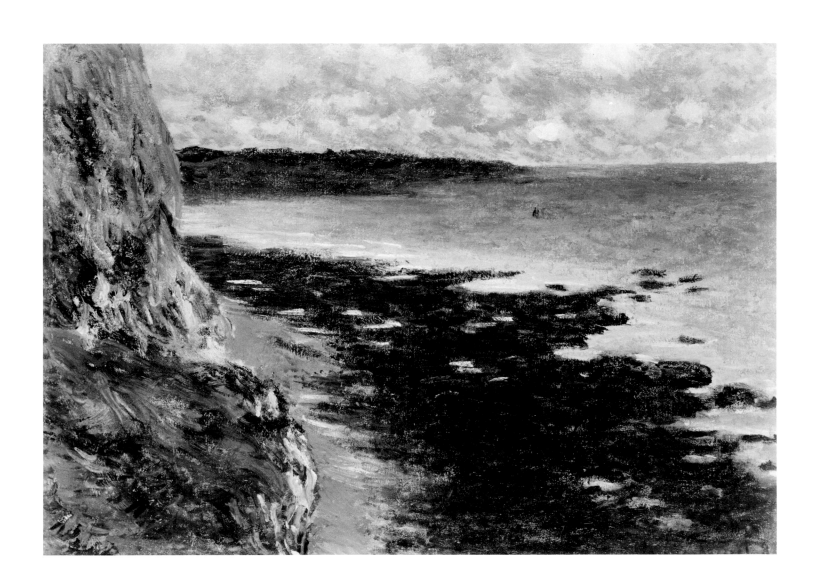

Georges Pierre Seurat
French, 1859–91

The Stonebreakers, Le Raincy,
ca. 1882

Oil on canvas
33 x 45.5 cm (14¼ x 17¾ in)

COLLECTIONS: Jacques and Pierre Puy-
bonnieux; Léon Appert; Léopold
Appert; Mme Vve. Léopold Appert;
private collection, Paris; Stephen Hahn
Gallery.

EXHIBITIONS: Galerie Bernheim-Jeune,
Paris, 1908, *Exposition Georges Seurat,*
no. 34; Musée Jacquemart-André, Paris,
1957, *Seurat,* no. 21; Philadelphia Mu-
seum of Art, Philadelphia, 1969, *Recent
Acquisitions by the Norton Simon, Inc.
Museum of Art,* no. 13.

LITERATURE: Jacques de Laprade, *Georges
Seurat* (Monaco, 1945), pl. 3; idem,
Seurat (Paris, 1951), pl. 10; Henri Dorra
and John Rewald, *Seurat: l'œuvre peint,
biographie et catalogue critique* (Paris,
1959), no. 21; C. M. de Hauke, *Seurat et
son œuvre,* 2 vols. (Paris, 1961), 1, no. 38.

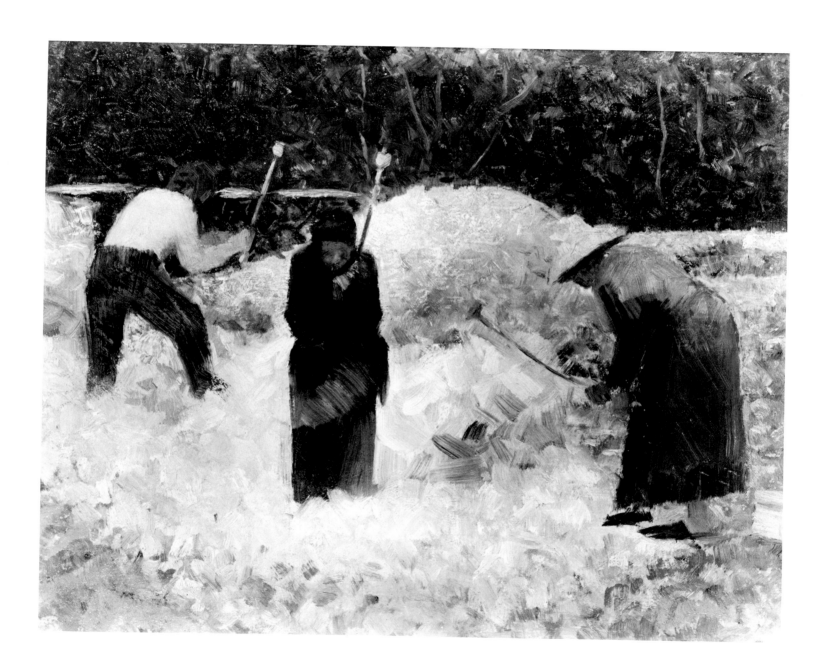

32

Paul Cézanne
French, 1839–1906

Uncle Dominique, 1865–67

Oil on canvas
46 x 38 cm (18 x 15 in)

COLLECTIONS: Auguste Pellerin; J.-V.
Pellerin; Frances Vogel Spitzer; Jane
Wade, Ltd.

EXHIBITIONS: Wildenstein and Co., Lon-
don, 1939, *Hommage to Paul Cézanne,*
no. 3; Wildenstein and Co., N.Y., 1959,
Cézanne, no. 4; Philadelphia Museum
of Art, Philadelphia, 1967, "The Frances
Vogel Spitzer Collection"; Philadelphia
Museum of Art, Philadelphia, 1969, *Re-
cent Acquisitions by the Norton Simon,
Inc. Museum of Art,* no. 2.

LITERATURE: Georges Rivière, *Le Maître
Paul Cézanne* (Paris, 1923), p. 196;
George Waldemar, "The Twilight of a
God," *Apollo,* 14 (1931): 77; Lionello
Venturi, *Cézanne: son art, son œuvre,*
2 vols. (Paris, 1936), 1, no. 79; 2, pl. 21;
Maurice Raynal, *Cézanne* (Paris, 1936),
p. 146, pl. 58; Fritz Novotny, *Paul
Cézanne* (N.Y., 1937), pl. 2; Bernard
Dorival, *Cézanne* (Paris, 1948), p. 142,
pl. 7.

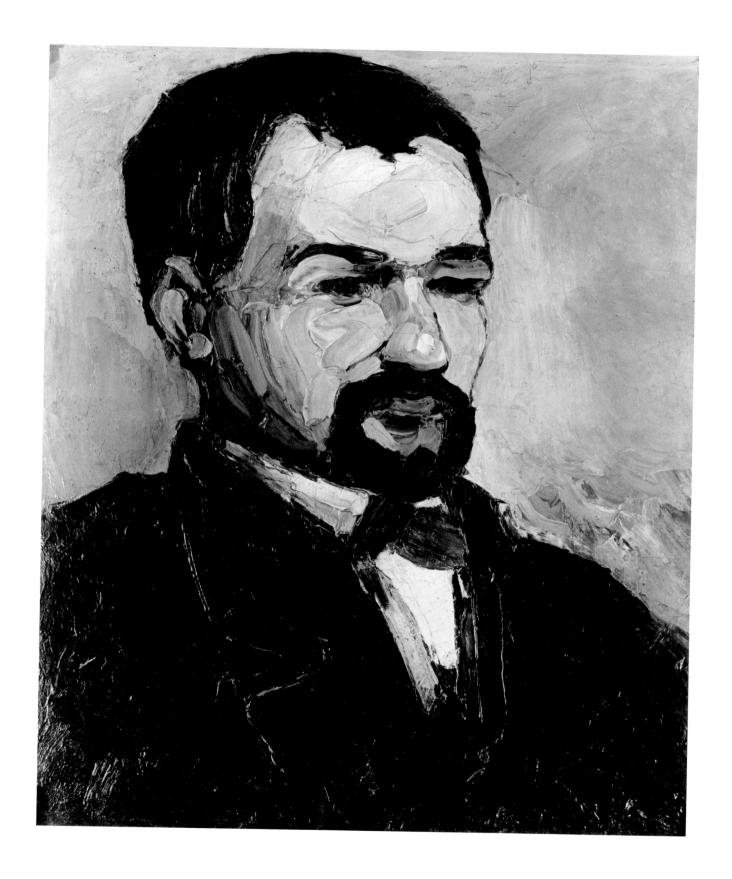

33

Vincent van Gogh
Dutch, 1853–90

Portrait of the Artist's Mother, 1888

Oil on canvas
39.5 x 31 cm (15½ x 12¼ in)

COLLECTIONS: Ambroise Vollard; A.
Rosenberg; Carl Moll; Paul Rosenberg;
Rev. Theodore Pitcairn (sale, Christie's,
London, June 28, 1968, no. 122).

EXHIBITIONS: Paul Cassirer, Berlin, May–
June 1914, no. 73; Secession, Vienna,
1925, *Die fuhrenden Meister der fran-
zösischen Kunst im XIX Jahrhundert*,
no. 74; Dresden, 1926, "Internationale
Kunstausstellung," no. 212; Wildenstein
and Co., N.Y., 1943, *Art and Life of Vin-
cent van Gogh*, no. 33; Philadelphia
Museum of Art, Philadelphia, on loan
summer 1960; Portland Art Museum,
Portland, Nov. 1968–Mar. 1969, "Recent
Acquisitions by the Norton Simon, Inc.
Museum of Art," no. 8.

LITERATURE: Gustave Coquiot, *Vincent
van Gogh* (Paris, 1923), p. 313; J. B. de
la Faille, *L'œuvre de Vincent van Gogh*,
4 vols. (Paris, 1928), 1, no. 477; idem,
Vincent van Gogh (Paris, 1939), no.
H502; Frank Elgar, *Van Gogh* (N.Y.,
1958), no. 146; Vincent van Gogh, *Com-
plete Letters of Vincent van Gogh*
(Greenwich, Conn., 1958), 3, nos. 546,
548; Marc-Edo Tralbaut, *Van Gogh*
(Munich, 1960), p. 13; Christie, Manson
and Woods, *Important Impressionist
and Modern Drawings, Paintings and
Sculpture* (London, June 28, 1968), no.
122; Robert Wallace, *The World of van
Gogh, 1853–1890* (N.Y., 1969), p. 8.

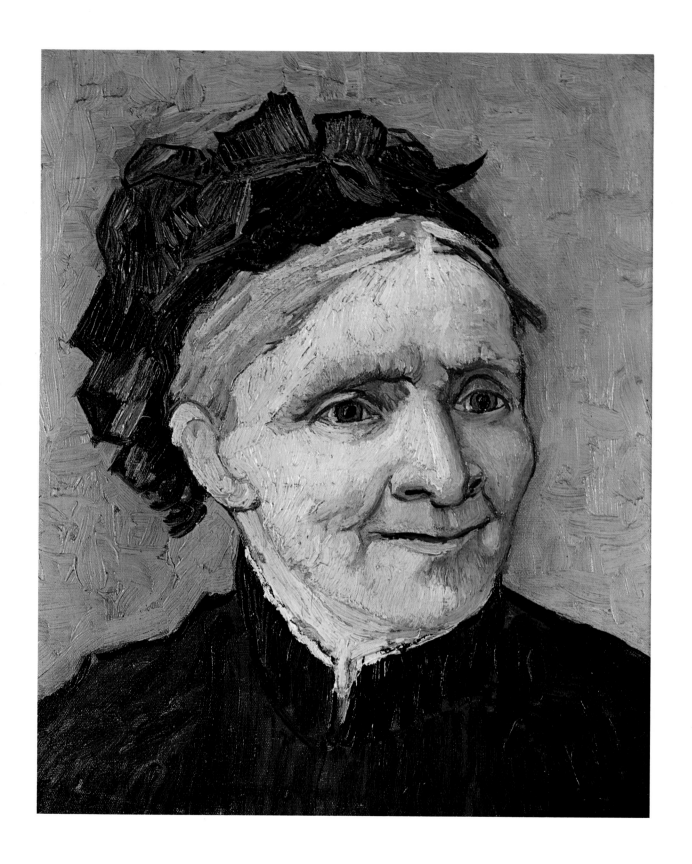

34

Johan Barthold Jongkind
Dutch, 1819–91

*The Church of Saint Médard and
the Rue Mouffetard,* 1871

Oil on canvas
43 x 57 cm (17 x 22¼ in)
Signed, dated, and inscribed, lower right:
Jongkind, 1871, Paris

COLLECTIONS: Saint-Sabin; private col-
lection, England; Drs. Fritz and Peter
Nathan.

EXHIBITIONS: Arthur Tooth and Sons,
London, 1949, *Anthology—Loan Exhi-
bition of French Pictures,* no. 16.

NOTE: A watercolor, signed and dated
1868, which was the study for this paint-
ing, is reproduced in Etienne Moreau-
Nélation's *Jongkind raconté par lui-
même* (Paris, 1918), fig. 86. Another
painted version of the same scene, signed
and dated *Paris 28 avril 1868,* was in the
Exposition Jongkind (Galerie Schmit,
Paris, 1966, no. 29).

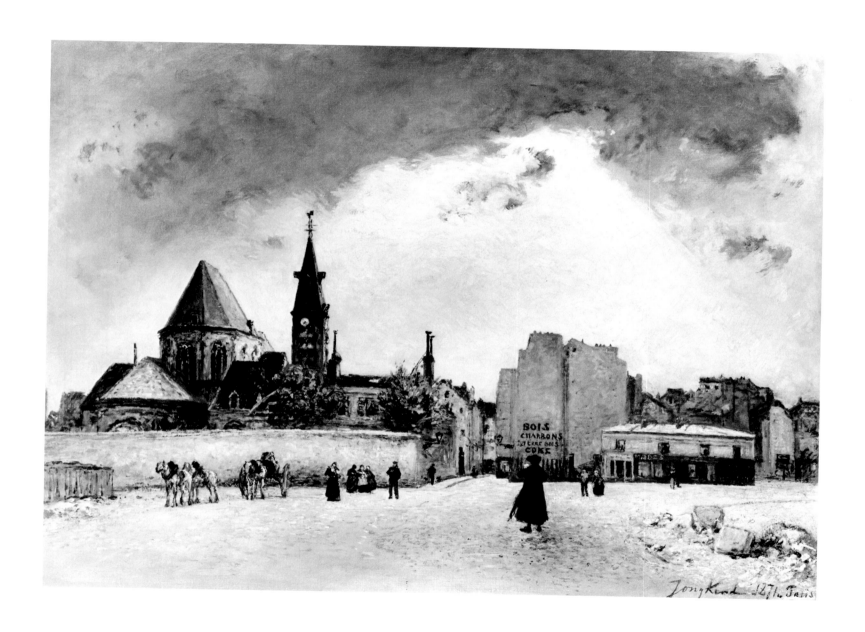

35

Paul Signac
French, 1863–1935

Seine at Les Andelys, 1886

Oil on canvas
46 x 65 cm (18 x 25½ in)
Dedicated, signed, and dated, lower
right: *A mon ami (Adolphe)*
Albert, P. Signac '86

COLLECTIONS: Private collection (sale,
Sotheby's, London, Oct. 23, 1963, no.
54); J. Horner; Stephen Hahn Gallery.

EXHIBITIONS: Portland Art Museum,
Portland, Nov. 1968–Mar. 1969, "Recent
Acquisitions by the Norton Simon, Inc.
Museum of Art," no. 19.

LITERATURE: Sotheby and Co., *Impres-
sionist and Modern Paintings, Draw-
ings and Sculpture* (London, Oct. 23,
1963), no. 54.

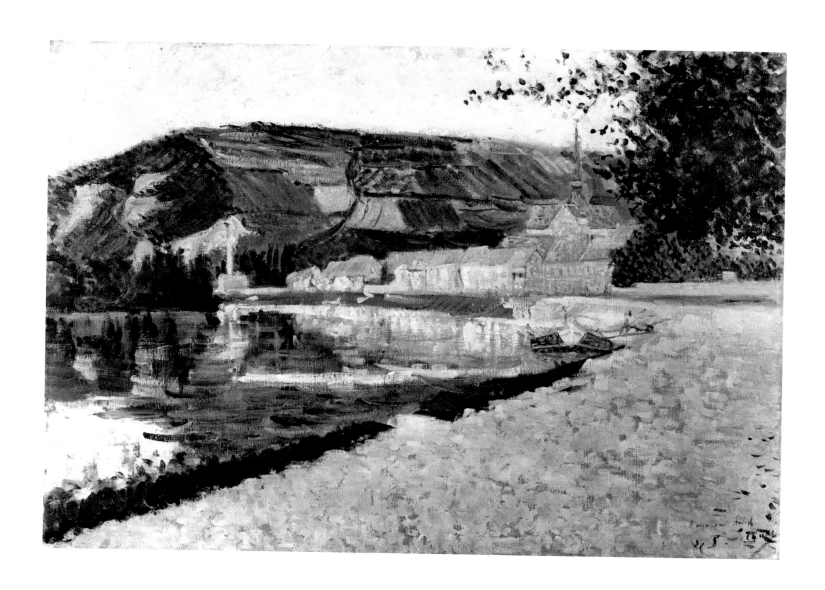

36

Pierre Auguste Renoir
French, 1841–1919

Girl in Yellow Hat, 1885

Oil on canvas
67 x 55.4 cm (26¼ x 21⅝ in)
Signed, lower left: *Renoir*

COLLECTIONS: Ambroise Vollard; M.
Knoedler and Co.; Mrs. Charles Suydam
Cutting; Wildenstein and Co.

EXHIBITIONS: M. Knoedler and Co., N.Y.,
1933, *Paintings from the Ambroise Vol-
lard Collection*, no. 27; Metropolitan
Museum of Art, N.Y., 1937, *Renoir: A
Special Exhibition of His Paintings*, no.
43; Duveen Galleries, N.Y., 1941,
Renoir, no. 55; Newark Museum, New-
ark, 1946, *Owned in New Jersey*, no. 61;
Wildenstein and Co., N.Y., 1950, *Renoir*,
no. 50; Newark Museum, Newark, 1954,
*From the Collection of Mrs. C. Suydam
Cutting*, no. 8; Wildenstein and Co.,
N.Y., 1958, *Renoir*, no. 47; Wildenstein
and Co., N.Y., 1965, *Olympia's Progeny*,
no. 42; Philadelphia Museum of Art,
Philadelphia, 1969, *Recent Acquisitions
by the Norton Simon, Inc. Museum of
Art*, no. 11.

LITERATURE: Ambroise Vollard, *Tab-
leaux, pastels et dessins de Pierre Au-
guste Renoir*, 2 vols. (Paris, 1918), 1: 4,
fig. 13; I. A. Hopper, "Vollard and
Stieglitz," *American Magazine of Art*,
36 (1933): 544.

NOTE: The sitter is the daughter of
Renoir's friend, the painter Frank Lami.

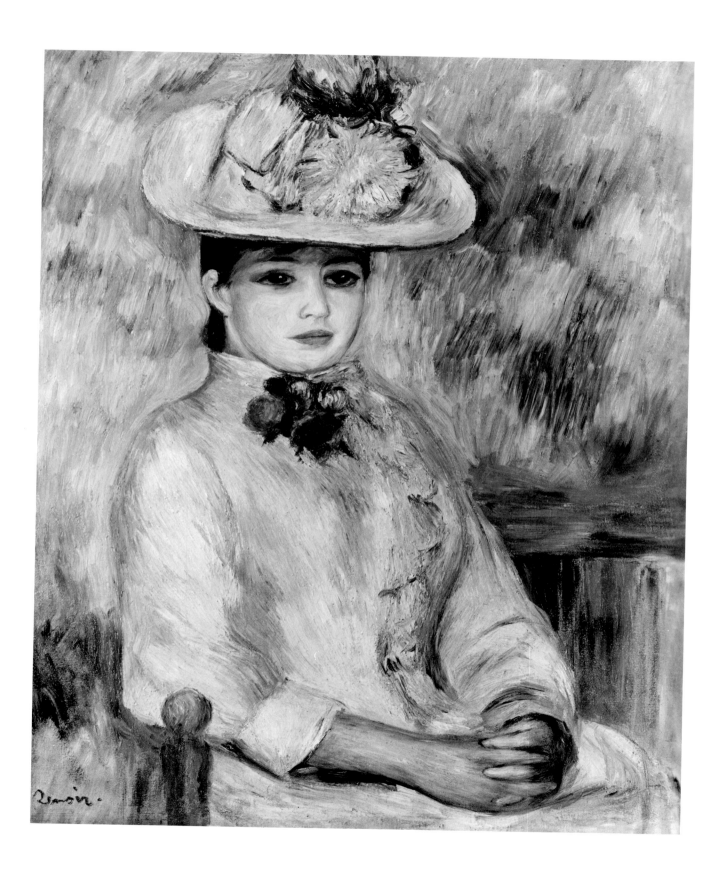

37

Pierre Auguste Renoir
French, 1841–1919

Reclining Nude, ca. 1890

Oil on canvas
33.5 x 41 cm (13 x 16 in)
Signed, lower right: *Renoir*

COLLECTIONS: Bernheim-Jeune; Olivier
Saincere; Farjon; Stephen Hahn Gallery.

EXHIBITIONS: Galerie Bernheim-Jeune,
Paris, 1927, *Cinquante Renoir,* no. 13;
Galerie Hervé, Montreal, 1967, "A.
Renoir," no. 11; Philadelphia Museum
of Art, Philadelphia, 1969, *Recent Ac-
quisitions by the Norton Simon, Inc.
Museum of Art,* no. 12.

LITERATURE: J. G. Goulinat, "Les Sources
du Métier de Renoir," *L'Art Vivant,*
no. 72 (1925), p. 23.

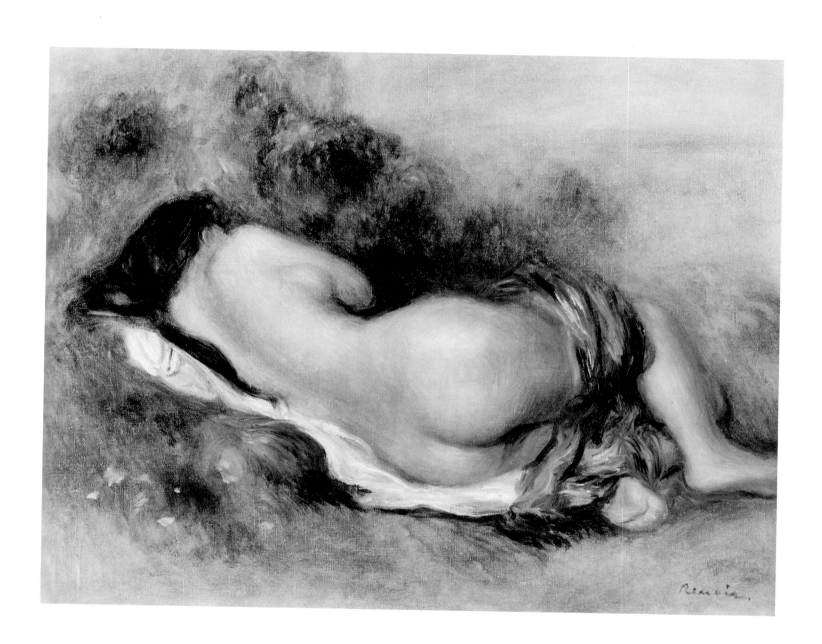

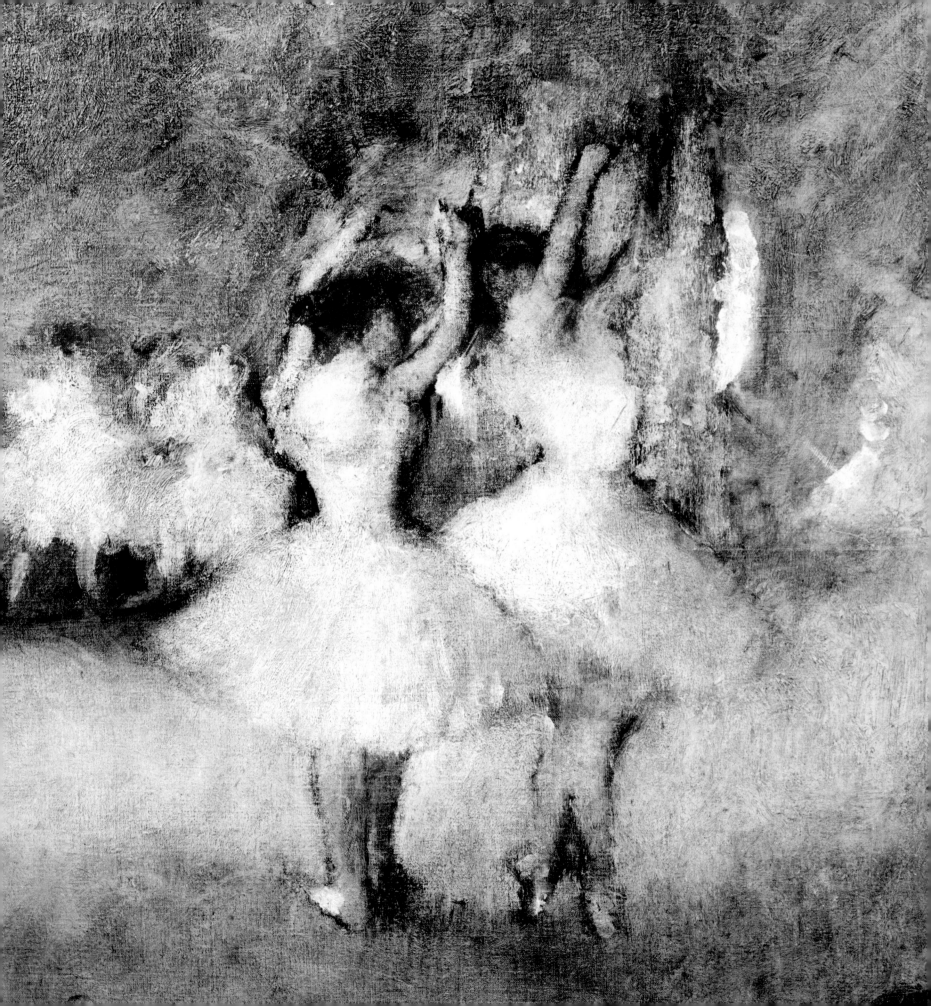

THE SUBJECTS selected as well as the techniques employed by painters in France in the latter part of the nineteenth century often indicate the widening gap between artists of academic and avant-garde styles. Advocates of realism and naturalism were determined to paint and exhibit subjects other than the venerated academic themes. By the 1870s several artists associated with the Impressionist circle did not restrict themselves to the conventional subjects and doctrinaire practices identified with the academic tradition in France. Among these artists was Edgar Degas, who, although respectful of the art of the past, was incorporating within his style borrowings from Japanese prints, an interest in photography, and innovative techniques. However, unlike most members of the Impressionist group, Degas was not concerned with the temporal qualities of nature and was content to relegate landscape to the background of compositions in which the primary attention focuses upon figures. Candidly and unselfconsciously presented, Degas's figures are not those usually encountered in works of art. He did not exploit the demimonde or any other segment of society, as did some of his contemporaries. One shares an intimacy with Degas's subjects, whether they are specific portraits or of anonymous persons.

The four paintings by Degas included in this collection were produced within a period of approximately thirty years, representing his mature style, usually dated from the mid-1870s. These four works allow the viewer to examine certain major changes that occur within Degas's style as he became increasingly experimental with media and techniques. Furthermore, these works assert the primacy of the human form in Degas's art. An admirer of the works of Ingres, Degas was also a great draftsman, a fact that is clearly evident in his early style and discernible in the later works as well.

The earliest painting by Degas in this exhibition is a small oil from the late 1870s, *Woman Combing Her Hair before a Mirror* (cat. 38). Although Degas frequently painted intimate views of people, one is rarely made aware of invading their privacy. The woman, seen almost frontally, raises her hands to adjust her hair as she gazes undistractedly into a mirror. This is a rather early use of this theme that Degas was to use repeatedly in the following years. It is altogether typical of his low-keyed realism.

The many scenes of ballet dancers are undoubtedly among Degas's best-known works. He sketched, painted, and modeled figures of dancers, in moments of activity and repose, often seen from unusual vantage points. In *Dance Rehearsal in the Foyer* (cat. 39), an oil painting of 1885, the positions of the two nearest dancers are echoed in a less distinctly painted pair in the middle ground. Additional figures appear as vague forms of white against the mottled walls of the foyer. The repeated forms of the legs of the foremost figure suggest movement. Her face conveys some expression, although, as in many works by Degas, facial features are not stressed, as they would add little to the overall impression of the scene.

In contrast to Degas's treatment of ballet dancers is the very small oil painting *Dancer Retying Her Slipper* (cat. 42) by Jean-Louis Forain. Forain's paintings and drawings often reveal obvious traces of the styles of artists whose

Degas and His Contemporaries

Thomas L. B. Sloan

works he admired, including Degas, with whom he came into contact in the 1870s. One also notices borrowings from Daumier and Manet in Forain's oeuvre, although his approach to the subjects he paints makes his style distinctive. Because of the exaggeration of the features of some of his figures, Forain's scenes often appear to be slightly comical. For instance, in the ballet scene, a painting that superficially suggests Degas's style, the portly gentleman with bulging eyes, a type that the critic Huysmans described in Forain's art as "paternal and obscene," draws our attention away from the dancer in the foreground.

One subject that appeared by the late 1860s in Degas's oeuvre, and to which he later returned many times, was that of laundrywomen, usually shown ironing. In one of the most forceful examples of this theme, *The Ironers* (cat. 40), two women are seen across a worktable in a laundry room; their poses and expressions clearly tell of the monotony of their laborious occupation. Fatigue is suggested by the yawning figure, and physical exertion by the other, who leans heavily on her iron. This scene, as in similar accounts in the writings of Degas's contemporary Zola, evokes decided feelings for the workers shown, which, aside from this recurring theme, is unusual for Degas. It is nevertheless worth noting that he selected a chore performed by women.

Degas worked in pastels in the 1870s, but by the mid-1880s as his eyesight weakened, it became his chief medium. *Woman Drying Her Hair* (cat. 41) does not raise any doubts about Degas's enduring abilities as a draftsman, although the color, applied in bold hatched lines, imparts a vibrant and robust quality to the seated figure, viewed from the rear. There is a general feeling of vitality in Degas's late works in pastel, in which the underlying sense of form and modeling is dramatically stressed. The subjects remain the same as earlier; the privacy of the bath is treated as an everyday event, and not as a voyeuristic spectacle, as might be expected from a less discreet artist.

To conclude with a slightly later work in pastels, *Vase of Flowers* by Odilon Redon (cat. 43) is a rather carefully defined treatment of this conventional subject. Although this is a typical example of one aspect of Redon's style, it does not betray the more unusual, enigmatic side of this artist's personality. Redon's earlier works, in mood and content, adumbrate the Symbolist movement, mentioned earlier in connection with a painting by Gustave Moreau (cat. 24). Throughout his career, Redon was obsessed with flowers, which appear prominently in his figurative subjects, as well as in studied isolation in numerous still lifes. However, unlike the painters who sought verisimilitude in their depictions of floral arrangements, Redon's works can almost be regarded as portraits of flowers, if one can allow such an extreme of anthropomorphism. Whereas Degas found pastels to be a suitable vehicle for bold expression in color in his late years, Redon turned to it as a means of rendering a delicate sensitivity in his final works.

38
Hilaire Germain Edgar Degas
French, 1834–1917

Woman Combing Her Hair
before a Mirror, ca. 1877

Oil on canvas
39.3 x 31.6 cm (15½ x 12½ in)
Stamped signature of the Degas *vente*,
lower right: *Degas*

COLLECTIONS: Estate of the artist (sale,
Galerie Georges Petit, Paris, May 6–8,
1918, no. 31); Jacques Seligmann (sale,
American Art Galleries, N.Y., Jan. 27,
1921, no. 24); Tannhauser; M. Knoedler
and Co.

EXHIBITIONS: California Palace of the
Legion of Honor, San Francisco, 1964,
Man: Glory, Jest and Riddle, no. 168.

LITERATURE: Galerie Georges Petit, *Cata-
logue des Tableaux, Pastels et Dessins
par Edgar Degas et Provenant de son
Atelier, Vente 1ᵉʳ* (Paris, May 6–8, 1918),
no. 31; American Art Galleries, *The
Notable Private Collection of Paintings
and Pastels by Hilaire Germain Edgar
Degas formed by Jacques Seligmann of
Paris* (N.Y., Jan. 27, 1921), no. 24; Paul-
André Lemoisne, *Degas et son œuvre*,
4 vols. (Paris, 1946), 2, no. 436.

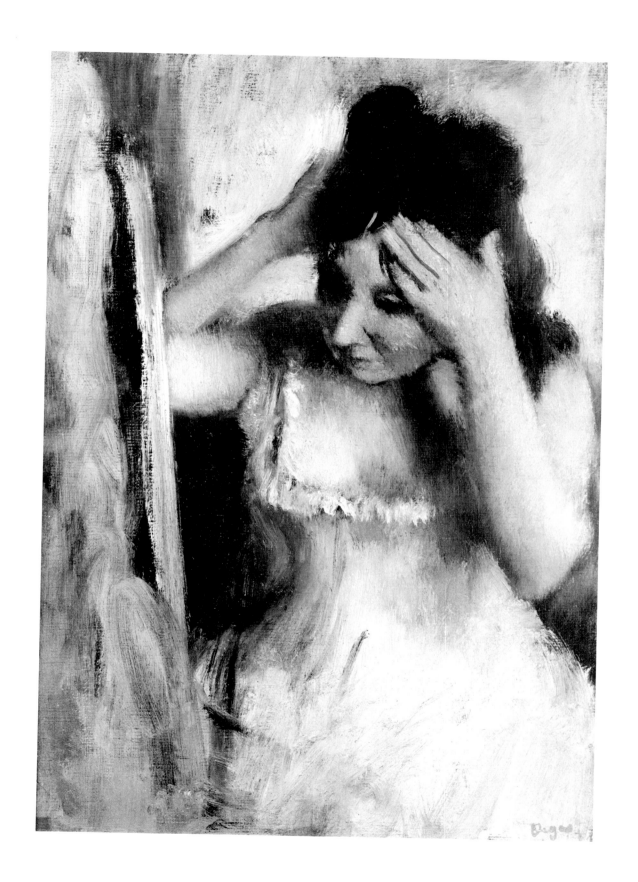

Hilaire Germain Edgar Degas
French, 1834–1917

Dance Rehearsal in the Foyer, 1885

Oil on canvas
89 x 96 cm (34⅞ x 37¾ in)
Stamped signature of the Degas *vente,*
lower right: *Degas*

COLLECTIONS: Estate of the artist (sale,
Galerie Georges Petit, Paris, May 6–8,
1918, no. 66); Durand-Ruel; Joseph
Hessel; Josef Stransky; Mrs. Pierre
Matisse.

EXHIBITIONS: Portland Art Museum,
Portland, Nov. 1968–Mar. 1969, "Recent
Acquisitions by the Norton Simon, Inc.
Museum of Art," no. 4.

LITERATURE: Galerie Georges Petit, *Cata-
logue des Tableaux, Pastels et Dessins
par Edgar Degas et Provenant de son
Atelier, Vente 1er* (Paris, May 6–8, 1918),
no. 66; Ralph Flint, "Private Collection
of Joseph Stransky," *Art News,* 29
(1931): 87–88; Paul-André Lemoisne,
Degas et son œuvre, 4 vols. (Paris, 1946),
3, no. 819.

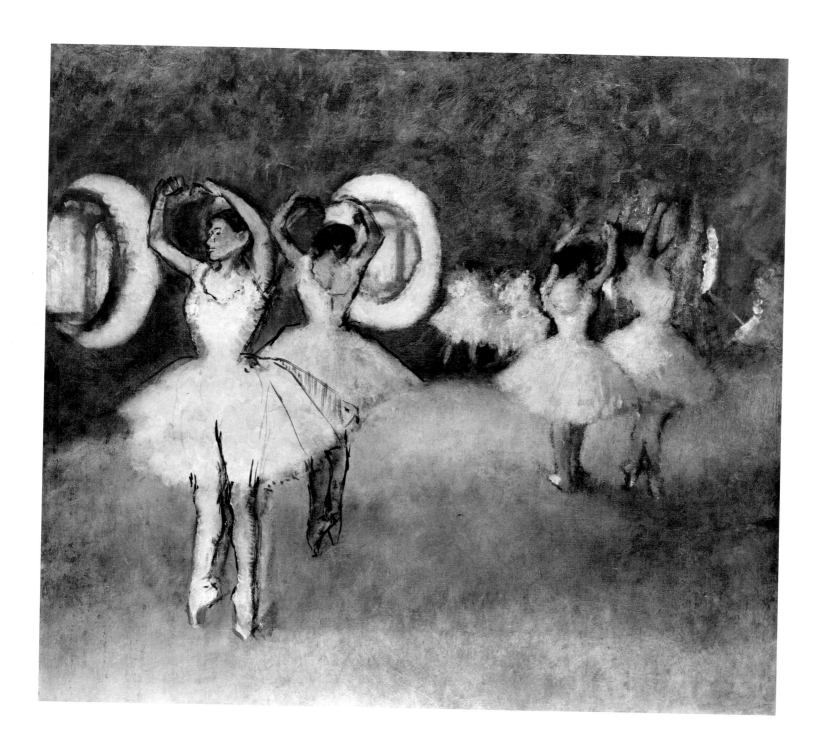

40

Hilaire Germain Edgar Degas
French, 1834–1917

The Ironers, ca. 1884

Oil on canvas
81.8 x 74.9 cm (32¼ x 29½ in)
Signed, lower left: *Degas*

COLLECTIONS: Oscar Schmitz; Chester A.
Beatty; Arthur Tooth and Sons; Norton
Simon and Robert Ellis Simon.

EXHIBITIONS: Dresden, 1926, "Interna-
tionale Kunstausstellung"; Kunsthaus,
Zurich, 1932, *Oscar Schmitz Collection*,
no. 23.

LITERATURE: Paul P. Fechter, "Die
Sammlung Schmitz," *Kunst und Künst-
ler*, 8 (1909–10): 22; Louis Hourticq,
"Edgar Degas," *Art et Décoration* (1912),
p. 106; Karl Scheffler, "Die Sammlung
Oscar Schmitz in Dresden," *Kunst und
Künstler*, 19 (1920–21): 186; Ambroise
Vollard, *Degas* (Paris, 1924), pl. 114;
O. Schurer, "Internationale Kunstaus-
stellung, Dresden," *Deutsche Kunst
und Dekoration* (1927), p. 273; J. B. Man-
son, *Life and Work of Edgar Degas* (Lon-
don, 1927), p. 52; Emil Waldmann, *Die
Kunst des Realismus und des Impres-
sionismus in XIX Jahrhundert* (Berlin,
1927), p. 97, pl. 484; A. A. Rubenstein,
*Catalogue de la collection Oscar Sch-
mitz* (N.Y., 1936), p. 57; Camille Mau-
clair, *Degas* (N.Y., 1941), p. 104; Paul-
André Lemoisne, *Degas et son œuvre*,
4 vols. (Paris, 1946), 2, no. 687.

NOTE: *The Ironers* is owned jointly by
the Norton Simon, Inc. Museum of Art
and The Norton Simon Foundation.

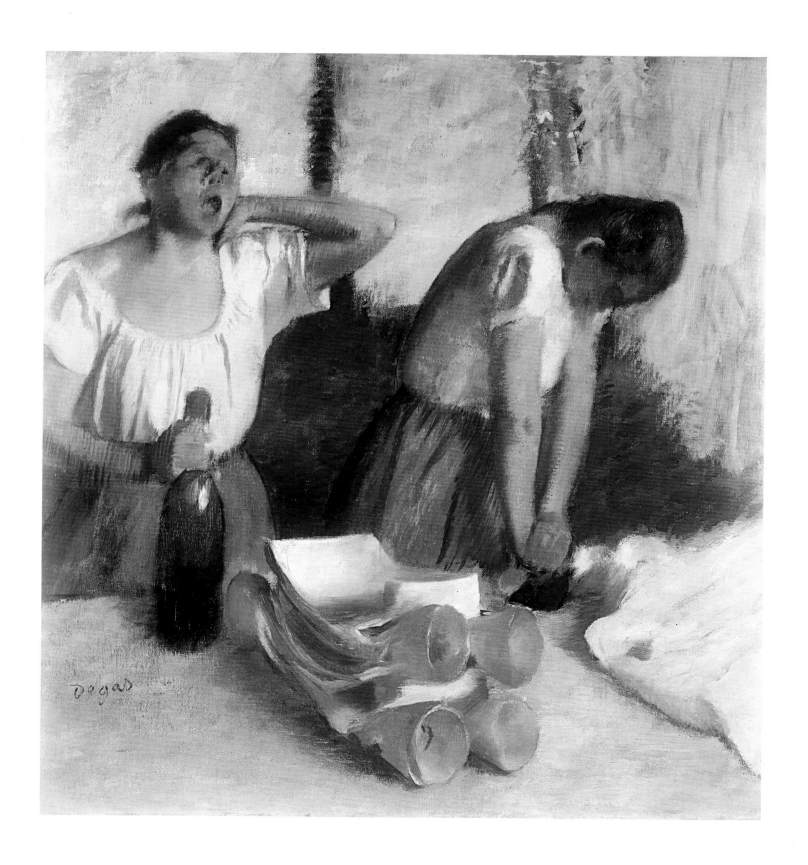

41

Hilaire Germain Edgar Degas
French, 1834–1917

Woman Drying Her Hair,
ca. 1905–07

Pastel on paper
71 x 63 cm (28 x 24½ in)
Stamped signature of the Degas *vente,*
lower right: *Degas*

COLLECTIONS: Estate of the artist (sale,
Galerie Georges Petit, Paris, Dec. 11–13,
1918, no. 134); Ambroise Vollard;
Charles Durand-Ruel; Sam Salz; private
collection, N.Y.; Sam Salz; Alex Reid
and Lefevre Gallery.

EXHIBITION: Galerie Durand-Ruel, Paris,
1960, *Edgar Degas,* no. 63.

LITERATURE: Galerie Georges Petit, *Cata-
logue des Tableaux, Pastels et Dessins
par Edgar Degas et Provenant de son
Atelier, Vente II* (Paris, Dec. 11–13,
1918), no. 134; Paul-André Lemoisne,
Degas et son œuvre, 4 vols. (Paris, 1946),
3, no. 1454.

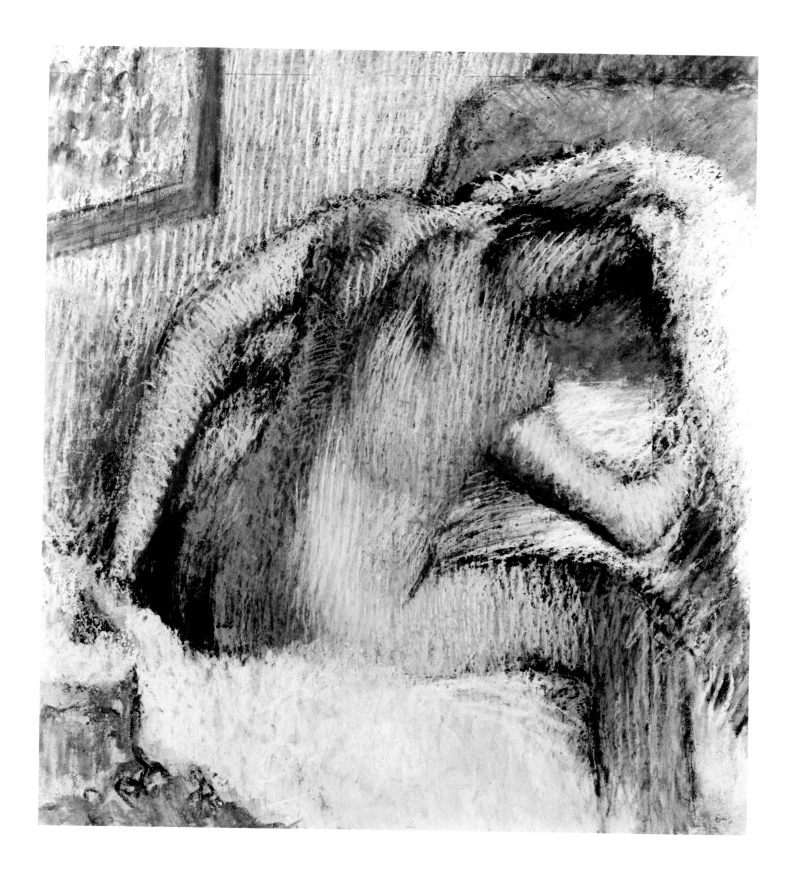

42

Jean-Louis Forain
French, 1852–1931

Dancer Retying Her Slipper,
ca. 1878–80

Oil on panel
27 x 21 cm (10½ x 8¼ in)
Inscribed and signed, lower right:
a Emma S. . . . , j. l. forain

COLLECTIONS: S. Chapelier; Hon. Mrs.
A. E. Pleydell-Bouverie (sale, Sotheby's,
London, July 3, 1968, no. 5).

EXHIBITIONS: Carnegie Institute, Pitts-
burgh, 1931, *Thirtieth Annual Interna-
tional Exhibition of Paintings,* no. 168,
pl. 22; Galerie Raphael Gerard, Paris,
1937, *Forain,* no. 47; Tate Gallery, Lon-
don, 1954, *The Pleydell-Bouverie Col-
lection,* no. 21; Roland, Browse and Del-
banco, London, 1964, *Forain,* no. 7;
Portland Art Museum, Portland, Nov.
1968–Mar. 1969, "Recent Acquisitions
by the Norton Simon, Inc. Museum of
Art," no. 6.

LITERATURE: Sotheby and Co., *Impres-
sionist and Modern Paintings, Drawings
and Sculpture* (London, July 3, 1968),
no. 5.

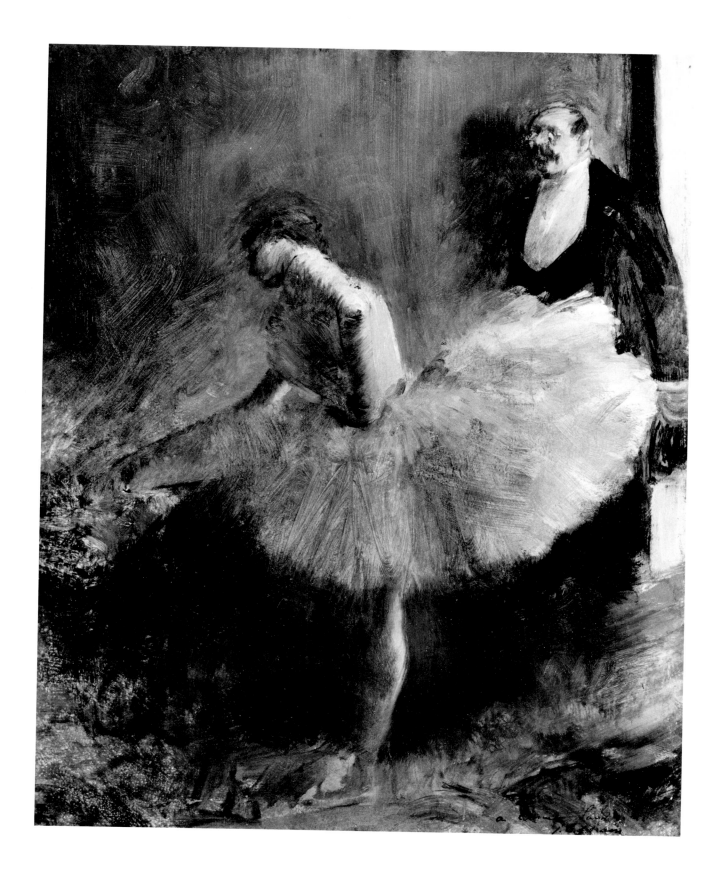

43

Odilon Redon
French: 1840–1916

Vase of Flowers, ca. 1912–16

Pastel on paper
65 x 51 cm (25½ x 20 in)
Signed, lower right: *Odilon Redon*

COLLECTIONS: Gustave Fayet; Jacques
Dubourg; M. Knoedler and Co.; Clare
Booth Luce; Marlborough Alte und
Moderne Kunst.

EXHIBITIONS: Galerie Barbazanges, Paris,
1920, *Exposition rétrospectif d'œuvres
d'Odilon Redon*; Nelson Gallery, Kansas
City, on loan Aug. 1968–Jan. 1969.

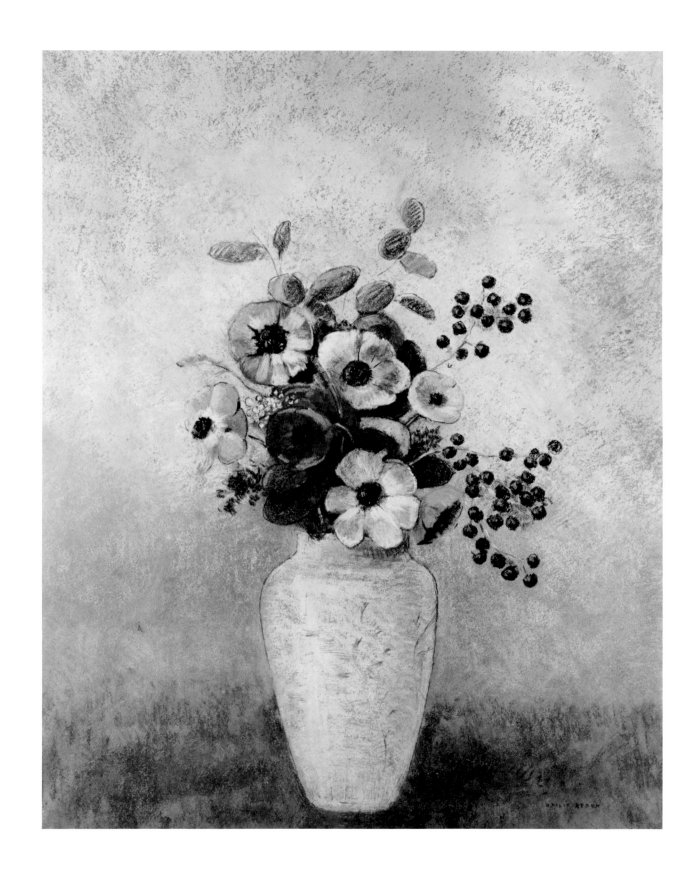

THE PERIOD between 1906 and 1947 saw a rapid evolution of new styles. Cubism not only made the most radical break with the past but was also the most influential new movement of the twentieth century. Picasso's *Les Demoiselles d'Avignon* of 1907 was the first work to present the new Cubist aesthetic, at least in embryo. The two paintings of 1906 by Picasso in the exhibition illustrate the contradictory classical and primitivist styles of the period immediately preceding *Les Demoiselles*. The earlier work, *Two Heads of Women* (cat. 44), is in the classicizing manner that occupied Picasso during the summer months he spent in Gosol, in the Spanish Pyrenees. The schematic treatment of hair in classical statuary is suggested by curling strokes of the brush while the sculptural qualities of the heads are emphasised through strong contrasts of light and shade.

In *Nude Combing Her Hair* (cat. 45) the references to classical art have disappeared. Instead there is a nonclassical asymmetry in the treatment of the head and body, with breasts displaced to the right and the lower body shifted slightly to the left, revealing part of the right buttock in what is otherwise a frontal view of the figure. Picasso here anticipates the more violent anatomical distortions of the figures in *Les Demoiselles*.

Picasso's *Pointe de la Cité* of spring 1912 (cat. 46) is a fully evolved Cubist painting. The subject matter—a closely packed group of houses on the Ile de la Cité in Paris—has been "analysed" into its component parts and reconstructed within the oval frame. Small, opaque planes in subdued shades of brown and gray are massed at the top center, while larger, more transparent planes touched with white fan out from the center and fade towards the edges, suggesting, perhaps, the water that surrounds the island. Occasional diagonal lines and an arbitrary use of light and shade convey the shifting spatial suggestions typical of high-analytical Cubism. This is surely one of the most beautiful canvases of the period and shows Picasso at his closest to abstraction. Without the clues of railings, attic windows, and gable roofs one might have difficulty in recognising the subject. Yet the starting point in reality becomes clear on close examination.

In the Juan Gris of 1915, *Still Life with a Poem* (cat. 49), the small, faceted planes of analytical Cubism have been opened out into the larger planes of synthetic Cubism. Objects are no longer fragmented into many separate parts. Gone too is the illusion of shallow space created by the use of shading in high-analytical Cubism. Gris is indebted here to the earlier "collages" of Picasso and Braque, where pieces of wallpaper imitated wood-graining and other textures. Gris forces us to look very carefully at the wood-graining of his table to decide whether or not it is paint. (It is.) At the bottom of the painting we see what appears to be a crumpled piece of paper bearing a poem by Pierre Reverdy attached to the canvas with a thumbtack. This is, however, a trompe l'oeil device and once again we are looking at paint. The poem is related to the painting with references to a bottle, money, and bystanders who sit down to table, presumably to play with the cards drawn by Gris.

The dislocations of space are much more explicit here than in the Picasso, for the apparent spatial position of a colored plane in one part of the painting

Cubism and Post-Cubism

Marian Burleigh-Motley

is contradicted elsewhere on the canvas. Look, for example, at the dislocation of the right side of the table. The brilliant red background reminds us of Gris's particular contribution to Cubism, his ability to handle bright hues within an austere Cubist construction.

The Russian variant of Cubism represented by Popova's *The Traveler* (cat. 50), also of 1915, is clearly indebted to Picasso and Braque in the use of stenciled letters that include a reference to the ubiquitous "newspaper" of French Cubism. But the style, with its mixture of analytical and synthetic Cubist elements, is closer to that of the more literal-minded minor French Cubists, Le Fauconnier and Metzinger, with whom Popova had studied in Paris from 1912 to 1914. Popova makes a colorful and humorous arrangement out of the basic image of a woman wearing a yellow necklace and carrying a bright green umbrella. Lines of the musical staff suggest the sound of music heard by the traveler, while glimpses of a railing, green grass, and a flag suggest the scenery through which she passes.

Picasso's *Open Window on the Rue de Penthièvre in Paris* of 1920 (cat. 47) presents some interesting problems in reading. Usually described as a still life on a table in front of an open window, it is possible to read the exterior view as painted on a canvas that is placed before the window embrasure. The familiar objects of Cubist still lifes, such as a guitar and book, are present in somewhat abstract but nonetheless recognisable guise. The playful transformation of leaves into a horizontal pattern recalls the earlier "collages."

The last painting by Picasso to be considered, *Bust of a Woman* of 1923 (cat. 48), although only three years later in date is in a completely different style. Returning to the classical world that had interested him in 1906, he now presents us with a large and powerful figure whose ponderousness recalls Roman rather than Greek art. Her anxiously nibbled hand seems prophetic of those psychological interests that were to occupy Picasso in the succeeding decade, during the years of his friendship with the Surrealist group.

Although Picasso had proposed an alternative to the Cubist style in his neoclassical works of the early 1920s (while simultaneously working in a synthetic Cubist style), other artists remained faithful to the premises of analytical Cubism or carried Cubism towards complete abstraction. The Dutch artist Piet Mondrian had been exposed to Cubist paintings as early as 1911 and, having settled in Paris in 1912, evolved an abstract variation of Cubism that he continued to explore and expand up to his death in 1944.

Mondrian's *Composition with Red, Yellow, and Blue* (cat. 51) was begun in England in 1939 and completed in New York in 1942, where the original austere arrangement of black vertical and horizontal lines of varying thicknesses was enlivened by the addition of color areas around the edges. Yet the dominant impression is of stability and order while the extension of the major lines of the composition to the edges of the canvas suggests that it is only part of a larger order—the order of the cosmos as Mondrian saw it.

Ben Nicholson's *Relief* (cat. 52) also dates from 1939, during the period of his close association with Mondrian in the Circle group in London. Nicholson had visited Mondrian's studio in Paris earlier in the 1930s and was clearly

much influenced by the older artist's classical discipline and sparseness of motif. Nicholson's style is also rooted in an earlier experience of Cubism. The similarities between their art in the late 1930s were recognised by both artists and their works of this period were reproduced side by side in the publication *Circle* of 1937, edited by Nicholson.

The *Relief*, however, carries none of the metaphysical implications of Mondrian's painting but rather seeks to demonstrate its self-sufficiency, using only basic geometrical forms in pure white unrelieved by color accents. The forms are carved in very thin relief planes which state explicitly the kind of shifting, shallow space implicit in analytical Cubism.

Cubism was not, however, the only style in vogue during the twenties and thirties. Surrealism had been proclaimed in a manifesto of 1924, and the exploration of dream imagery and dream space had been carried on by artists such as Joan Miro and Jean Arp, employing a new vocabulary of seemingly abstract and yet palpably living, or biomorphic, forms.

Arshile Gorky is usually seen as the artist who succeeded in marrying Cubist to Surrealist imagery in the crucial years 1943 to 1947 in New York. In *Plumage Landscape* (cat. 53) the colorful, biomorphic forms seem to have a life of their own; they swell beyond the confines of their outlines and drift across the shallow space like pollen before the wind. An insect-like head, or perhaps a fetus, appears left of center; fish-like forms float in the lower left-hand corner; the dominant and central image is the juxtaposition of penis and fertilized egg. This image confirms the suggestions of germination and flowering scattered across the "landscape"—a landscape that is made up of observed nature and interior imagination in a complex intertwining of meanings and motifs.

Gorky in 1947, like Mondrian in 1942, had only a short time to live when the works we have been discussing were produced, but both—and this despite Mondrian's poverty and Gorky's impending suicide—seem to celebrate the continuity of life, in one case in the metaphysical, and in the other in the organic sphere.

44

Pablo Ruiz y Picasso
Spanish, b. 1881

Two Heads of Women, 1906

Gouache on brown paper
56.8 x 40.9 cm (22⅜ x 16⅛ in)
Signed, lower right: *Picasso*

COLLECTIONS: Ima Hogg; Hirschl and
Adler.

EXHIBITIONS: Museum of Fine Arts,
Houston, 1960, *From Gauguin to Gorky
in Cullinan Hall*, no. 50; Philadelphia
Museum of Art, Philadelphia, 1969,
*Recent Acquisitions by the Norton
Simon, Inc. Museum of Art*, no. 7.

LITERATURE: Christian Zervos, *Pablo
Picasso* (Paris, n.d.), 1, no. 335; Pierre
Daix and Georges Boudaille, *Picasso:
The Blue and Rose Periods* (Greenwich,
Conn., 1967), no. XVI 1.

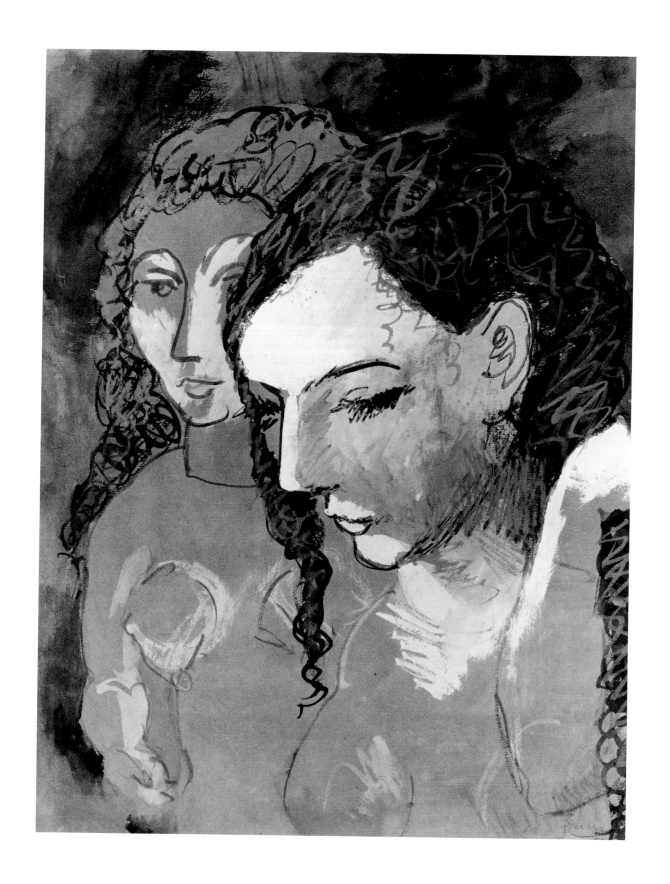

45

Pablo Ruiz y Picasso
Spanish, b. 1881

Nude Combing Her Hair, 1906

Oil on canvas
104 x 79.8 cm (41 x 31½ in)
Signed, top right: *Picasso*

COLLECTIONS: Ambroise Vollard; Jacques
Ulmann; Beatrice Ulmann; Paul
Rosenberg and Co.

EXHIBITIONS: Galerie Georges Petit, Paris,
1932, *Picasso,* no. 39; Kunsthaus, Zurich,
1932, *Picasso,* no. 34; Jacques Selig-
mann, N.Y., 1936, *Picasso's "Blue" and
"Rose" Periods, 1901–1906,* no. 34; Tate
Gallery, London, 1960, *Picasso,* no. 31;
Philadelphia Museum of Art, Philadel-
phia, 1969, *Recent Acquisitions by the
Norton Simon, Inc. Museum of Art,*
no. 8.

LITERATURE: Christian Zervos, *Pablo
Picasso* (Paris, n.d.), 1, no. 344, pl. 163;
Pierre Daix and Georges Boudaille,
Picasso: The Blue and Rose Periods
(Greenwich, Conn., 1967), no. XVI 9.

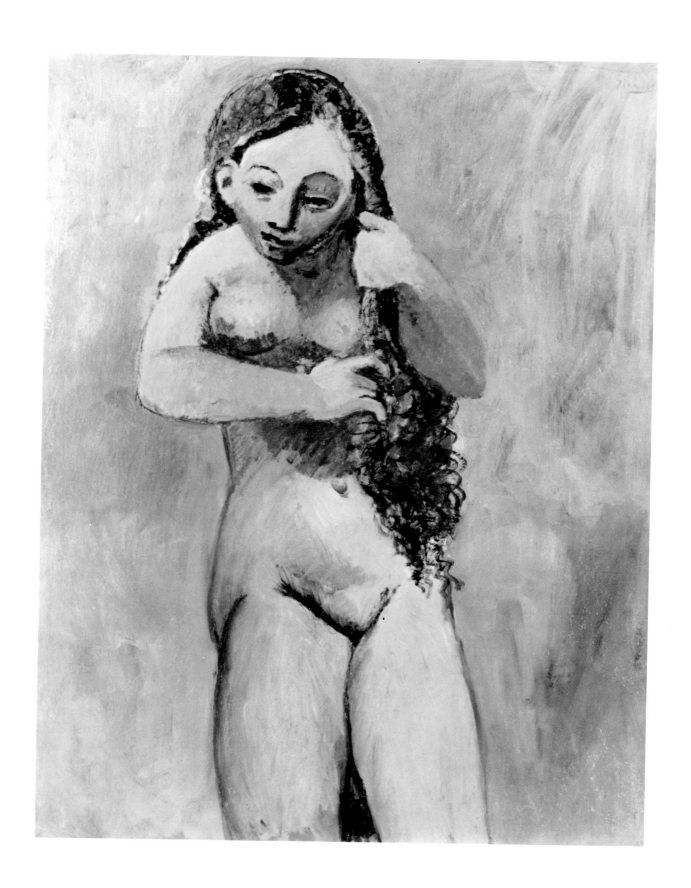

46

Pablo Ruiz y Picasso
Spanish, b. 1881

Pointe de la Cité, 1912

Oil on canvas
92 x 73 cm (35½ x 28 in)

COLLECTIONS: Galerie Kahnweiler; Galerie Flechtheim; Galerie Rosengart; Raoul Laroche; Galerie Berggruen; Norman Grantz (sale, Sotheby's, London, Apr. 23, 1968, no. 23).

EXHIBITIONS: Nelson Gallery, Kansas City, on loan Aug.–Dec. 1968; Fine Arts Gallery, San Diego, 1969, *Modern Masters of Spanish Painting;* Los Angeles County Museum of Art, Los Angeles, Dec. 1970–Feb. 1971, "The Cubist Epoch," no. 239.

LITERATURE: Christian Zervos, *Pablo Picasso* (Paris, n.d.), 2, part 1, pl. 309; Paul Waldberg, "La Ville rêvée et la ville vécue," *XXe Siècle,* 26 (1966): 49–50; Sotheby and Co., *Important Twentieth Century Paintings* (London, Apr. 23, 1968), no. 23; Douglas Cooper, *The Cubist Epoch* (N.Y., 1971), pp. 50–51.

47

Pablo Ruiz y Picasso
Spanish, b. 1881

*Open Window on the Rue de
Penthièvre in Paris,* 1920

Oil on canvas
165 x 140 cm (64½ x 43 in)
Signed and dated, lower right:
Picasso 1920

COLLECTIONS: Paul Rosenberg.

EXHIBITIONS: Tate Gallery, London, 1960,
Picasso, no. 92; Paul Rosenberg and Co.,
N.Y., 1962, *Picasso: An American Trib-
ute,* no. 13; University of California at
Irvine, Irvine, 1967, *A Selection of Nine-
teenth and Twentieth Century Works
from the Hunt Foods and Industries
Museum of Art Collection,* p. 23; Los
Angeles County Museum of Art, Los
Angeles, Dec. 1970–Feb. 1971, "The
Cubist Epoch," no. 255.

LITERATURE: Christian Zervos, *Pablo
Picasso* (Paris, n.d.), 4, pl. 23; Douglas
Cooper, *The Cubist Epoch* (N.Y., 1971),
pl. 1.

48

Pablo Ruiz y Picasso
Spanish, b. 1881

Bust of a Woman, 1923

Oil with fixed black chalk on canvas
100 x 81.5 cm (39¼ x 32 in)
Signed, top right: *Picasso*

COLLECTIONS: Pablo Picasso; Galerie
Beyeler; Paul Rosenberg and Co.; Hunt
Foods and Industries.

EXHIBITIONS: Galerie Beyeler, Basel,
1966, *Picasso*, no. 32.

LITERATURE: Pablo Picasso, Alfred H.
Barr, Jr., and Roland Penrose, *Picasso*
(Basel, 1967), no. 33.

49

Juan Gris
Spanish, 1887–1927

Still Life with a Poem, 1915

Oil on canvas
81 x 65 cm (31¾ x 25½ in)
Signed and dated, lower left: *Juan Gris*
11-15

COLLECTIONS: Edmond Rosenberg; Mr.
and Mrs. Henry Clifford; M. Knoedler
and Co.; Allan Bluestein (sale, Parke-
Bernet, N.Y., Apr. 3, 1968, no. 19).

EXHIBITIONS: Galerie Roland Balay et
Louis Carré, Paris, 1938, *Juan Gris,* no. 6;
Jacques Seligmann and Co., N.Y., 1938,
Retrospective Exhibition—Juan Gris,
no. 5; Philadelphia Museum of Art,
Philadelphia, 1947, *Masterpieces of
Philadelphia Private Collections,* no.
62; California Palace of the Legion of
Honor, San Francisco, 1949, *Illusionism
and Trompe l'Oeil,* p. 74; Museum of
Modern Art, N.Y., 1958, *Juan Gris,* p. 50;
Los Angeles County Museum of Art, Los
Angeles, Dec. 1970–Feb. 1971, "The
Cubist Epoch," no. 119.

LITERATURE: "Juan Gris: A Pivotal Figure
of the School of Paris," *Art News,* 37
(1938): 13–14; Rosamund Frost, *Con-
temporary Art: The March from
Cézanne until Now* (N.Y., 1942), p. 58;
Daniel-Henry Kahnweiler, *Juan Gris:
His Life and Work* (N.Y., 1947), p. 139,
pl. 23; David M. Robb, *The Harper His-
tory of Painting* (N.Y., 1951), p. 836,
fig. 458; José Camón Aznar, *Picasso y
el Cubismo* (Madrid, 1956), p. 167, fig.
101; James Thrall Soby, *Juan Gris* (N.Y.,
1958), p. 50; Parke-Bernet Galleries,
*Highly Important Impressionist and
Modern Paintings, Drawings and Sculp-
ture* (N.Y., Apr. 3, 1968), no. 19; Ron
Padgett, "Poets and Painters in Paris,
1919–1939," *Art News Annual,* 34
(1968): 88; Douglas Cooper, *The Cubist
Epoch* (N.Y., 1971), pp. 223, 288, pl. 269.

NOTE: Incorporated in the painting is a
poem by Pierre Reverdy, the translation
of which is:

Would she behave herself better under your
 arm or on the table?
The bottle's neck protrudes from a pocket
 and money in your hand, less long than
 the sleeve.
They had inflated the glass tube and
 breathed in the air.
When the one they were expecting came
 into the room, the first bystanders sat
 down to table . . . and the flame that
 shines in their eyes, from whence does it
 come?

From Ron Padgett, "Poets and Painters
in Paris, 1919–1939," *Art News Annual,*
34 (1968): 88. Reprinted by permission
of the publisher.

50

Liubov Popova
Russian, 1889–1924

The Traveler, 1915

Oil on canvas
142 x 105.5 cm (56 x 41½ in)

COLLECTIONS: Private collection, Moscow
(sale, Sotheby's, London, Apr. 26, 1967,
no. 52).

EXHIBITIONS: Stroganov College, Mos-
cow, 1924, "Posthumous Exhibition of
the Artist-Constructivist, L. S. Popova,"
no. 18; Los Angeles County Museum of
Art, Los Angeles, Dec. 1970–Feb. 1971,
"The Cubist Epoch," no. 292.

LITERATURE: Camilla Gray, *The Great
Experiment: Russian Art 1863–1922*
(N.Y., 1962), fig. 143; Sotheby and Co.,
*Impressionists and Modern Paintings
and Sculpture* (London, Apr. 26, 1967),
no. 52; Philip Wilson, ed., *Art at Auc-
tion: The Year at Sotheby's and Parke-
Bernet, 1966–67* (N.Y., 1967), p. 68;
Douglas Cooper, *The Cubist Epoch*
(N.Y., 1971), pp. 162, 309, pl. 167, no.
292.

NOTE: The Russian inscriptions on the
painting are (counterclockwise):

ор	—O R, possibly abbreviation for "dangerous region" or for a "hand pollinator"
журналы	—journals, periodicals, magazines
газ	—gas (natural)
п кл	—forest-clearing machine (plough)
шляп	—"of hats," possibly part of an advertisement

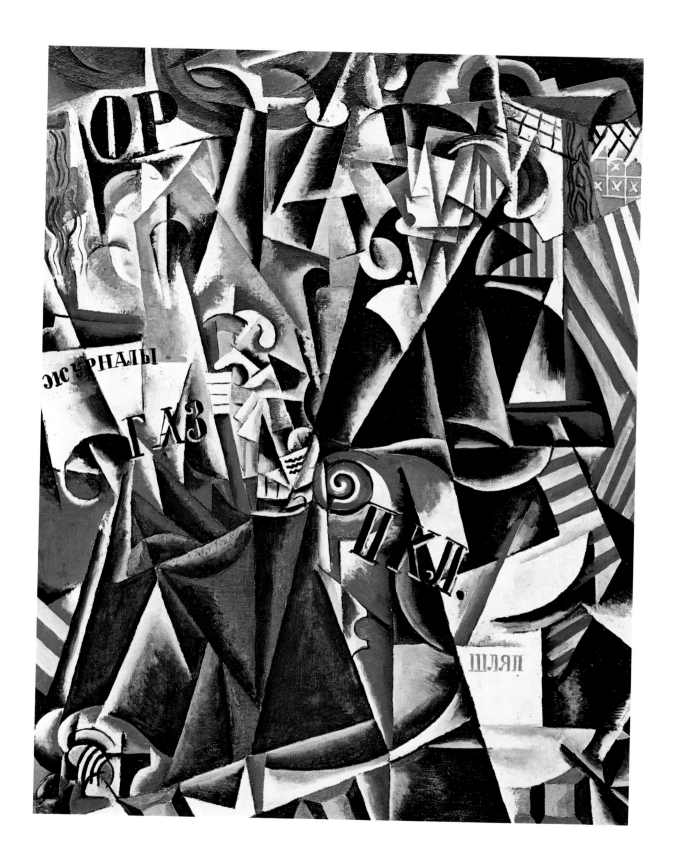

51

Piet Mondrian
Dutch, 1872–1944

*Composition with Red, Yellow,
and Blue,* 1939–42

Oil on canvas
80.5 x 73.5 cm (31½ x 28¾ in)
Signed, lower left: *P.M.;* dated, lower
right: *'39, '42*

COLLECTIONS: Harry Holtzman; Galerie
des Arts Anciens et Modernes.

EXHIBITIONS: Sidney Janis Gallery, N.Y.,
1957, *Mondrian,* no. 29; Marlborough-
Gerson Gallery, N.Y., 1964, *Mondrian,
de Stijl and Their Impact,* no. 24; Uni-
versity of California at Irvine, Irvine,
1967, *A Selection of Nineteenth and
Twentieth Century Works from the
Hunt Foods and Industries Museum of
Art Collection,* p. 20.

LITERATURE: Michel Seuphor, *Piet Mon-
drian: Life and Work* (N.Y., 1956), no.
577, pl. 416; Frank Elgar, *Mondrian*
(N.Y., 1968), p. ~~184.~~ *189*

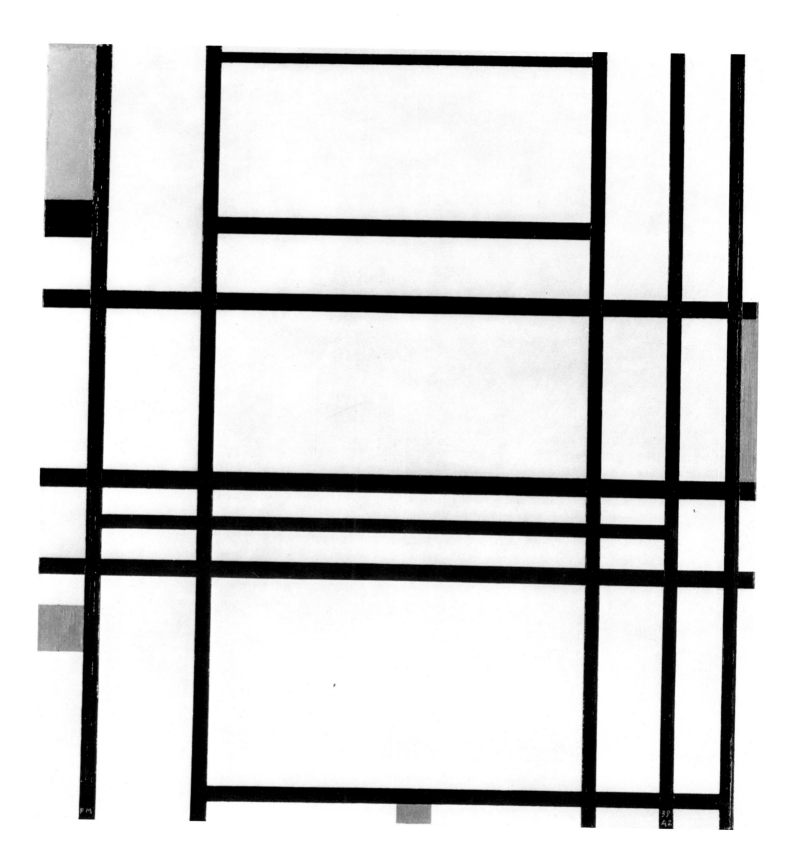

Ben Nicholson
English, b. 1894

*Decor for 7th Symphony Ballet
(4th Movement): White Relief
Version I*, 1939

Oil on carved board
38.5 x 49.5 cm (15¼ x 19½ in)
Signed, dated, and inscribed, on the re-
verse: *Ben Nicholson 1939. This relief
should be hung in a strong side light.
B. N.*

COLLECTIONS: Dr. and Mrs. J. L. Martin;
G. David Thompson; Galerie des Arts
Anciens et Modernes.

EXHIBITIONS: British Pavilion, Venice,
1954, "Biennale XXVII," no. 12; Stedelijk
Museum, Amsterdam, 1954, *Ben Nichol-
son*, no. 17; Marlborough Fine Arts, Lon-
don, 1969, *European Masters*, no. 44.

LITERATURE: Herbert Read, *Ben Nichol-
son—Paintings, Reliefs, Drawings*,
2 vols. (London, 1955), I, no. 62; John
Russell, *Ben Nicholson: Drawings,
Paintings and Reliefs, 1911–1968* (Lon-
don, 1969), no. 38 (as version 2).

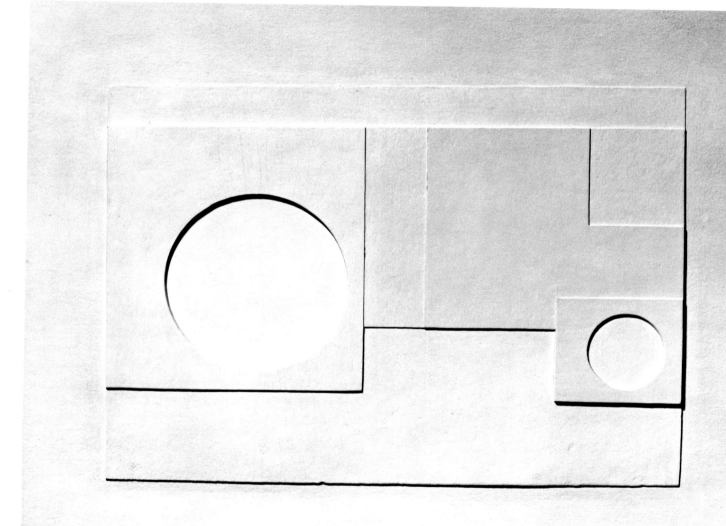

53

Arshile Gorky
Armenian/American, 1904–48

Plumage Landscape, 1947

Oil on canvas
97 x 130 cm (38 x 51 in)
Signed and dated, upper right:
A. Gorky, 47

COLLECTIONS: Sidney Janis Gallery;
G. David Thompson; Galerie Beyeler;
Mrs. Muriel Steinberg; Paul Kantor Gal-
lery; Norton Simon.

EXHIBITIONS: Kunstmuseum, Dusseldorf,
1960, *Sammlung G. David Thompson,
Pittsburgh*, pl. 49; Los Angeles County
Museum of Art, Los Angeles, 1965, "Spe-
cial Exhibition for the College Art Asso-
ciation"; Los Angeles County Museum
of Art, Los Angeles, 1965, *New York
School: The First Generation; Paintings
of the 1940s and 1950s*, no. 26; Univer-
sity of California at Irvine, Irvine, 1967,
*A Selection of Nineteenth and Twen-
tieth Century Works from the Hunt
Foods and Industries Museum of Art
Collection*, p. 13.

LITERATURE: Lawrence Alloway, "The
Biomorphic Forties," *Artforum*, 4 (1965):
20, fig. 2; Julian Levy, *Arshile Gorky*
(N.Y., 1966), pl. 204.

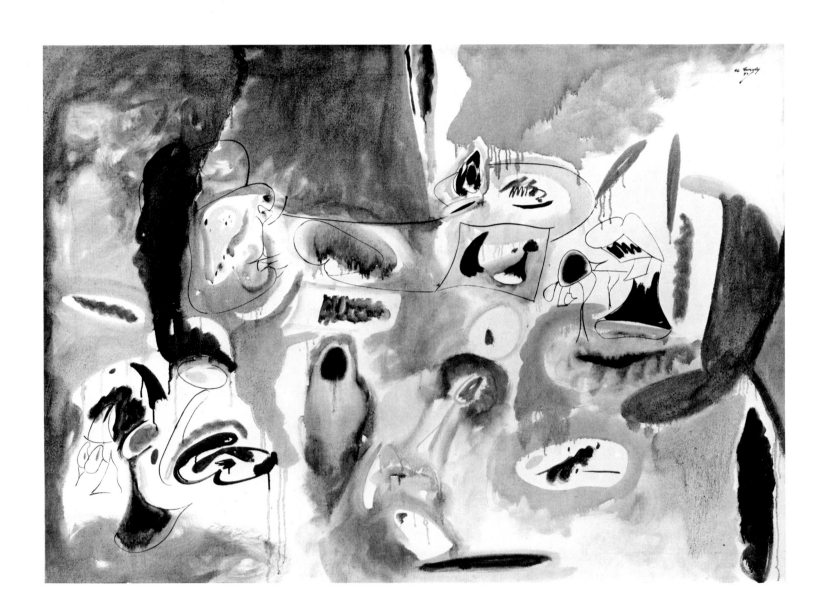

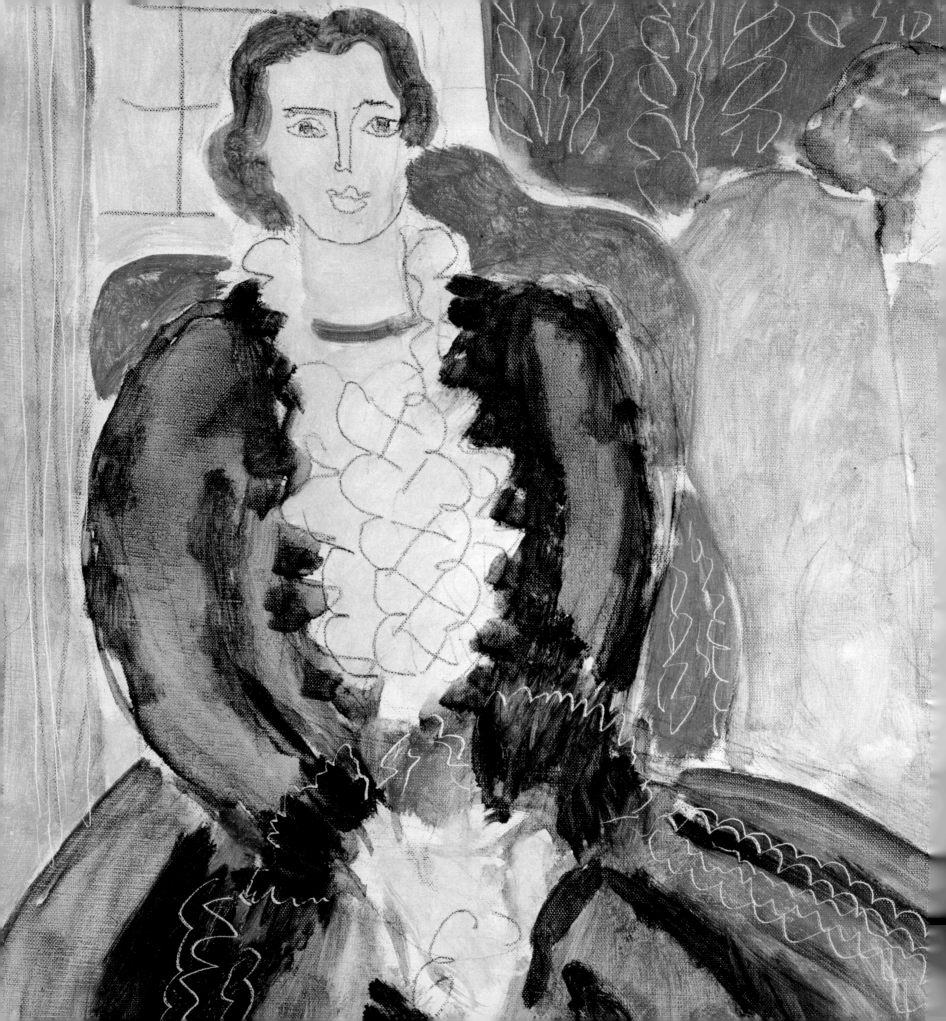

The School of Paris

Robert Judson Clark

THE SCHOOL OF PARIS is a convenient, if imprecise, term referring to the cosmopolitan group of painters who worked in the French capital from the turn of this century until the Second World War, when the focus of avant-garde art transferred to New York. In the last third of the nineteenth century, Paris had become the unchallenged center of culture for the Western world. In addition to literature, contributions in painting had assured this position, which was to be briefly challenged in the 1920s by Berlin. Impressionism had developed in and near the city on the Seine; the crisis of Post-Impressionism had brought renewed vigor, sometimes in quite personal ways at the hands of the Symbolists. In the new century, Fauvism, Cubism, and Surrealism were to be major French contributions—made with the help of a growing number of foreign painters whose ideas thrived on French soil.

There was mileage left, however, in the approach to painting established by the Impressionists. Maurice Utrillo (1883–1955), the son of Suzanne Valadon, was encouraged to paint by his artist-mother as a means of distracting him from the alcoholism that had plagued him since childhood. The *Basilica of Saint Denis* (cat. 54) continued a tradition of painting Gothic churches in the sunlight—seen in the works of Corot, Sisley, van Gogh, and of course, Monet. Here, Utrillo rendered the stonework of this symbol of French culture in blues and yellows, as suggested by the Impressionists. But it is an arbitrary patchwork of pigments, creating a solid abstract pattern, rather than an attempt at effects of sunlight on tracery, which had been studied by Monet on the more ornate facade of the cathedral at Rouen. Utrillo's view is more typically French: cool, studied, almost classical in its formulation.

Utrillo was a prolific painter; but his range of subject matter was surprisingly limited. He chose to paint the streets and buildings of Paris and its suburbs as though he were a topographer. Montmartre was his favorite realm —not the busier boulevards of downtown Paris. *Place du Tertre at Montmartre* (cat. 55) is typical of such views. It is well constructed with convincing perspectives; yet the chalky colors and vacuous sky, as well as the slightly inhabited streets, make it lonely and artificial, a stage setting without protagonists. Utrillo later lost much of his artistic vigor. The two canvases in this exhibition, however, represent the painter at his best.

Foreigners often reacted quite differently to the Parisian scene. Marc Chagall (b. 1889), a native of the Russian provincial town of Vitebsk, came to Paris in the late summer of 1910. French urban life enchanted him; Paris was a place for romance and fantasy. But there recurred in his paintings themes from his homeland, of religious traditions and recollections of family. *The Violinist* (cat. 56) (the date is surely to be read "1911, fourth month," not 1911–14) reveals his Russian love of bright color, which was encouraged in this city of Fauvism and Orphism. With roots in his own Jewish heritage, the subject is viewed with the naïveté of Rousseau. There is also some influence from Cubism, which can be seen in the planes of the fiddler's coat and the window above his shoulder, as well as in the contrast between the literal depiction of the folksy details of the cabin and the extended planes at the

upper right. The total effect of these unresolved elements is the magic of this painter: personal images in a world of color and metaphor, anticipating Surrealism of the 1920s.

The remaining three artists in this section, Vlaminck, Rouault, and Matisse, were, like Utrillo, native Frenchmen. Coincidentally, they participated in the Salon d' Automne in the fall of 1905. This was the exhibition that gave the name Fauvism to that crucial but short-lived movement, because the bright colors and energetic brushwork seen there suggested to the critic Louis Vauxcelles the savagery of wild beasts. Maurice de Vlaminck (1876–1958), one of the foremost Fauves, was a convert to painting after seeing the van Gogh exhibition in 1901. Vlaminck had bright red hair and wore technicolor clothes. The sound of slapping his painted wooden necktie on cafe tabletops was equal to the shock that awaited the public when it confronted his paintings. *Still Life with Lemons* (cat. 57) is surely indebted to compositions of Cézanne, who had died the previous year; but the verve with which it is painted comes from van Gogh. Colors were often used straight from the tube and juxtaposed in strident collisions of reds, pinks, yellows, and blues. Here are both tradition and revolution: the still life becomes a vehicle for intense personal expression and benign violence in the studio. Vlaminck soon abandoned this agitated style; he was never as great again.

Such early canvases by the Fauvists were an inspiration for some German Expressionists. Equally expressive, but on a different level, was the work of Georges Rouault (1871–1958), who, although a participant in the first Fauve exhibition, remained an individual without classification. Intensely religious and moralistic, his early commentaries were full of outrage and disgust. *The Sirens* (cat. 58) is one of an extensive series on life in the brothels of Paris, seen not with the detachment of Toulouse-Lautrec, but with complete revulsion. In darkened, musty interiors Rouault portrayed his pathetic figures as soggy mounds of bruised flesh, exposed to everything but sunlight.

Rouault gradually turned to more overtly religious messages, using brilliant colors in mosaics of impasto as though they were panels of stained glass, the medium in which he had worked as a young apprentice. Whether painting scenes from the life of Christ, or studies of circus figures and peasants in costume, his works were endowed with a hieratic and mystical quality. *Chinese Man* (cat. 59) is a secular icon of an oriental in traditional costume.

How different was the later work of the leading Fauvist, the greatest French painter of his century, Henri Matisse (1869–1954). Like Renoir, he loved the female figure, and after a sequence of many moods and styles, returned to it during the 1920s in a series of "odalisques," well represented in this collection. *Woman in an Armchair (Antoinette)* (cat. 60) was done in pallid tones, like watercolor. It emphasized sculptural form without being "neoclassical," as Picasso's figures would be during the next few years. In *Odalisque with Tambourine* (cat. 61), an unusually fine work painted at Nice in 1926, the effects of Matisse's sojourns on the Mediterranean are more obvious, as are his ties to the exoticism of Ingres and especially Delacroix. The languid

dancer in a diaphonous blouse is seen against a Moorish screen, which provides a lively pattern of red and blue. Such decorative richness was later simplified in a series of seated figures in bouyant, almost Elizabethan gowns. *Small Blue Dress before a Mirror* (cat. 62) is a masterful arrangement of the subject in her interior setting, painted with what appears to be unsurpassed ease, with occasional details scratched in with the tip of the brush handle or a pencil. This delightful combination of drawing and painting emphasizes the complete Frenchness of Matisse: intelligence without being too distant, exuberance without overstatement or frivolity, all tempered by the consistent denominator of consummate taste.

54

Maurice Utrillo
French, 1883–1955

Basilica of Saint Denis, 1909–10

Oil on canvas
68.4 x 48 cm (27 x 19 in)
Signed, lower left: *Maurice Utrillo V.*

COLLECTIONS: H. Bing; private collection, Switzerland; Drs. Fritz and Peter Nathan.

EXHIBITIONS: Kunsthalle, Basel, 1942, *Utrillo,* no. 246; Kunsthalle, Bern, 1949, *Utrillo,* no. 30; Portland Art Museum, Portland, Nov. 1968–Mar. 1969, "Recent Acquisitions by the Norton Simon, Inc. Museum of Art," no. 21.

LITERATURE: Adolphe Tabarant, *Utrillo* (Paris, 1926), p. 37; Gabriel Joseph Gros, *Maurice Utrillo: sa légende* (Lausanne, 1947), p. 15; Paul Pétridès, *L'Oeuvre complet de Maurice Utrillo,* 2 vols. (Paris, 1959), 1, no. 81.

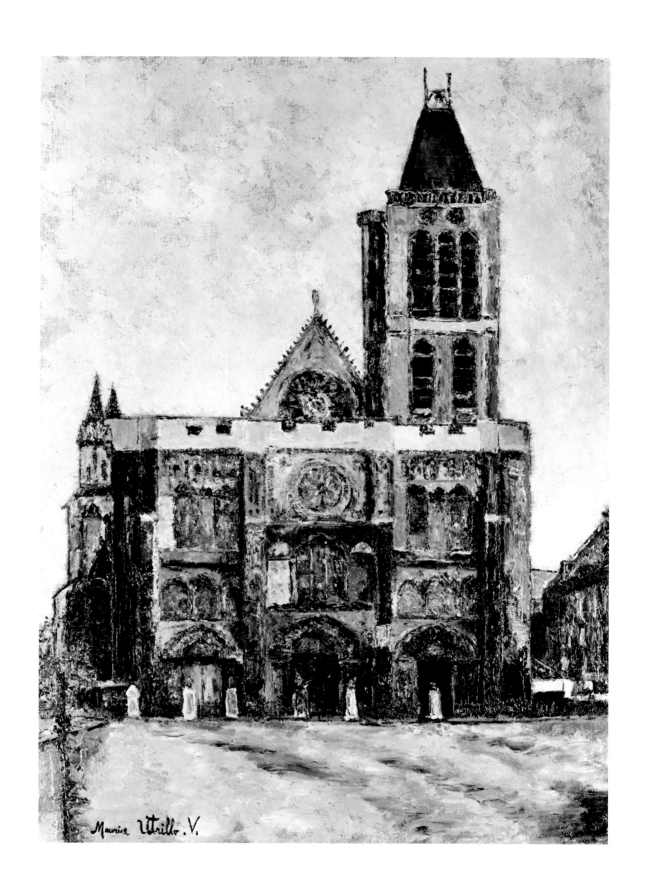

55

Maurice Utrillo
French, 1883–1955

Place du Tertre at Montmartre,
ca. 1911

Oil on canvas
53 x 72.5 cm (21 x 28½ in)
Signed, lower right: *Maurice Utrillo V*

COLLECTIONS: Sam Salz; private collection (sale, Christie's, London, June 28, 1968, no. 24).

EXHIBITIONS: Galerie Barbazanges, Paris, 1922, "Utrillo"; Galerie Charpentier, Paris, 1959, *Cent Tableaux par Utrillo,* no. 39; Portland Art Museum, Portland, Nov. 1968–Mar. 1969, "Recent Acquisitions by the Norton Simon, Inc. Museum of Art," no. 22.

LITERATURE: Paul Pétridès, *L'Oeuvre complet de Maurice Utrillo,* 2 vols. (Paris, 1959), I, no. 217; Christie, Manson and Woods, *Important Impressionist and Modern Drawings, Paintings and Sculpture* (London, June 28, 1968), no. 24.

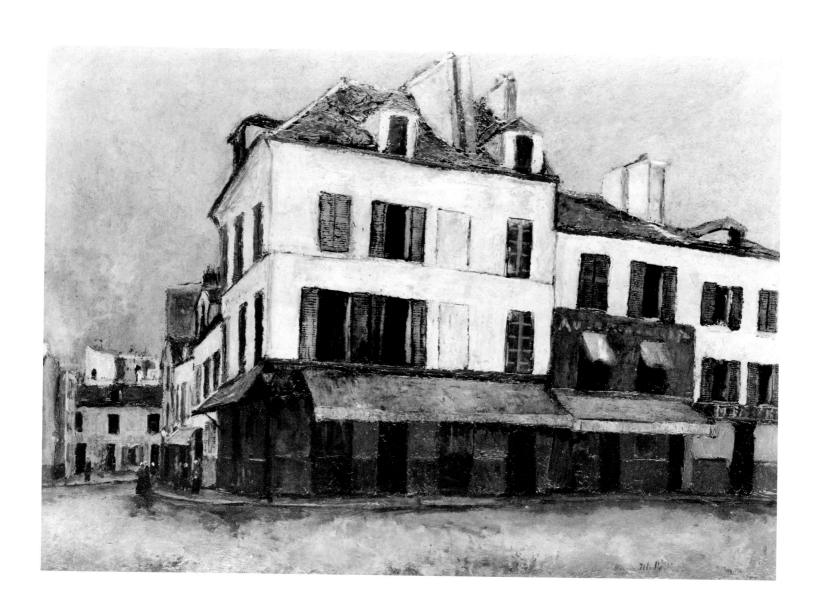

Marc Chagall
Russian, b. 1889

The Violinist, 1911

Oil on canvas
92.5 x 67.5 cm (37 x 27½ in)
Signed and dated, lower left: *Chagall
1911 4*

COLLECTIONS: Bernheim-Jeune; R. Sturgis
Ingersoll; Jane Wade, Ltd.

EXHIBITIONS: Philadelphia Museum of
Art, Philadelphia, Nov. 1931–Jan. 1932,
"Living Artists"; Philadelphia Museum
of Art, Philadelphia, 1947, "Masterpieces
of Philadelphia Private Collections";
Kunstverein, Hamburg, 1959, *Marc
Chagall,* no. 43; Musée des Arts Déco-
ratifs, Paris, 1959, *Marc Chagall,* no. 54;
La Jolla Museum of Art, La Jolla, 1962,
*Marc Chagall—75th Anniversary Exhi-
bition,* no. 4.

LITERATURE: Franz Meyer, *Marc Chagall*
(Cologne, 1961), no. 118.

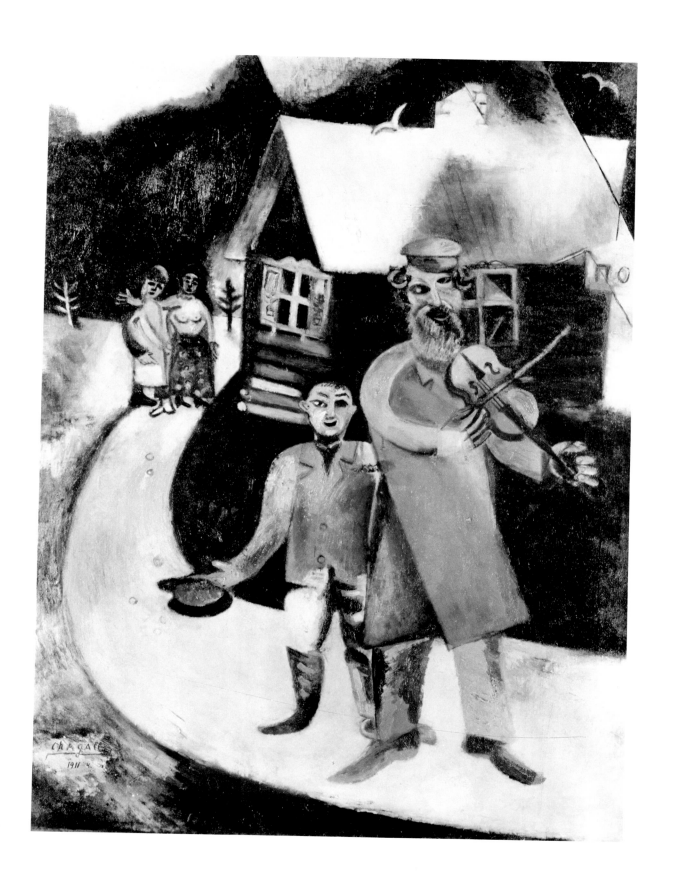

57

Maurice de Vlaminck
French, 1876–1958

Still Life with Lemons, 1907

Oil on board
50.5 x 65 cm (19¾ x 25½ in)
Signed, lower left: *Vlaminck*

COLLECTIONS: Sidney Janis; Leigh Block;
Galerie des Arts Anciens et Modernes.

EXHIBITIONS: Museum of Modern Art,
N. Y., 1952, *Les Fauves,* no. 151; Mu-
seum for Contemporary Art, Dallas,
1959; University of California at Irvine,
Irvine, 1967, *A Selection of Nineteenth
and Twentieth Century Works from the
Hunt Foods and Industries Museum of
Art Collection,* p. 27; Klaus Perls Gal-
leries, N. Y., 1968, *Vlaminck: His Fauve
Period,* no. 16.

58

Georges Rouault
French, 1871–1958

The Sirens, 1906–08

Gouache on paper
69 x 55 cm (27 x 21½ in)
Monogrammed and dated, top left:
1906 G.R.; dated, top right: *1908*

COLLECTIONS: John Quinn; R. Sturgis
Ingersoll; Jane Wade, Ltd.

LITERATURE: Forbes Watson, *The John
Quinn Collection of Paintings, Water-
colors, Drawings and Sculpture* (Hunt-
ington, N.Y., 1926), p. 14.

59

Georges Rouault
French, 1871–1958

Chinese Man, 1937

Oil on paper mounted on canvas
104 x 72 cm (41 x 28½ in)

COLLECTIONS: Ambroise Vollard; Ambassador Hugo Gouthier; Perls Galleries; Allan Bluestein (sale, Parke-Bernet, N.Y., Apr. 3, 1968, no. 52).

EXHIBITIONS: Museum of Modern Art, N.Y., on loan June 1968–Mar. 1969.

LITERATURE: Pierre Courthion, *Georges Rouault* (N.Y., 1961), no. 356; Parke-Bernet Galleries, *Highly Important Impressionist and Modern Paintings, Drawings and Sculpture* (N.Y., Apr. 3, 1968), no. 26.

NOTE: This subject appears as plate 38 of the artist's series of etchings entitled *Misère et Guerre*, published by Vollard in 1948. The title of the plate, which was executed in 1926, is *Chinois inventa dit-on, la poudre à canon, nous en fit don.*

60

Henri Matisse
French, 1869–1954

*Woman in an Armchair
(Antoinette),* ca. 1919

Oil on canvas
52.5 x 36 cm (20¾ x 14¼ in)
Signed, lower left: *Henri Matisse*

COLLECTIONS: Private collection (sale,
Sotheby's, London, Mar. 30, 1966, no.
66); Llewellyn Jones; Stephen Hahn
Gallery.

EXHIBITIONS: Musée des Beaux-Arts, Lu-
cerne, 1949, *Henri Matisse,* no. 72;
Stephen Hahn Gallery, N.Y., 1967, *Le
Nu,* no. 7; Minneapolis Institute of Arts,
Minneapolis, on loan 1968.

LITERATURE: Sotheby and Co., *Impres-
sionist and Modern Paintings, Drawings
and Sculpture* (London, Mar. 30, 1966),
no. 66.

61

Henri Matisse
French, 1869–1954

Odalisque with Tambourine, 1926

Oil on canvas
92 x 65.2 cm (36 x 25½ in)
Signed, lower right: *Henri Matisse;* inscribed on back: *Danseuse au tambourin (Harmonie bleue)*

COLLECTIONS: Mme Georges Duthuit;
Pierre Loeb; Joseph Hessel; Paul Rosenberg; Marguerite Rosenberg.

EXHIBITIONS: Carnegie Institute, Pittsburgh, 1933, *Thirty-first Annual International Exhibition of Paintings,* no. 215, pl. 18; Musée d'Art Moderne, Paris, 1937, "Les Maîtres de l'art indépendant," no. 22; University of California at Los Angeles, Los Angeles, 1966, *Henri Matisse,* no. 60; University of California at Irvine, Irvine, 1967, *A Selection of Nineteenth and Twentieth Century Works from the Hunt Foods and Industries Museum of Art Collection,* p. 16.

LITERATURE: Roger Fry, *Henri Matisse* (N.Y., 1930), p. 10; idem, *Henri Matisse* (London, 1935), pl. 47; George-Michel Michel, *Chefs-d'œuvre de peintres contemporains* (N.Y., 1945), unpaginated.

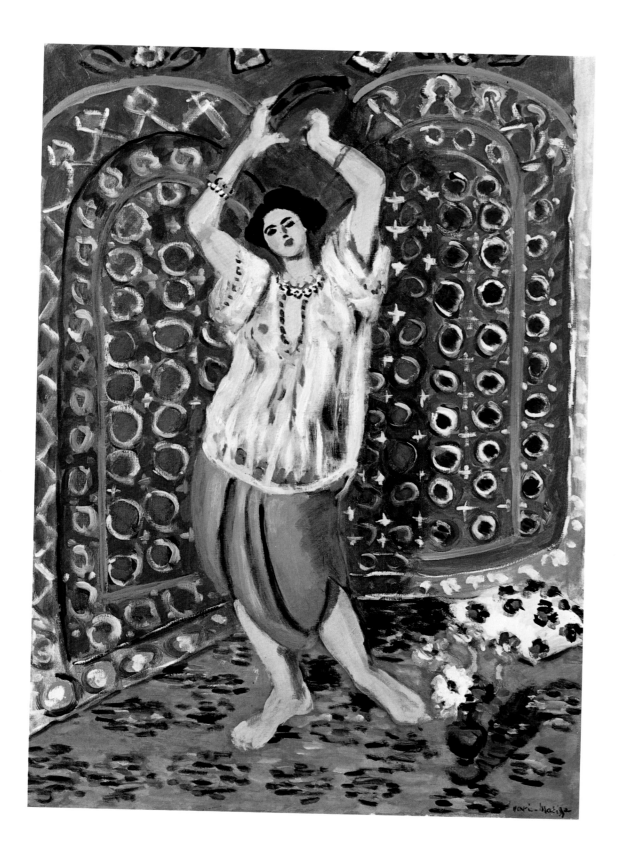

62

Henri Matisse
French, 1869–1954

*Small Blue Dress before
a Mirror*, 1937

Oil on canvas
63 x 48 cm (25½ x 19½ in)
Signed and dated, lower left: *Henri
Matisse 37*

COLLECTIONS: Paul Rosenberg; Marshall
Hermann Goering; Galerie de l'Elysée;
Delt Scheff; Jacques Dubourg (sale,
Palais Gallièra, Paris, Dec. 3, 1967, no.
55); Paul Rosenberg and Co.

EXHIBITIONS: Paul Rosenberg and Co.,
Paris, 1938, *Henri Matisse*, no. 18; Port-
land Art Museum, Portland, Nov. 1968–
Mar. 1969, "Recent Acquisitions by the
Norton Simon, Inc. Museum of Art,"
no. 18.

LITERATURE: Palais Gallièra, *Tableaux
Modernes—Sculptures* (Paris, Dec. 3,
1968), no. 55.

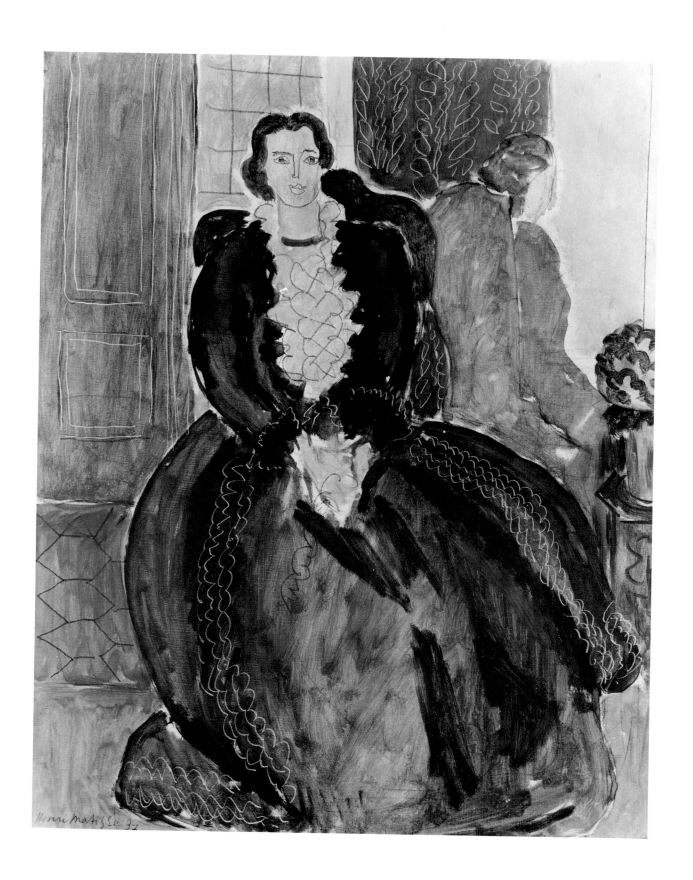

IN THE FIRST decade after 1900 a number of disparate movements challenged the conservative structure of the German art establishment. The scope of these efforts ranged from such individual artists as Emil Nolde and Ernst Barlach, who developed in virtual isolation, to more or less organized movements: *Die Brücke* in Dresden, *Der Blaue Reiter* in Munich, and the Worpswede painters. The small group of paintings and watercolors by Nolde and Franz Marc in this exhibition summarizes well the new goals toward which the most progressive northern artists moved, and suggests the singular qualities that created in Germany a new art rather unlike that developing simultaneously in Paris.

Nolde (born Emil Hansen; he later adopted as his surname the name of the town where he was born in 1867) developed slowly as an artist; he was almost forty years old before he began producing works of real maturity. His work is often grouped with that of *Die Brücke*, although he was not a founding member and only worked directly with that group for a short time. Much older than any of the original members of this closely knit group of young architectural students and essentially opposed to a communal mentality, he was nevertheless attracted to them by similar ideals. The basis for their art lay in a re-evaluation of what a work of art ought to convey—namely, the underlying tensions and psychological possibilities of man's relationship with other men, nature, and the social order.

The principal means by which these artists hoped to effect changes were not unique in the overall atmosphere of change throughout Europe; the Nabis, the Fauves, and such isolated artists as van Gogh and Gaugin had long since begun an assault on conventional limits of coloristic and formal technique. Outrageously unnatural color and severe distortion of form suggested to Nolde and the *Brücke* artists emotional states of mind and a reality more profound than surface appearance.

Even before Nolde learned of this group, he had begun experimenting with sometimes grotesque distortion of form and a use of color that was bold and often independent of optical appearance. Nolde claimed he was little influenced by the *Brücke* artists, but it is interesting that the more fantastic aspect of his imagery never reappeared after his sojourn with them. Rather, in his graphic work, oils, and watercolors the sense of forces somewhat beyond rational conception creeps into his depictions of nature or transforms representations of traditional religious subjects into a new Christian iconography. His major subjects were flower pieces of the most ravishing sensuousness, the brooding north German landscape, and portraits of incredible economy and feeling, all produced with a peculiarly north German mysticism.

Although a technician of the highest quality in oil paint and a printmaker of great power, he developed into one of the great watercolorists of all times. About 1919 he began to notice what watercolor would do by itself on the paper as it swirled, blotted, and dried; to Nolde the mystic this suggested a property of the medium quite in keeping with his ideas about the forces that lay behind all nature. The flowers he painted are usually identifiable, as are the red poppies in the work on exhibition (cat. 63), but his superb

German Expressionism

John David Farmer

understanding of the evocative quality of watercolor—brilliant, transparent, and yet blurred as if at one remove from normal vision—is one of Nolde's great contributions to modern art.

Not surprisingly, Nolde's extraordinary depictions of religious subjects, his coloristic and formal liberties, and perhaps his former artistic associations led to his disgrace in the eyes of the Nazi government in the 1930s. Like most of the "degenerate artists" (as the Nazis branded them), he was forbidden to sell, then exhibit, and finally paint at all. From this point watercolor became Nolde's sole medium, the results being the astonishing *ungemalte Bilder* (unpainted pictures), a great body of watercolors Nolde painted in absolute secrecy during his years of exile. Two of the works shown here, *The Lonesome Couple* (cat. 64) and *Portrait of a Gentleman* (cat. 65), are from this group and show his continuing mastery of the medium under conditions of extreme adversity. Apparently, they were intended to serve as notations for future works since he began to translate some of them into oil after the war, but their self-sufficiency as works of art is evident.

Der Blaue Reiter took its name from an *Almanach* published concurrently with the group's first exhibition in 1911. Among the members were Wassily Kandinsky and August Macke, both recent acquaintances of Franz Marc and the closest to him in artistic sensibility, Alexei Jawlensky, Paul Klee, and Gabriele Münter. Marc and Macke, unlike the *Brücke* painters, were aware of and strongly influenced by contemporary developments in Paris, especially Fauvism, Cubism, and Robert Delaunay's Orphism. Both painters began experimenting with a breaking-up of space based primarily on rhythms of movement. For Marc, who had always been interested in animals, the rhythms of natural forces developed into increasingly abstract patterns; shortly before his tragic, early death in 1916 he was producing completely nonrepresentational studies.

Like Kandinsky, he was a theorist, and a logic of form and color underlies his mature work. But unlike the Russian artist, whose sources were partially Eastern and exotic, Marc can be considered a natural successor to the ideas of nineteenth-century German romanticism. He shared with many of the artists, writers, and theorists of that century a sense of mysticism, particularly regarding color. Moreover, there is sometimes a classical strain to his art that links him with the great "Roman" Germans of the mid-nineteenth century. In the *Bathing Girls* (cat. 68), for instance, the debt to Cézanne is obvious; less apparent, but no less crucial to an understanding of the work, is the reminiscence of Hans von Marées's austere and monumental figure pieces of the late nineteenth century. The geometry of the forms, the Arcadian subject, and the repetition of shapes—nudes, trees, rocks—transpose the scene from the transitory to the timeless, just as von Marées had done in his major canvases and frescoes. Added to this, however, already in 1910, is the suggestion of human form moving in rhythm with nature, prefiguring the dynamism of Marc's late, virtually abstract compositions.

63
Emil Nolde
German, 1867–1956

Red Poppy, ca. 1925–30

Watercolor on paper
34.5 x 47 cm (13½ x 18¾ in)
Signed, lower right: *Nolde*

COLLECTIONS: The Seebüll Foundation of
Ada and Emil Nolde.

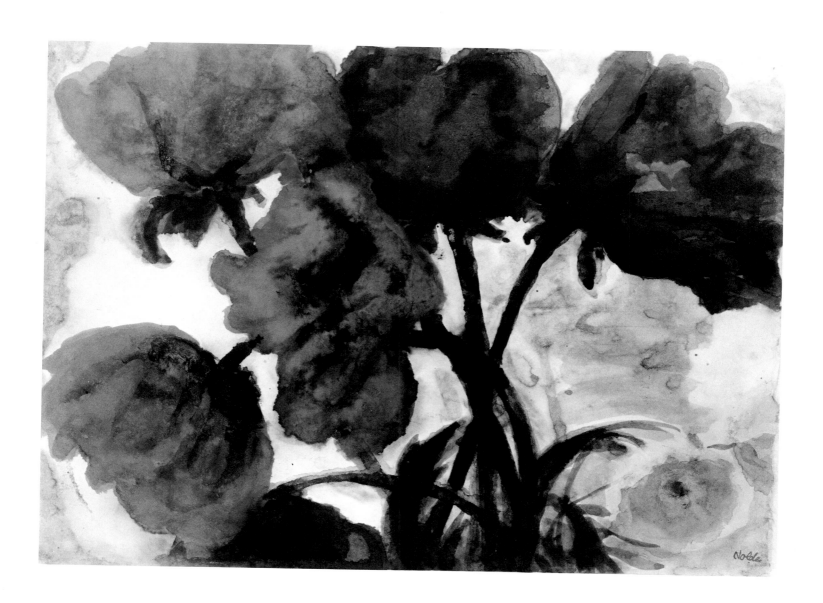

64

Emil Nolde
German, 1867–1956

Lonesome Couple, n.d.

Watercolor on paper
26 x 23 cm (10¼ x 9⅛ in)
Signed, lower right: *Nolde*

COLLECTIONS: The Seebüll Foundation of
Ada and Emil Nolde; M. Knoedler
and Co.

EXHIBITIONS: M. Knoedler and Co., N.Y.,
1967, *Unpainted Pictures: Emil Nolde,*
no. 7.

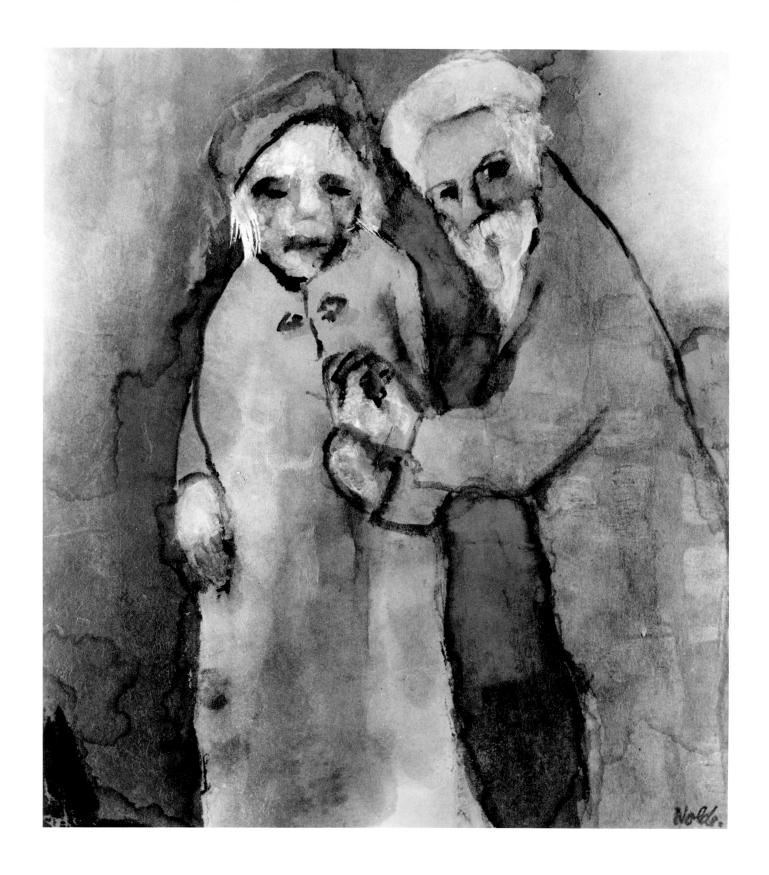

65

Emil Nolde
German, 1867–1956

Portrait of a Gentleman, n.d.

Watercolor on paper
20 x 15.5 cm (7⅞ x 6 in)
Signed, lower left: *Nolde*

COLLECTIONS: The Seebüll Foundation of
Ada and Emil Nolde; M. Knoedler
and Co.

EXHIBITIONS: M. Knoedler and Co., N.Y.,
1967, *Unpainted Pictures: Emil Nolde,*
no. 53.

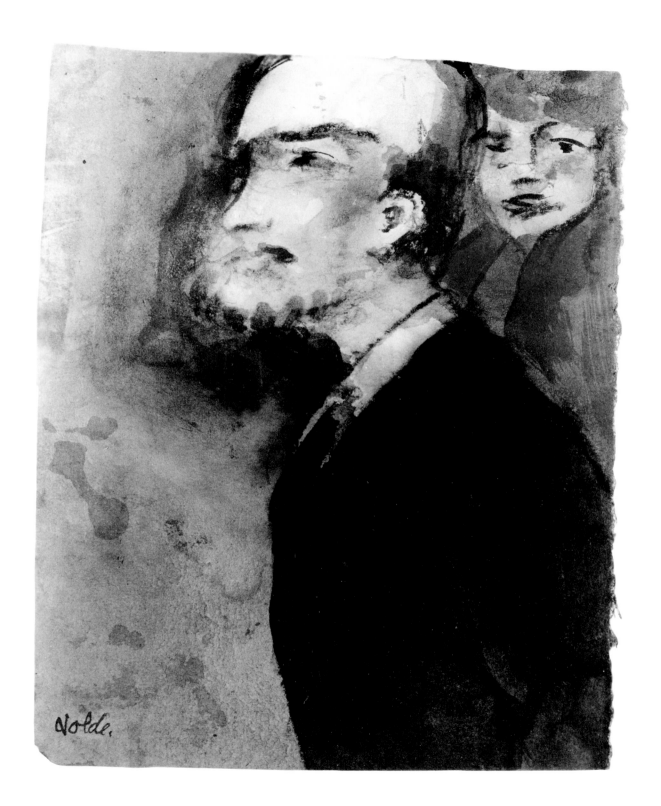

Nolde.

66

Emil Nolde
German, 1867–1956

Woman's Portrait (Red-Brown and Blue Hair), ca. 1920–25

Watercolor on paper
48 x 34.8 cm (18¾ x 13¾ in)
Signed, lower right: *Nolde*

COLLECTIONS: The Seebüll Foundation of Ada and Emil Nolde.

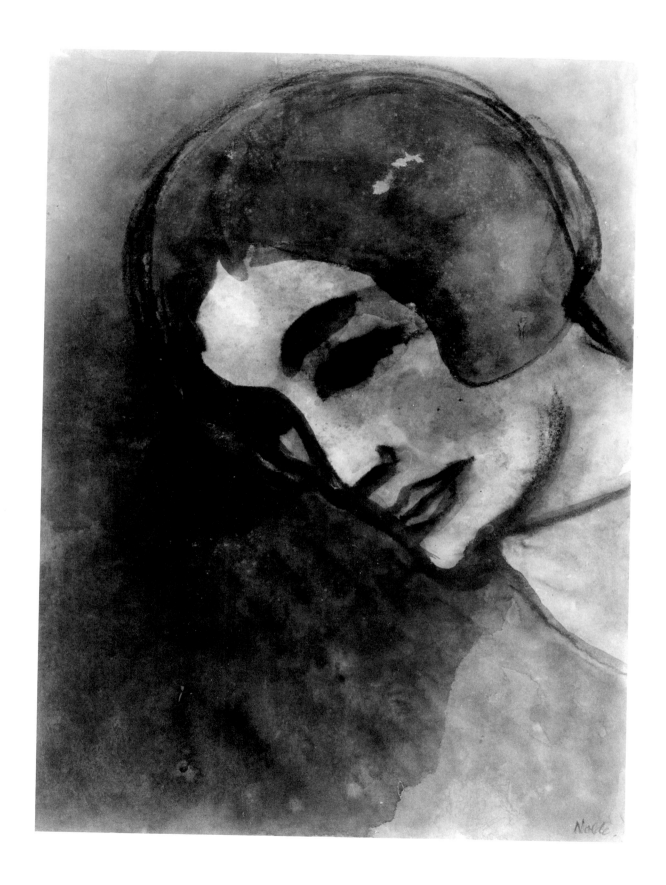

67

Emil Nolde
German, 1867–1956

Two Farmhouses under Red Skies,
ca. 1935

Watercolor on paper
22.8 x 26.5 cm (8⅞ x 10¾ in)
Signed, lower right: *Nolde*

COLLECTIONS: The Seebüll Foundation of
Ada and Emil Nolde.

68

Franz Marc
German, 1880–1916

Bathing Girls, ca. 1910

Oil on canvas
139 x 196 cm (54½ x 77½ in)

COLLECTIONS: Warner Duecher; Städtische Kunstsammlungen (sale, Fischer Galerie, Lucerne, June 30, 1939, no. 91); E. Buhrle; Marlborough-Gerson Gallery.

EXHIBITIONS: Haus der Kunst, Munich, 1949, *Der Blaue Reiter, München und die Kunst des 20. Jarhunderts, der Weg von 1908–1914*, no. 218; Marlborough-Gerson Gallery, N.Y., 1968, *International Expressionism, Part I*, no. 33; Museum of Modern Art, N.Y., on loan June 1968–Mar. 1969.

LITERATURE: Alois J. Schardt, *Franz Marc* (Berlin, 1936), p. 163; Fischer Galerie, *Gemälde und Plastiken Meister aus Deutschen Museen* (Lucerne, June 30, 1939), no. 91; Klaus Lankheit, *Franz Marc: Katalog der Werke* (Cologne, 1970), no. 121.

SCULPTURE has emerged in the twentieth century as a major art form for the first time since the seventeenth century. If one were to ask who were the first-rank sculptors of the eighteenth century and of the nineteenth before Rodin, perhaps it would be difficult to think of names other than those of Jean-Antoine Houdon and, less renowned, Canova and Carpeaux. When we consider the dominant place that sculpture has held in the history of art from ancient Egypt until the seventeenth century of our era, this decline is all the more remarkable. The decline was not for want of patronage. Although the eighteenth century provided fewer monumental public commissions than the Renaissance or Baroque, the nineteenth century saw mountains of sculptural monuments crowding the parks and public squares and adorning the architecture of the period. By this time, however, academic classicism had achieved such a rigid grip on the sculptural tradition that it was literally impossible for a sculptor to get a commission or even to survive unless he conformed. Even Jean-Baptiste Carpeaux (cat. 69), the finest portrait sculptor between Houdon and Rodin, was occasionally unsuccessful in his monumental sculptures.

This was the situation until the third quarter of the nineteenth century, when Rodin emerged on the scene. It is the achievement of Rodin almost single-handed to have recharted the course of sculpture and to have given the art an impetus that was to lead to a major renaissance over the next hundred years. He began a revolution, as had Courbet in painting, with a reaction against the sentimental idealism of the academicians, through the closest return to nature; and then, through a re-examination of the masters of medieval and Renaissance sculpture, he attacked all the traditional elements and problems of sculpture with an energy, imagination, and invention unparalleled by any other sculptor of his time.

The basic medium of expression of sculpture from the beginning of time until the twentieth century has been the human figure. It is in terms of the figure, presented in isolation, in combination, in action or in repose, that the sculptor has explored the elements of sculpture—space, mass, volume, line, texture, light, and movement. Of these elements, volume and space and their interaction have been traditionally the primary concern of the sculptor. Rodin (cat. 70) not only built on ancient, medieval, and Renaissance concepts of spatial existence and movement, but in his late works extended these beyond the limits of any predecessor, with the exception, perhaps, of Bernini.

Aristide Maillol (cat. 71–78), also one of the major figures of early modern sculpture, began his career as a painter. At the opposite extreme from the violent variety of Rodin, he concentrated his whole attention on a restatement of the classic ideals of sculpture, stripped of all the academic accretions of sentimental or erotic synthetic idealism, and brought down to earth in the homely actuality of his models. Concentrating almost exclusively on the subject of the single female figure, standing, sitting, or reclining, and almost always in repose, he stated over and over again the fundamental thesis of sculpture as integrated volume, as mass surrounded by tangible space. At the same time, the nudes of Maillol always contained the breath of life, a healthy

19th- and 20th-Century Sculpture

H. H. Arnason

sensuousness that reflects the living model rather than any abstract classical ideal.

One of the most indicative symptoms of the revival of sculpture at the end of the nineteenth century is the number of important painters who practiced sculpture. Gauguin, Degas, Renoir, Bonnard were among them, followed in this century by Picasso, Matisse, Modigliani, and many others. Degas (cat. 79, 80) is unquestionably the greatest of the late nineteenth-century sculptor-painters. His sculptures were conceived in sculptural terms, concerned with the fundamental plastic problems of the medium. The posthumous bronzes retain the sense of the original wax material, built up, layer by layer, to a surface in which every fragment of wax is clearly articulated.

Whereas the first major revolution of twentieth-century sculpture, like that of the late nineteenth century, continued, like the first modern painting, to be centered in France, and specifically in Paris, certain notable sculptors did emerge in Germany in the early years of the century. Wilhelm Lehmbruck, a German who worked in Paris between 1910 and 1914, in pieces like his *Standing Woman* (cat. 81) reveals the influence of Maillol. However, the withdrawn quality of the face reflects a personal expression that becomes more explicit in the slightly later works in which he employed a form of Romanesque elongation to suggest qualities of inwardness and melancholy. The German Expressionist sculptors represented a wide variety of points of view, although in general they did not depart very far from nature in the direction of expressive distortion or of abstraction. Ernst Barlach (cat. 82) looked back for his sources to German medieval art as well as to the folk art of Germany and Russia. His are sculptures of simple yet strongly felt emotion, stated with the broadness of caricature in terms of tentatively abstracted sculptural masses.

One of the first great figures of the modern revolution in sculpture during the early years of the twentieth century was Brancusi. Although he created no school, he strongly affected the course of subsequent sculpture. His sculpture traces a continuing search for the essence of forms, in a reaction against the complexity of Rodin. It moved constantly towards an intensive examination of a few, fundamental shapes in terms of which he sought to define the nature of sculpture itself. He was never really an abstractionist because there was always in his works a subject idea reduced to a single fundamental. Thus, birds became the idea of flight; a cock, the cock's comb or even the cock's crow; the head, a pure ovoid form (cat. 83). The simplification of forms involved not only the essential statement of a subject but the essential statement of the nature of materials and of sculpture as objects existing in and surrounded by space.

Following the revolutions in painting created by the Post-Impressionists and Fauves, the Cubists, beginning in 1907 with Picasso and Braque, sought to destroy finally the Renaissance concept of a painting as an imitation of the natural world and to assert its own identity, its own pictorial space, arising out of its own physical nature as a flat canvas surface to which pigment is applied. In sculpture, at a slightly later moment, the problem was a com-

parable search for the fundamentals of sculptural form through stripping off all the illusionistic accretions of the Renaissance tradition. Whereas Brancusi went his own way, Cubism, with its strict geometry of spatial analysis, seemed immediately applicable to the problems of sculpture and was quickly adapted. Picasso's first portrait sculptures maintained much of the romantic nostalgia of his Blue Period paintings (cat. 84, 85) or occasionally reflected his discovery of Iberian or African primitive sculpture. With his *Head of a Woman* (cat. 86) he attempted a literal translation into sculpture of a Cubist painting. Historically, this is an important work as the first Cubist sculpture although it does not solve all the problems involved in the translation of media. Further experiments were carried on by Archipenko, Duchamp-Villon, Henri Laurens, and, above all, by Jacques Lipchitz—who remains perhaps the master of Cubist sculpture in his ability fully to integrate three-dimensional shapes while maintaining a sense of specific human content (cat. 92). It was this desire to make a statement relevant to the problems of humanity that led Lipchitz, after 1920, away from specific Cubism to his monumental themes, taken from primitive art, from classical antiquity, and the Old and New Testaments (cat. 93).

Picasso and Matisse, continuing the great tradition of the painter-sculptors, turned periodically throughout their careers to sculptural problems either closely related to or in some way supplementing the different phases of their developments in painting. During the late 1920s and the 1930s many elements of Surrealist fantasy permeated the sculpture of Picasso, as it did his painting, although in the sculptural sketches his fantasy frequently took the forms of delightful caricatures (cat. 87–91). Matisse's sculptures characteristically repeated the figures in his paintings to the point where they at times seemed to be deliberate translations of one medium into the other. Nevertheless, his sculptures always maintained a very strongly traditional sense of spatial organization with the spiraling figure defining surrounding space in the tradition of Giovanni da Bologna and the late Renaissance. In certain contrasting figures the artist explored a form of primitive frontality. This direction was most monumentally defined in the *Backs* (cat. 94–97), four great bas-reliefs dating between 1909 and 1929. In the *Backs* Matisse in effect summarized his sculptural progression from relative naturalism to architectural abstraction.

The Norton Simon, Inc. Museum of Art collection of modern sculpture is thus a selection of works by the pioneers of modern sculpture—including Henry Moore (cat. 98, 99) and Marino Marini (cat. 100)—embodying principally the continuing tradition of figure sculpture.

69

Jean-Baptiste Carpeaux
French, 1827–75

The Prince Imperial,
Louis Bonaparte, ca. 1867

Bronze (unique cast)
H: 32.5 cm (12¾ in)
Signed at base of the neck, rear:
J. B. Carpeaux

COLLECTIONS: Jean Perier (sale, Paris,
Mar. 10–11, 1933); private collection
(sale, Parke-Bernet, N.Y., Apr. 5, 1967,
no. 2).

LITERATURE: Paul Vitry, *Carpeaux* (Paris,
n.d.), p. 54; Parke-Bernet Galleries,
*Important XIX and XX Century Sculp-
ture* (N.Y., Apr. 5, 1967), no. 2.

NOTE: The sitter, the son of Napoleon
III, is shown at the age of eleven. Two
larger versions in marble exist, one in
the Bacri Collection and the other in the
Petit Palais, Paris.

70

Auguste Rodin
French, 1840–1917

Pas-de-Deux B, n.d.

Bronze (edition of 12, cast no. 12)
H: 33.3 cm (13 in)
Signed and numbered on the front
figure's upraised foot: *A. Rodin, No. 12;*
stamped on right foot of front figure:
Georges Rudier, Fondeur, Paris; copy-
righted on right foot of rear figure:
© *by Musée Rodin 1966*

COLLECTIONS: Musée Rodin.

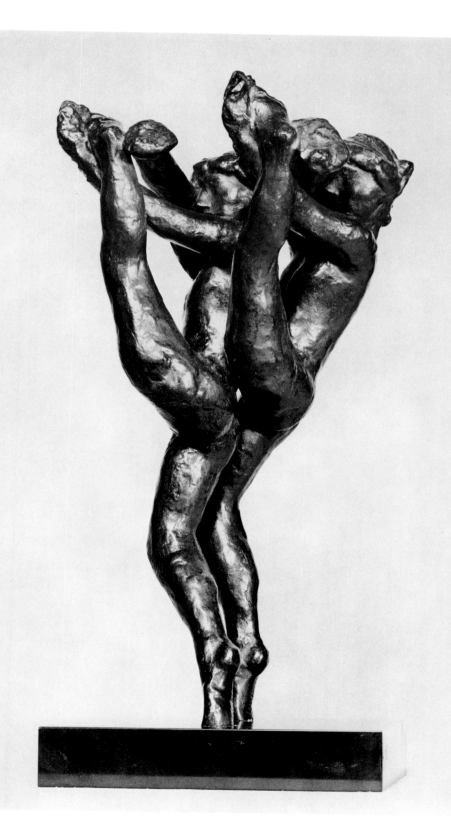

Aristide Joseph Bonaventure Maillol
French, 1861–1944

Washerwoman, 1896

Bronze (edition of 6, cast no. 3)
H: 11.5 cm (4½ in); L: 26.5 cm (10½ in)
Signed with the artist's monogram and
numbered on the washcloth: *AM 3/6*;
stamped on the skirt, right rear: *Alexis
Rudier, Fondeur, Paris*

COLLECTIONS: Galerie Dina Vierny.

LITERATURE: George Waldemar, *Aristide
Maillol* (Greenwich, Conn., 1965), p. 63.

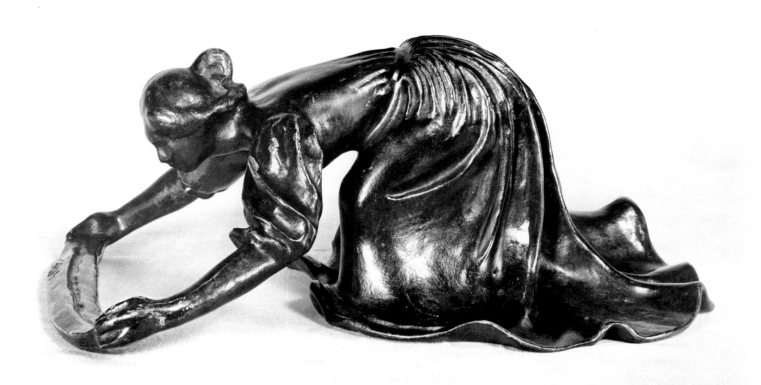

72

Aristide Joseph Bonaventure Maillol
French, 1861–1944

Leda, 1900

Bronze
H: 29.3 cm (11½ in)
Signed with the artist's monogram and
stamped on base, rear: *AM Alexis
Rudier, Fondeur, Paris*

COLLECTIONS: Galerie Dina Vierny.

LITERATURE: George Waldemar, *Aristide
Maillol* (Greenwich, Conn., 1965),
p. 137.

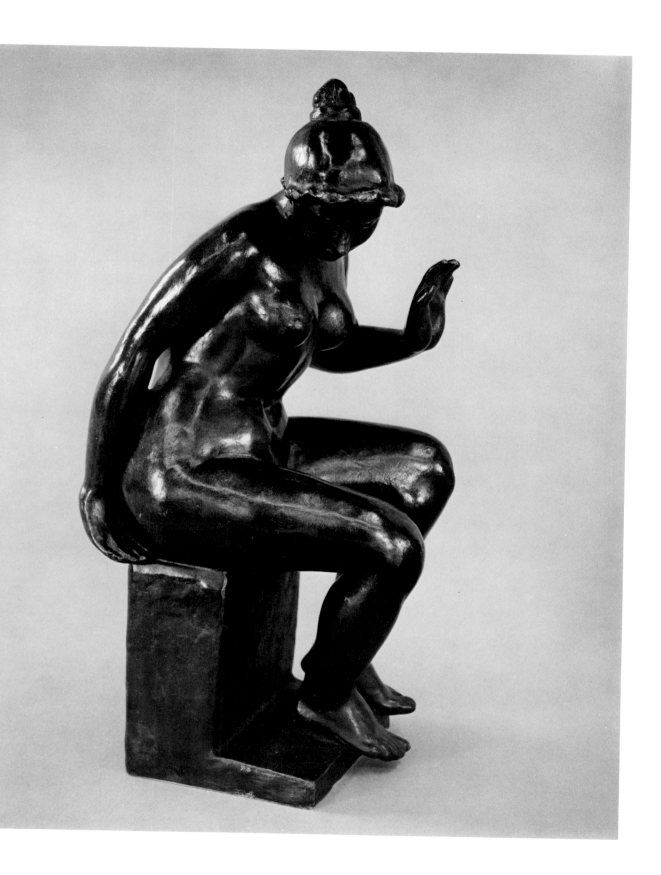

73

Aristide Joseph Bonaventure Maillol
French, 1861–1944

Study for "Thought," 1902

Bronze (edition of 6, cast no. 4)
H: 18 cm (7 in)
Signed with the artist's monogram and
numbered on base, right side: *AM 4/6;*
stamped on base, rear: *Alexis Rudier,
Fondeur, Paris*

COLLECTIONS: Galerie Dina Vierny.

LITERATURE: George Waldemar, *Aristide
Maillol* (Greenwich, Conn., 1965),
p. 131.

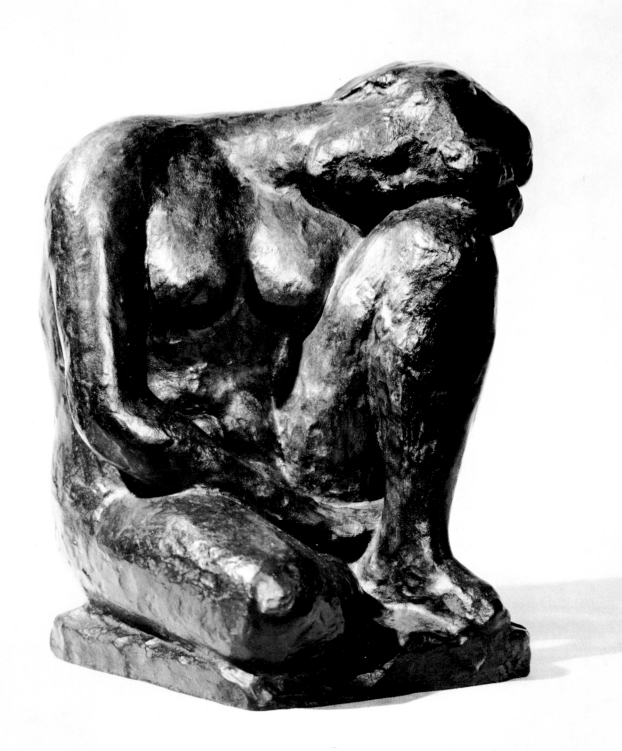

74

Aristide Joseph Bonaventure Maillol
French, 1861–1944

Seated Woman, 1902

Bronze (edition of 6, cast no. 1)
H: 28 cm (11 in)
Signed with the artist's monogram,
numbered, and stamped on base, rear:
AM 1/6; Alexis Rudier, Fondeur, Paris

COLLECTIONS: Estate of the artist;
Galerie Dina Vierny.

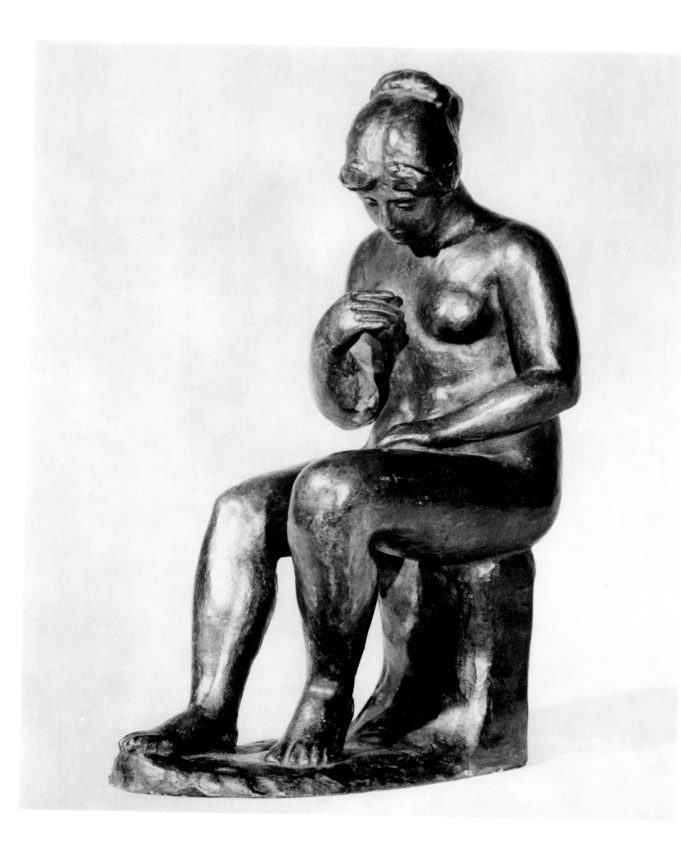

75

Aristide Joseph Bonaventure Maillol
French, 1861–1944

Night, 1905

Bronze
H: 18 cm (7 in)
Signed on right foot: *AM*; stamped with
the founder's mark: *AR*

COLLECTIONS: Estate of the artist;
Galerie Dina Vierny.

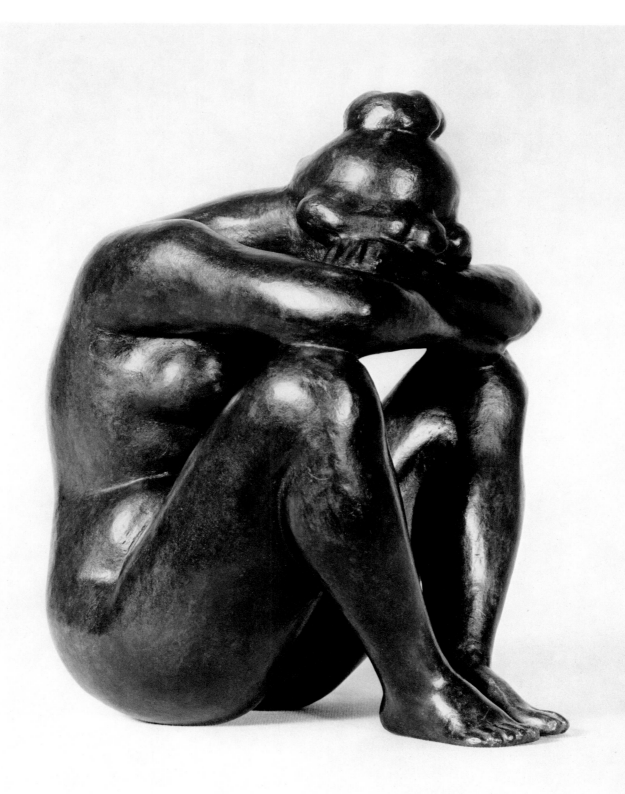

76

Aristide Joseph Bonaventure Maillol
French, 1861–1944

Woman with a Dove, 1905

Bronze
H: 26 cm (9 in); W: 16 cm (6¼ in)
Signed with the artist's monogram and
inscribed on base, top: *AM, N5HC;*
stamped on base, rear: *Alexis Rudier,
Fondeur, Paris*

COLLECTIONS: Galerie Dina Vierny.

LITERATURE: George Waldemar, *Aristide
Maillol* (Greenwich, Conn., 1965),
p. 144.

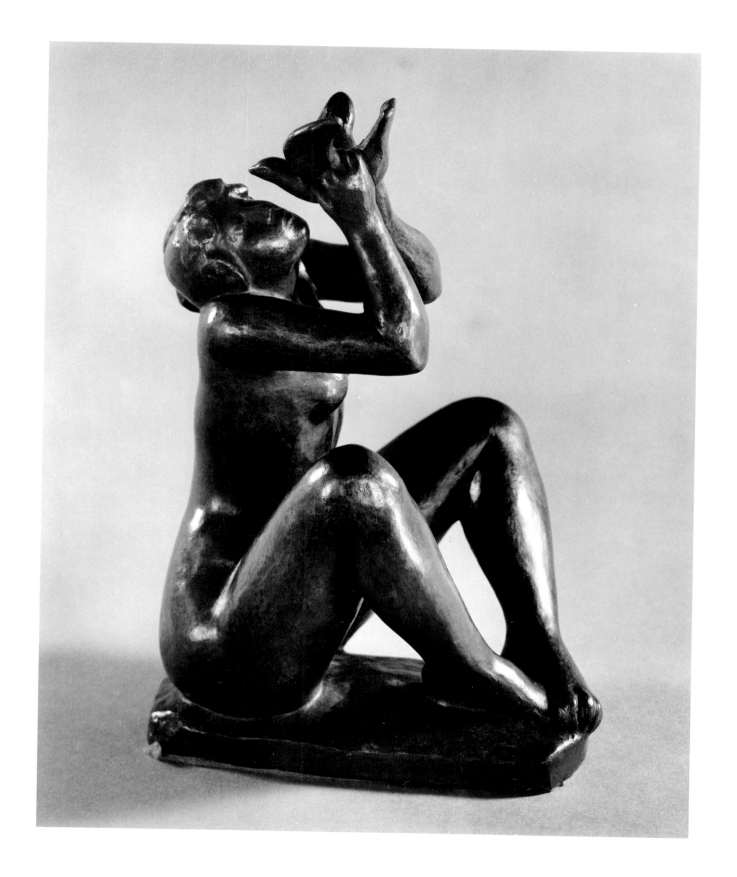

77

Aristide Joseph Bonaventure Maillol
French, 1861–1944

Torso of Venus, 1918

Bronze (edition of 6, cast no. 3)
H: 114 cm (44½ in)
Signed with the artist's monogram and
numbered at base of the figure's right
leg: *AM 3/6;* stamped on the figure's left
leg, underside: *Alexis Rudier, Fondeur,
Paris*

COLLECTIONS: Galerie Dina Vierny.

EXHIBITIONS: Los Angeles County Museum of Art, Los Angeles, 1968–71,
"Sculpture from the Collections of Norton Simon, Inc. and the Hunt Industries
Museum of Art."

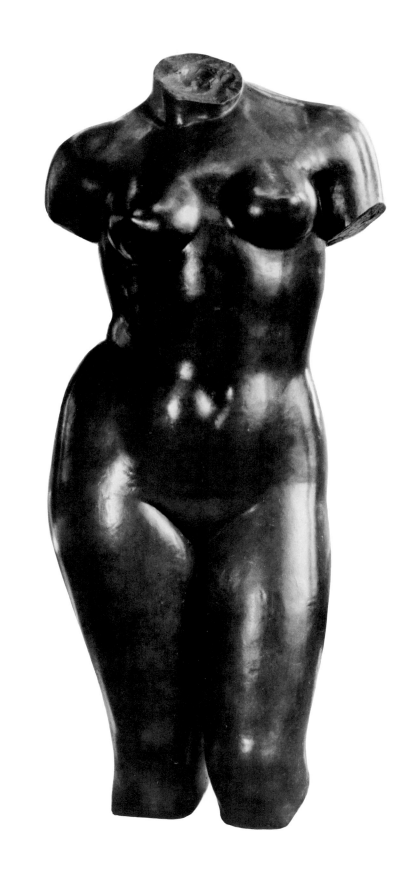

78

Aristide Joseph Bonaventure Maillol
French, 1861–1944

Young Man Standing, 1930

Bronze (edition of 6, plus this artist's
proof cast)
H: 31.5 cm (12¼ in)
Signed with the artist's monogram on
base, top: *AM;* marked on base, left side:
Épreuve d'Artiste; stamped on base,
rear: *Alexis Rudier, Fondeur, Paris*

COLLECTIONS: Galerie Dina Vierny.

LITERATURE: George Waldemar, *Aristide
Maillol* (Greenwich, Conn., 1965),
p. 195.

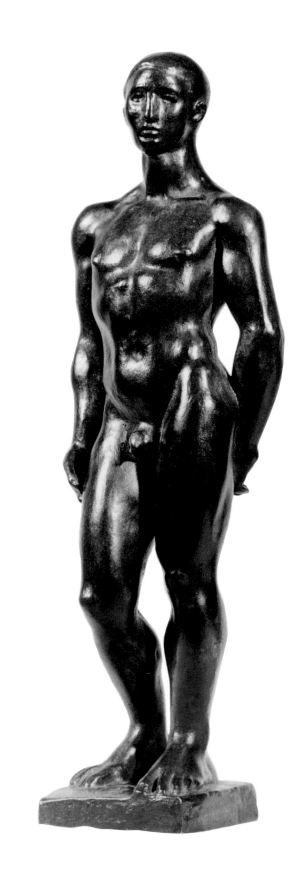

79

Hilaire Germain Edgar Degas
French, 1834–1917

Grande Arabesque, First Time,
ca. 1882–85

Bronze (edition of 22, cast no. HER)
H: 48.5 cm (19 in)
Signed on base, top front left: *Degas;*
stamped and numbered on base, top rear
right: *Cire Perdue A. A. Hebrard,*
18 HER

COLLECTIONS: A. A. Hebrard; Stephen
Hahn Gallery.

LITERATURE: John Rewald, *Degas: Works
in Sculpture* (N.Y., 1944), no. 35; idem,
Degas: Sculpture, The Complete Works
(N.Y., 1956), p. 148.

NOTE: The cast number 18 HER indi-
cates that this bronze is number 18 of
the series of 72 wax sculptures which
were cast in bronze by A. A. Hebrard
after the artist's death and that this cast
was reserved for the founder, the others
being lettered A through T, with one
other cast bearing a special mark (HER
D) denoting that it was to go to the
artist's family.

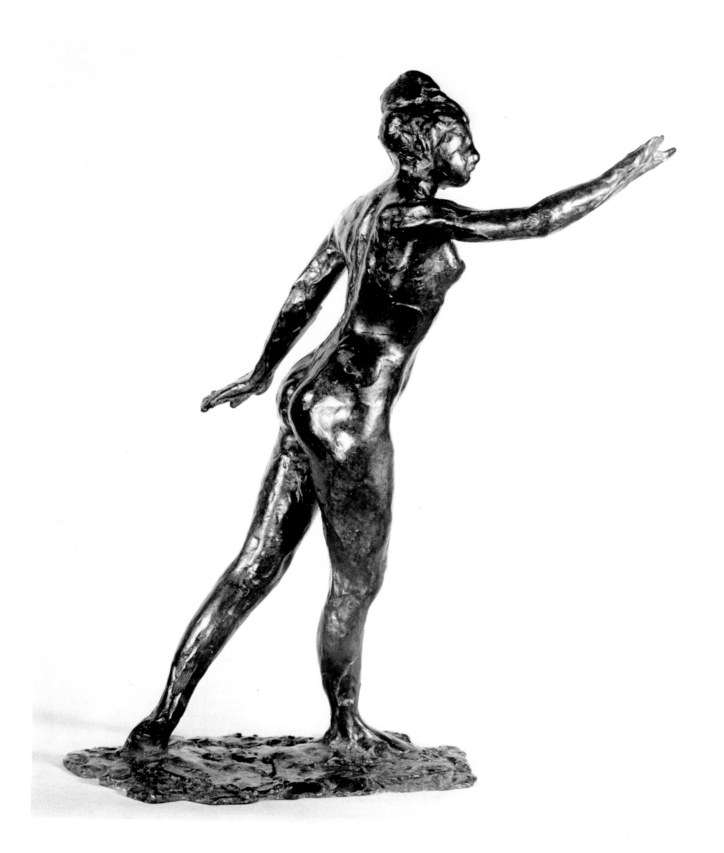

80

Hilaire Germain Edgar Degas
French, 1834–1917

*Woman Rubbing Her Back with
a Sponge, Torso,* ca. 1885–90

Bronze (edition of 22, cast no. HER D)
H: 33.5 cm (17 in)
Signed, right thigh: *Degas;* numbered
and stamped, left thigh: 28 HER D, *Cire
Perdue A. A. Hebrard*

COLLECTIONS: Heirs to the estate of
Edgar Degas; private collection, Paris;
Paul Rosenberg and Co.

EXHIBITIONS: Nelson Gallery, Kansas
City, on loan Aug. 1968–Jan. 1969.
LITERATURE: John Rewald, *Degas: Works
in Sculpture* (N.Y., 1944), no. 51; idem,
Degas: Sculpture, The Complete Works
(N. Y., 1956), no. LI.

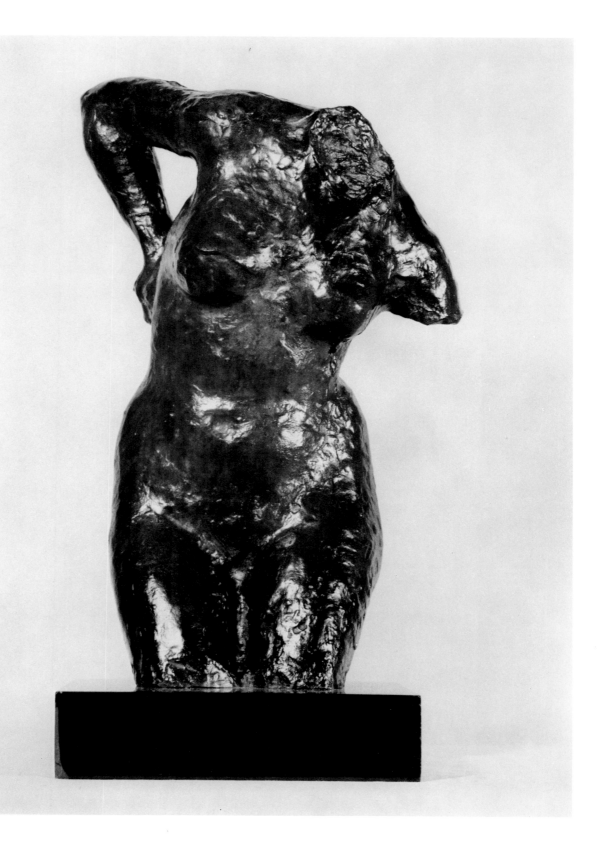

81

Wilhelm Lehmbruck
German, 1881–1919

Standing Woman, 1910

Bronze
H: 196 cm (75¼ in)

COLLECTIONS: Estate of the artist; Manfred and Guido Lehmbruck.

LITERATURE: August Hoff, *Wilhelm Lehmbruck: Leben und Werk* (Berlin, 1961), p. 160.

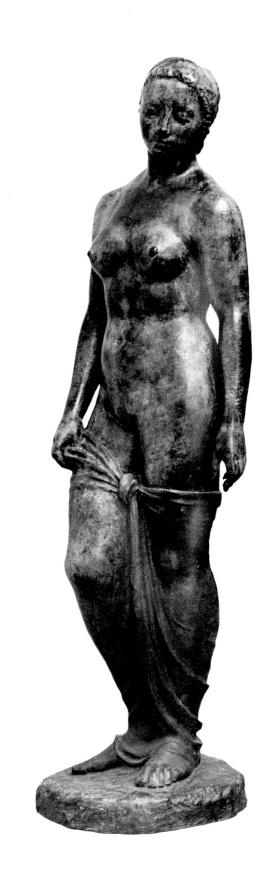

Ernst Barlach
German, 1870–1938

The Avenger, 1914

Bronze
H: 44 cm (17¼ in); W: 58.5 cm (22⅞ in);
Depth: 22 cm (8¾ in)
Signed and dated (incorrectly) on base,
top: *E. Barlach 1922*; stamped on right
side of base, top left: *H. Noack Berlin*

COLLECTIONS: Marlborough-Gerson Gal-
lery; Norton Simon.

EXHIBITIONS: Grunewald Graphic Art
Foundation, University of California,
Los Angeles, 1972, "Ernst Barlach."

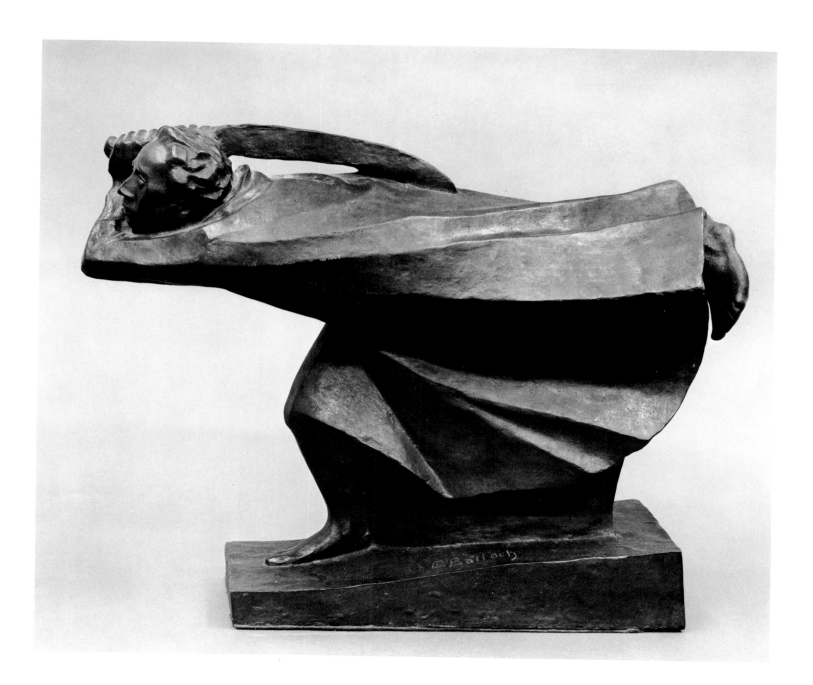

83

Constantin Brancusi
Rumanian, 1876–1957

Muse, 1912

Bronze (edition of 5, cast no. 1) on lime-
stone base
H: 43.5 cm (17½ in); Base: 25.5 cm
(10 in)
Signed, numbered, and stamped on head
at base, rear: *Brancusi 1/5; Susse
Fondeur Paris 69*

COLLECTIONS: Estate of the artist;
Alexandre Istrati.

EXHIBITIONS: University of California
Art Gallery, Los Angeles, 1972, *Twen-
tieth Century Sculpture from Southern
California Collections,* p. 14.

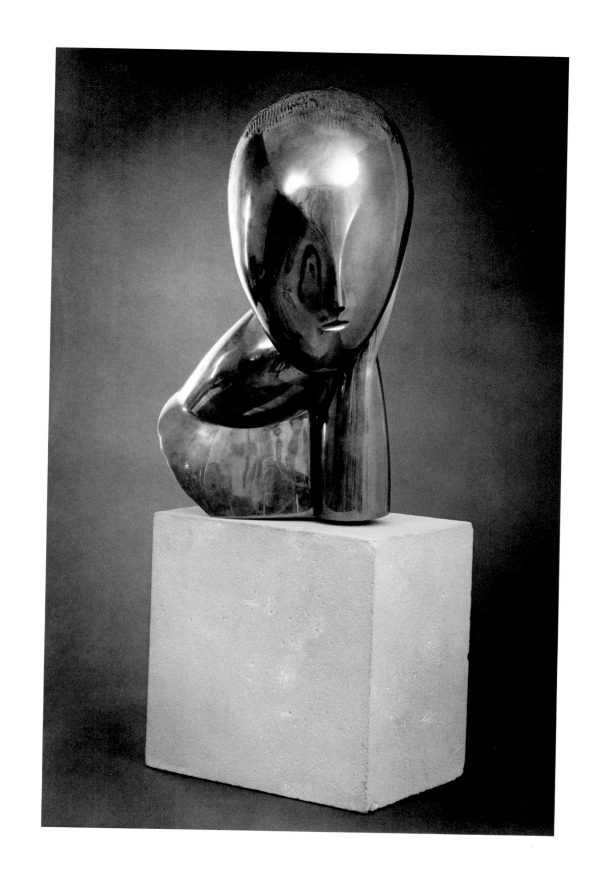

84

Pablo Ruiz y Picasso
Spanish, b. 1881

Head of a Jester, 1905

Bronze (unnumbered edition)
H: 40 cm (15¾ in)
Signed at base, rear: *Picasso*

COLLECTIONS: Ambroise Vollard; private
collection, United States; Stephen Hahn
Gallery.

LITERATURE: Alfred H. Barr, Jr., *Picasso:
Fifty Years of His Art* (N.Y., 1946), p. 38;
Daniel-Henry Kahnweiler, *Les Sculp-
tures de Picasso* (Paris, 1948), pl. 2;
G. C. Argan, *Scultura di Picasso* (Venice,
1953), pl. IV; W. Boeck and Jaime
Sabartes, *Picasso* (London, 1955), no. 32;
Christian Zervos, *Pablo Picasso* (Paris,
n.d.), I, no. 322; Roland Penrose, *Sculp-
ture of Picasso* (N.Y., 1967), p. 52; Tate
Gallery, *Picasso: Sculpture, Ceramics,
Graphic Work* (London, 1967), p. 8.

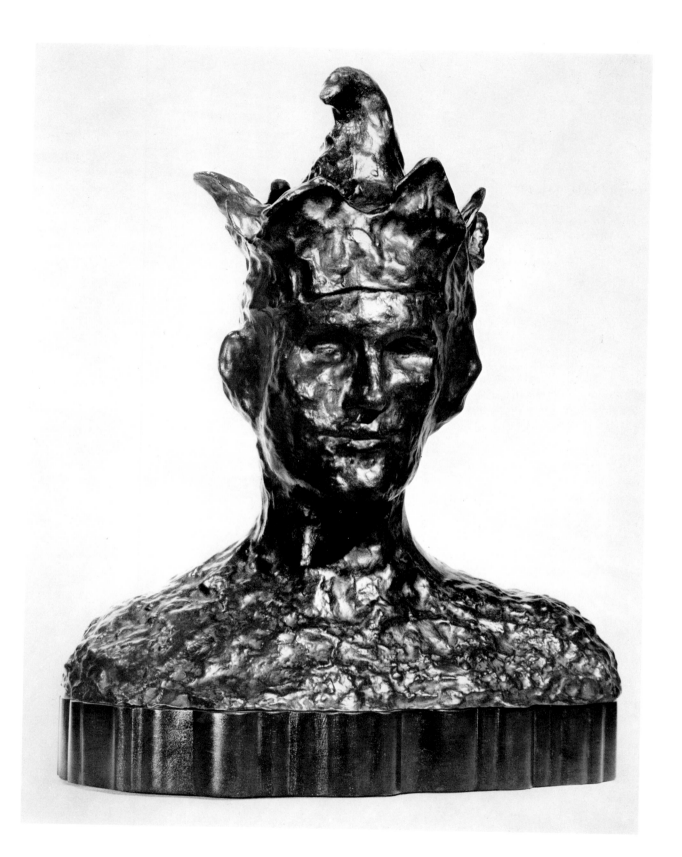

85

Pablo Ruiz y Picasso
Spanish, b. 1881

Head of Fernande, 1905

Bronze (edition of 9, cast no. 7)
H: 34.3 cm (13⅜ in)
Signed, numbered, and stamped on the
back at base: 7/9 *Picasso, Cire Perdue C.
Valsuani*

COLLECTIONS: Galerie Beyeler; G. David
Thompson; Stephen Hahn Gallery.

EXHIBITIONS: Galerie Beyeler, Basel, 1960,
La Femme, no. 60; Galleria d'arte mod-
erna, Milan, 1961; Philadelphia Mu-
seum of Art, Philadelphia, 1969, *Recent
Acquisitions by the Norton Simon, Inc.
Museum of Art,* no. 6.

LITERATURE: Christian Zervos, *Pablo
Picasso* (Paris, n.d.), 1, no. 323, pl. 149;
Tate Gallery, *Picasso: Sculpture, Ceram-
ics and Graphic Work* (London, 1967),
p. 8; Roland Penrose, *Sculpture of
Picasso* (N.Y., 1967), p. 53.

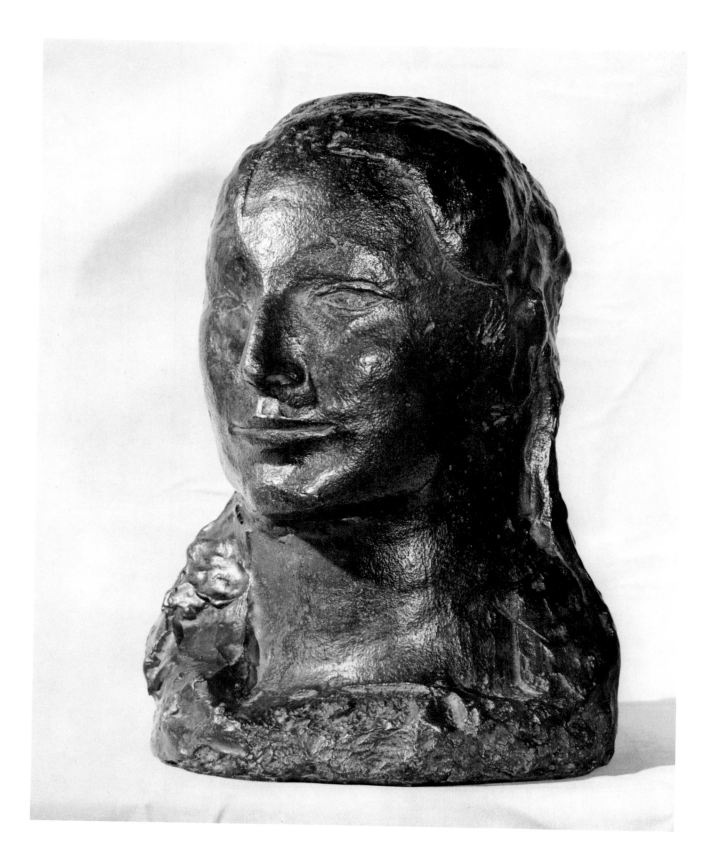

Pablo Ruiz y Picasso
Spanish, b. 1881

Head of a Woman, 1909

Bronze (edition of 9, cast no. 3)
H: 41 cm (16¼ in)
Signed on figure's left shoulder: *Picasso;*
stamped and numbered at base, rear:
Cire Perdue C. Valsuani 3/9

COLLECTIONS: Stephen Hahn Gallery.

EXHIBITIONS: Los Angeles County Museum of Art, Los Angeles, Dec. 1970–
Feb. 1971, "The Cubist Epoch," no. 288.

LITERATURE: Christian Zervos, *Pablo Picasso* (Paris, n.d.), 2, part 2, no. 573;
Tate Gallery, *Picasso: Sculpture, Ceramics, Graphic Work* (London, 1967), p. 10;
Douglas Cooper, *The Cubist Epoch* (N.Y., 1971), p. 232, pl. 281.

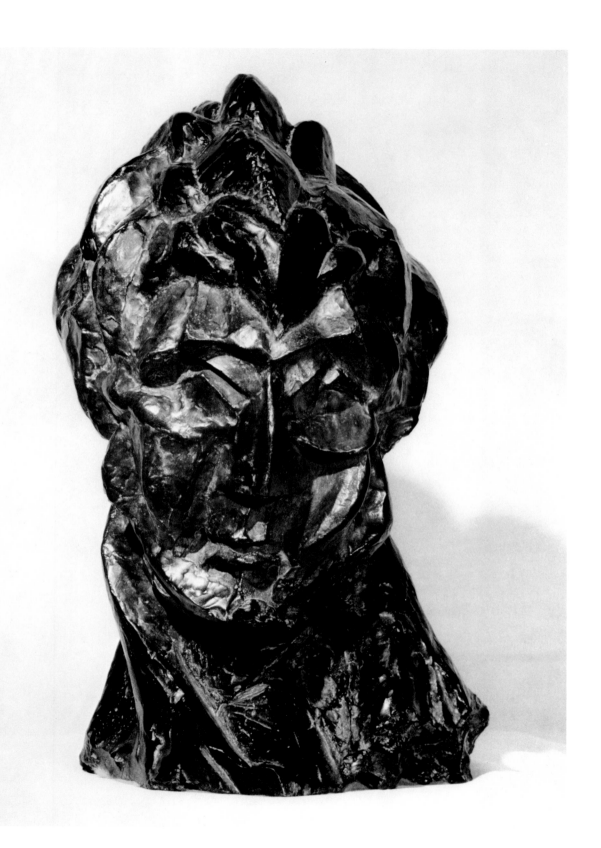

87

Pablo Ruiz y Picasso
Spanish, b. 1881

Woman I, 1945

Bronze (edition of 10, cast no. 3)
H: 23 cm (9 in)
Numbered on base, rear: *3/10*; stamped
on base: *Cire Perdue C. Valsuani*

COLLECTIONS: Berggruen et Cie.

EXHIBITIONS: Tate Gallery, London,
1967, *Picasso: Sculpture, Ceramics,
Graphic Work*, no. 85.

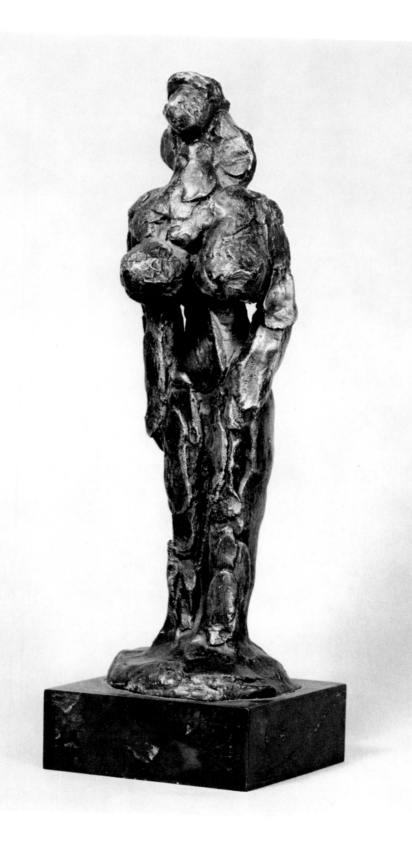

88

Pablo Ruiz y Picasso
Spanish, b. 1881

Woman II, 1945

Bronze (edition of 10, cast no. 3)
H: 20 cm (7⅞ in)
Numbered on figure's right leg, base,
rear: *3/10*

COLLECTIONS: Berggruen et Cie.

EXHIBITIONS: Tate Gallery, London,
1967, *Picasso: Sculpture, Ceramics,
Graphic Work*, no. 86.

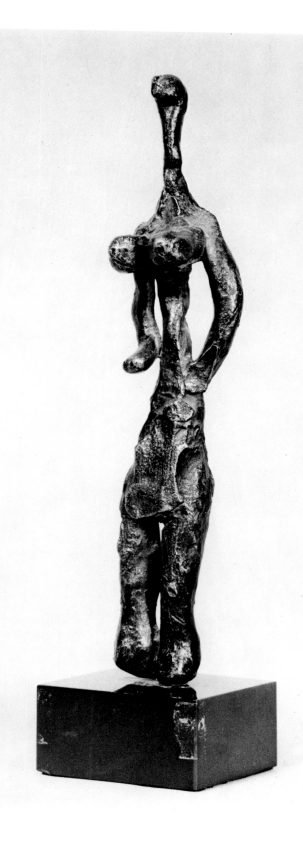

89

Pablo Ruiz y Picasso
Spanish, b. 1881

Woman III, 1945

Bronze (edition of 10, cast no. 4)
H: 18.5 cm (7¼ in)
Numbered on base, rear: 4/10

COLLECTIONS: Berggruen et Cie.

EXHIBITIONS: Tate Gallery, London,
1967, *Picasso: Sculpture, Ceramics,
Graphic Work*, no. 87.

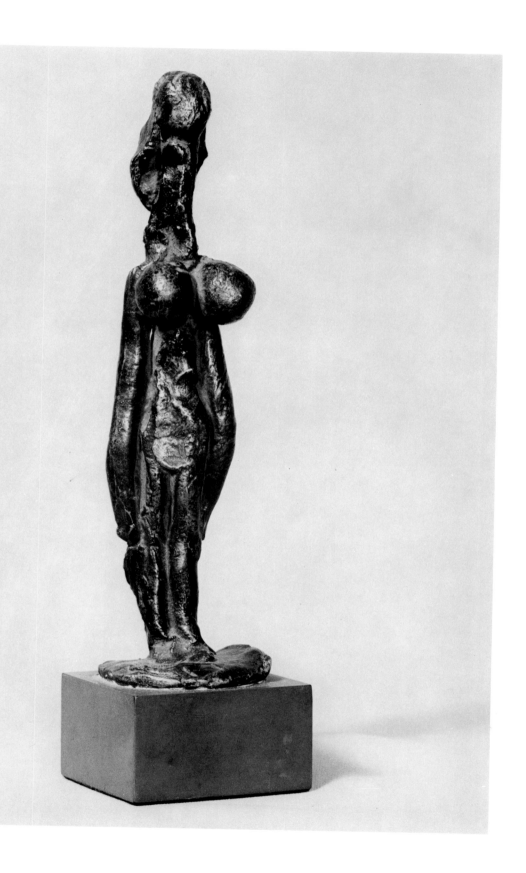

90

Pablo Ruiz y Picasso
Spanish, b. 1881

Woman IV, 1947

Bronze (edition of 10, cast no. 3)
H: 21 cm (8¼ in)
Numbered on base, rear: *3/10*; stamped
on base, rear: *Cire Perdue C. Valsuani*

COLLECTIONS: Berggruen et Cie.

EXHIBITIONS: Tate Gallery, London,
1967, *Picasso: Sculpture, Ceramics,
Graphic Work*, no. 89.

91

Pablo Ruiz y Picasso
Spanish, b. 1881

Woman V, 1947

Bronze (edition of 10, cast no. 3)
H: 8.5 cm (3⅜ in)
Numbered on base: *3/10*

COLLECTIONS: Berggruen et Cie.

EXHIBITIONS: Tate Gallery, London,
1967, *Picasso: Sculpture, Ceramics,
Graphic Work*, no. 90.

92

Jacques Lipchitz
Lithuanian/American, b. 1891

Sculpture, 1916, 1916

Stone
H: 104 cm (41½ in)

COLLECTIONS: Marlborough-Gerson
Gallery.

EXHIBITIONS: Museum of Modern Art,
N.Y., 1936, *Cubism and Abstract Art,*
no. 137; Marlborough-Gerson Gallery,
N.Y., 1968, *Lipchitz: The Cubist Period
1913–1930,* no. 25; Metropolitan Mu-
seum of Art, N.Y., on loan June 1968;
Los Angeles County Museum of Art,
Los Angeles, Dec. 1970–Feb. 1971, "The
Cubist Epoch," no. 193.

LITERATURE: Douglas Cooper, *The Cubist
Epoch* (N.Y., 1971), p. 251, pl. 307.

93

Jacques Lipchitz
Lithuanian/American, b. 1891

Figure, 1926–30

Bronze (edition of 7, cast no. 2)
H: 228 cm (85¼ in); W: 99.5 cm (39 in);
Depth: 74 cm (29 in)
Signed, numbered, and dated on base,
rear: *J. Lipchitz* ② *1926–30*

COLLECTIONS: Philip Johnson; Marl-
borough-Gerson Gallery.

EXHIBITIONS: Corcoran Gallery of Art,
Washington, D.C., 1960, *Jacques Lip-
chitz: A Retrospective Exhibition of
Sculpture and Drawings,* no. 12; Los
Angeles County Museum of Art, Los
Angeles, 1968–71, "Sculpture from the
Collections of Norton Simon, Inc. and
the Hunt Industries Museum of Art."

LITERATURE: A. M. Hammacher, *Jacques
Lipchitz: His Scultpure* (N.Y., 1960),
p. 46.

94
Henri Matisse
French, 1869–1954

The Back I, ca. 1909

Bronze (edition of 10, cast no. 0)
H: 188 cm (74 in)
Signed and numbered on lower left of
base: *Henri Matisse 0/10, Georges
Rudier, Fondeur, Paris*

COLLECTIONS: Estate of the artist; Pierre
Matisse Gallery.

EXHIBITIONS: Los Angeles County Mu-
seum of Art, Los Angeles, 1968–71,
"Sculpture from the Collections of Nor-
ton Simon, Inc. and the Hunt Industries
Museum of Art."

LITERATURE: Alfred H. Barr, Jr., *Matisse:
His Art and His Public* (N.Y., 1951),
p. 313; Herbert Read, *A Concise History
of Modern Sculpture* (N.Y., 1966), p. 40;
Albert E. Elsen, *The Sculpture of Henri
Matisse* (N.Y., 1972), pp. 186, 194; Alicia
Legg, *The Sculpture of Matisse* (N.Y.,
1972), p. 26.

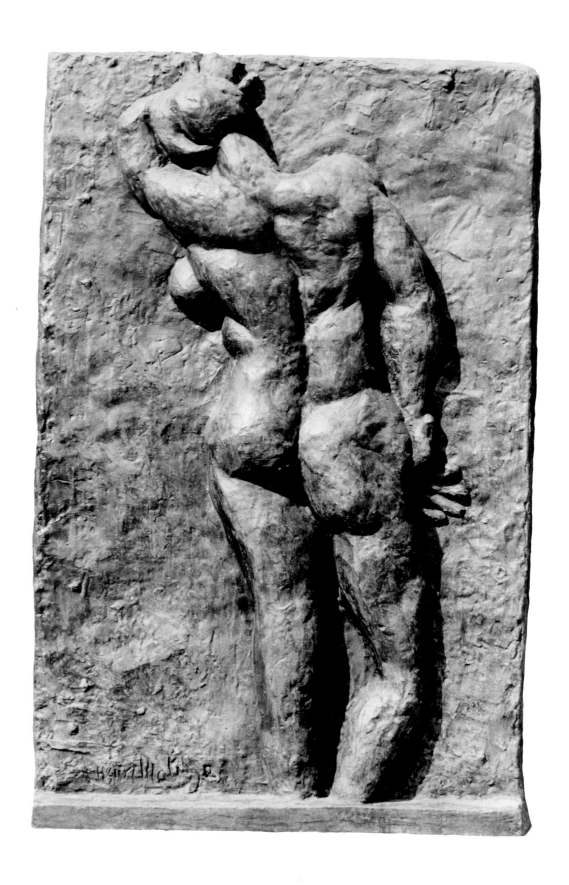

95

Henri Matisse
French, 1869–1954

The Back II, 1913

Bronze (edition of 10, cast no. 0)
H: 187 cm (73⅝ in)
Stamped on lower right of base, front:
Georges Rudier, Fondeur, Paris

COLLECTIONS: Estate of the artist; Pierre
Matisse Gallery.

EXHIBITIONS: Los Angeles County Museum of Art, Los Angeles, 1968–71,
"Sculpture from the Collections of Norton Simon, Inc. and the Hunt Industries
Museum of Art."

LITERATURE: Herbert Read, *A Concise
History of Modern Sculpture* (N.Y.,
1966), p. 40; Albert E. Elsen, *The Sculpture of Henri Matisse* (N.Y., 1972), pp.
189, 194; Alicia Legg, *The Sculpture of
Matisse* (N.Y., 1972), p. 27.

96

Henri Matisse
French, 1869–1954

The Back III, ca. 1916–17

Bronze (edition of 10, cast no. 0)
H: 187 cm (73½ in)
Stamped, lower right: *Georges Rudier, Fondeur, Paris*

COLLECTIONS: Estate of the artist; Pierre Matisse Gallery.

EXHIBITIONS: Los Angeles County Museum of Art, Los Angeles, 1968–71, "Sculpture from the Collections of Norton Simon, Inc. and the Hunt Industries Museum of Art."

LITERATURE: Alfred H. Barr, Jr., *Matisse: His Art and His Public* (N.Y., 1951), p. 458 (as *Back II*); Herbert Read, *A Concise History of Modern Sculpture* (N.Y., 1966), p. 41; Albert E. Elsen, *The Sculpture of Henri Matisse* (N.Y., 1972), pp. 191, 195; Alicia Legg, *The Sculpture of Matisse* (N.Y., 1972), p. 28.

Henri Matisse
French, 1869–1954

The Back IV, 1929

Bronze (edition of 10, cast no. 0)
H: 188 cm (74 in)
Stamped, lower right: *Georges Rudier, Fondeur, Paris*

COLLECTIONS: Estate of the artist; Pierre Matisse Gallery.

EXHIBITIONS: Los Angeles County Museum of Art, Los Angeles, 1968–71, "Sculpture from the Collections of Norton Simon, Inc. and the Hunt Industries Museum of Art."

LITERATURE: Alfred H. Barr, Jr., *Matisse: His Art and His Public* (N.Y., 1951), p. 459 (as *Back III*); Herbert Read, *A Concise History of Modern Sculpture* (N.Y., 1966), p. 41; Albert E. Elsen, *The Sculpture of Henri Matisse* (N.Y., 1972), pp. 193, 195; Alicia Legg, *The Sculpture of Matisse* (N.Y., 1972), p. 29.

Henry Moore
English, b. 1898

Three Standing Figures, 1953

Bronze (edition of 8, unnumbered)
H: 74 cm (29 in)

COLLECTIONS: Mary Moore; Jeffrey H.
Loria and Co.

LITERATURE: David Sylvester, ed., *Henry
Moore*, 3 vols. (London, 1965), 2, no. 49.

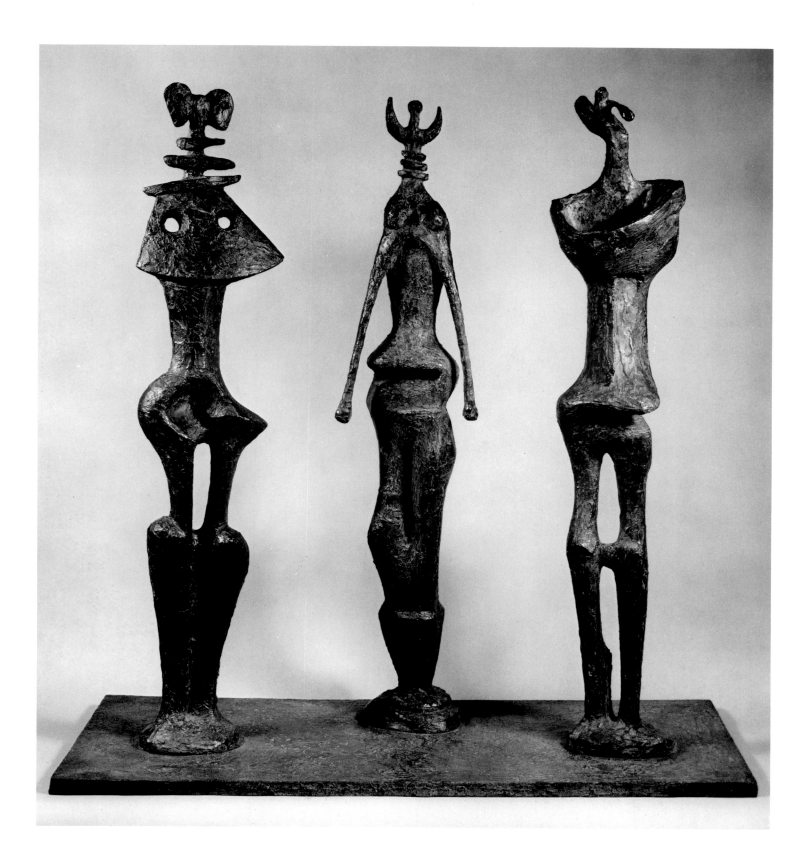

99

Henry Moore
English, b. 1898

*Mother and Child against
Open Wall*, 1956

Bronze (edition of 12, unnumbered)
H: 20.5 cm (8 in)

COLLECTIONS: Jeffrey H. Loria and Co.

LITERATURE: David Sylvester, ed., *Henry
Moore*, 3 vols. (London, 1965), 3, no.
40d.

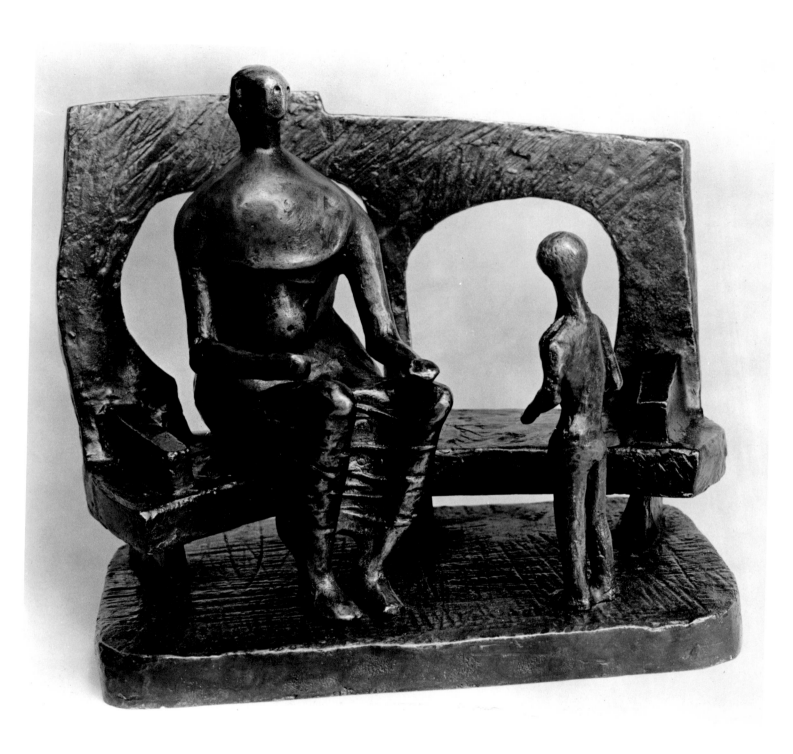

100

Marino Marini
Italian, b. 1901

Horse and Rider, 1947

Bronze
H: 105 cm (39½ in)
Signed: *M.M.*

COLLECTIONS: Laing Galleries; Dr. Ben
Raxlen (sale, Parke-Bernet, N.Y., Apr. 4,
1968, no. 147).

EXHIBITIONS: Brooklyn Museum, N.Y.,
on loan June 1968.

LITERATURE: Burchholz Gallery, *Marino
Marini* (N.Y., 1950), pl. 19; Umbra
Apollonio, *Marino Marini* (Milan,
1953), pl. 83; Parke-Bernet Galleries,
*Important Nineteenth and Twentieth
Century Sculpture* (N.Y., Apr. 4, 1968),
no. 147.

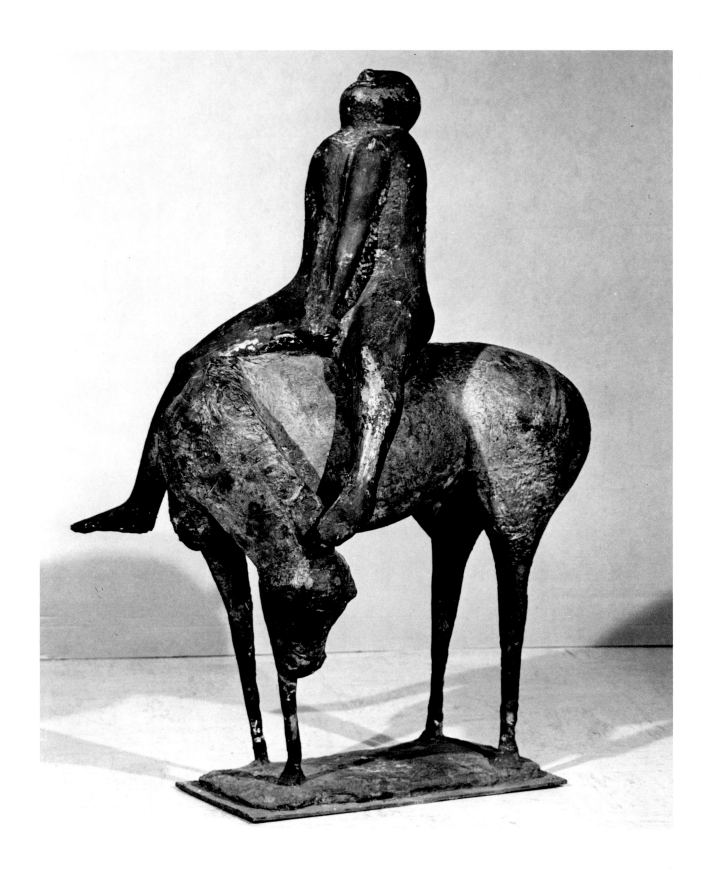

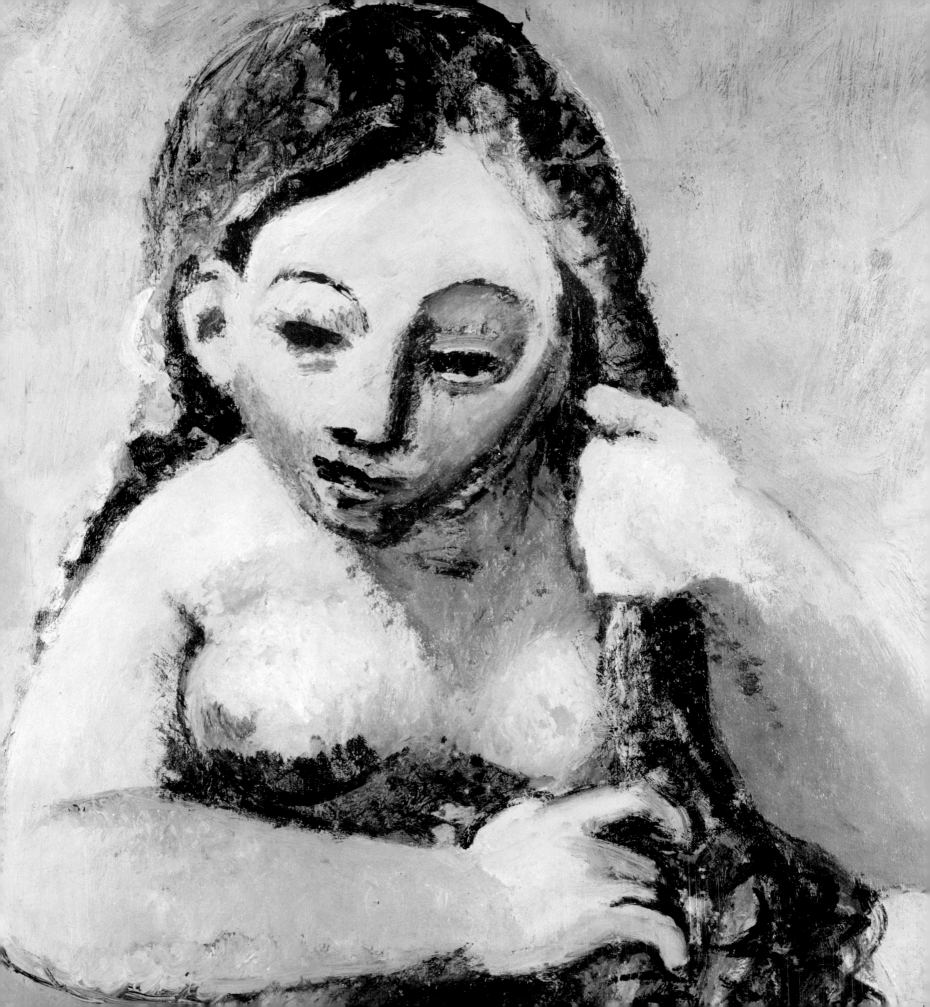

H. H. ARNASON was Professor and Chairman of the Department of Art, University of Minnesota, Director of the Walker Art Center, Minneapolis, and Vice-President for Art Administration, the Solomon R. Guggenheim Museum.

MARIAN BURLEIGH-MOTLEY is Lecturer in the Department of Art and Archaeology, Princeton University.

ROBERT JUDSON CLARK is Assistant Professor in the Department of Art and Archaeology, Princeton University.

JOHN DAVID FARMER is Curator of European Paintings at The Art Institute of Chicago.

FELTON L. GIBBONS is Associate Professor in the Department of Art and Archaeology, Princeton University, and Faculty Consultant on Drawings at The Art Museum.

SAM HUNTER is Professor in the Department of Art and Archaeology, Princeton University.

ROBERT A. KOCH is Professor in the Department of Art and Archaeology, Princeton University, and Curator of Prints at The Art Museum.

JOHN RUPERT MARTIN is the Marquand Professor in the Department of Art and Archaeology, Princeton University.

THOMAS L. B. SLOAN is Assistant Professor in the Department of Art and Archaeology, Princeton University.

JOSEPH C. SLOANE is Professor and Chairman of the Department of Art at the University of North Carolina, Chapel Hill.

DAVID W. STEADMAN is Acting Director at The Art Museum and Lecturer in the Department of Art and Archaeology, Princeton University.

The Contributors

Details of works of art (all from the Norton Simon, Inc. Museum of Art collection) reproduced in this book are as follows:

Page 2: Matisse, *Odalisque with Tambourine*
Page 14: Bassano, *Flight into Egypt*
Page 17: Bassano, *Flight into Egypt*
Page 24: Master of Alkmaar, *Road to Calvary*
Page 26: Cranach, *Eve*
Page 34: Ruisdael, *Woody Landscape with a Pool and Figures*
Page 50: Guardi, *View of the Rialto from the Grand Canal*
Page 52: Vigée-Lebrun, *Theresa, Countess Kinsky*
Page 64: Courbet, *Forest Pool*
Page 86: Signac, *Seine at Les Andelys*
Page 114: Degas, *Dance Rehearsal in the Foyer*
Page 116: Degas, *Woman Drying Her Hair*
Page 130: Picasso, *Pointe de la Cité*
Page 154: Matisse, *Small Blue Dress before a Mirror*
Page 176: Nolde, *Red Poppy*
Page 178: Marc, *Bathing Girls*
Page 192: Matisse, *The Back I*
Page 260: Picasso, *Nude Combing Her Hair*

Index of Artists Represented

(Numbers refer to catalogue numbers)